es musición habitada Gorpas yennad Habitas Albandasa media

MANUAL

basic betacam camerawork

No longer the property of the No longer the Public Library.
Boston Public Library the Library and Boston Public Library the Library and Boston Public Library the Library the Library and the Boston Public Library the Librar

MANUAL

16MM FILM CUTTING John Burder

BASIC BETACAM CAMERAWORK, Third Edition

Peter Ward

BASIC FILM TECHNIQUE Ken Daley

BASIC STUDIO DIRECTING Rod Fairweather

BASIC TV REPORTING, Second Edition Ivor Yorke

BASIC TV TECHNOLOGY, Second Edition Robert L. Hartwig

THE CONTINUITY SUPERVISOR, Fourth Edition
Avril Rowlands

CREATING SPECIAL EFFECTS FOR TV AND VIDEO, Third Edition Bernard Wilkie

DIGITAL VIDEO CAMERAWORK Peter Ward

EFFECTIVE TV PRODUCTION, Third Edition Gerald Millerson

FILM TECHNOLOGY IN POST PRODUCTION Dominic Case

GRAMMAR OF THE EDIT Roy Thompson

GRAMMAR OF THE SHOT Roy Thompson

LIGHTING FOR VIDEO, Third Edition Gerald Millerson

LOCAL RADIO JOURNALISM, Second Edition Paul Chantler and Sim Harris

MOTION PICTURE CAMERA AND LIGHTING EQUIPMENT

David W. Samuelson

MOTION PICTURE CAMERA TECHNIQUES David W. Samuelson

MULTI-CAMERA CAMERAWORK Peter Ward

NONLINEAR EDITING Patrick Morris

SINGLE CAMERA VIDEO PRODUCTION, Second Edition Robert B. Musburger

SOUND RECORDING AND REPRODUCTION, Third Edition

SOUND TECHNIQUES FOR VIDEO AND TV, Second Edition Glyn Alkin

THE USE OF MICROPHONES, Fourth Edition Alec Nisbett

VIDEO CAMERA TECHNIQUES, Second Edition

Gerald Millerson

Glyn Alkin

THE VIDEO STUDIO, Third Edition Alan Bermingham *et al*

TV TECHNICAL OPERATIONS Peter Ward

third edition

basic betacam camerawork

peter ward

Focal Press

OXFORD AUCKLAND BOSTON JOHANNESBURG MELBOURNE NEW DELHI

Focal Press
An imprint of Butterworth-Heinemann
Linacre House, Jordan Hill, Oxford OX2 8DP
225 Wildwood Avenue, Woburn, MA 01801-2041
A division of Reed Educational and Professional Publishing Ltd

R A member of the Reed Elsevier plc group

First published 1994 Reprinted 1994, 1995, 1997 Second edition published as *Basic Betacam & DVCPRO Camerawork* 1998 Third edition published as *Basic Betacam Camerawork* 2001

© Peter Ward 2001

All rights reserved. No part of this publication may be reproduced in any material form (including photocopying or storing in any medium by electronic means and whether or not transiently or incidentally to some other use of this publication) without the written permission of the copyright holder except in accordance with the provisions of the Copyright, Designs and Patents Act 1988 or under the terms of a licence issued by the Copyright Licensing Agency Ltd, 90 Tottenham Court Road, London, England W1P 0LP. Applications for the copyright holder's written permission to reproduce any part of this publication should be addressed to the publishers

British Library Cataloguing in Publication Data

Ward, Peter, 1936-

Basic betacam camerawork. - 3rd ed. - (Media manual)

- Videorecording
- I. Title

778.5'992

Library of Congress Cataloguing in Publication Data A catalogue record for this book is available from the Library of Congress

A catalogue record for this book is available from the Library of Congress

ISBN 0 240 51604 4

For information on all Focal Press publications visit our website at www.focalpress.com

Composition by Genesis Typesetting, Rochester, Kent Printed and bound in Great Britain by Biddles Ltd, www.biddles.co.uk

Contents

ACKNOWLEDGEMENTS	7	EXPOSURE	64
INTRODUCTION	8	CONTRAST RANGE	66
		VISUAL PERCEPTION	68
TELEVISION FUNDAMENTALS		CONTRAST CONTROL	70
THE (NON) STANDARD TV		ELECTRONIC CONTRAST	
SIGNAL	10	CONTROL	72
COLOUR	12	ADJUSTING EXPOSURE	74
THE DIGITAL SIGNAL	14	ZEBRA EXPOSURE INDICATOR	76
WHY COMPRESSION IS		PRODUCTION REQUIREMENTS	78
NEEDED	16	FACE TONES	80
COMPRESSION STANDARDS	18	GAIN, NOISE AND SENSITIVITY	82
CHARGE-COUPLED DEVICES		ELECTRONIC SHUTTERS	84
(CCDs)	20	TIME-LAPSE CONTROLS	86
FRAME INTERLINE TRANSFER		TIME CODE	88
(FIT)	22	TIME CODE AND PRODUCTION	
CCD INTEGRATION	24	TIME CODE LOCK	92
		MENUS	94
FORMATS		GAMMA AND LINEAR MATRIX	96
RECORDING FORMATS	26		
FORMAT AND PRODUCTION		CUSTOMIZING THE IMAGE	
BUDGET	28	CUSTOMIZING THE IMAGE	98
BETACAM FORMAT	30		100
DIGITAL BETACAM FORMAT	32		102
BETACAM SX	34		104
THE DV AND DVCAM FORMAT	36		106
THE TOOM ENG			108
THE ZOOM LENS	00		110
THE ZOOM LENS	38	VIEWING DISTANCE	112
ANGLE OF VIEW	40	DDOODAMME DDODUCTION	
DEPTH OF FIELD RESOLUTION	42 44	PROGRAMME PRODUCTION INVISIBLE TECHNIQUE	444
DUAL FORMAT CAMERAS	44		114
DUAL FUNIVIAT CAMENAS	40		116 118
CAMERA CONTROLS			120
CAMERA CONTROLS	48		122
LENS CONTROLS	50	COMPOSITION AND THE LENS	
COLOUR TEMPERATURE	52		126
IN-CAMERA FILTERS	54	. ,	128
WHITE BALANCE	56	CONTROLLING COMPOSITION	-
BLACK BALANCE	58		132
VIEWFINDER	60	C. MILLE WATCHER OF FELO	102
MONOCULAR AND 5-INCH	30	VIDEO JOURNALISM	
VIEWFINDER	62		134

OBJECTIVITY	136	COLOUR AND MOOD	180
STRUCTURE	138	ELECTRICAL LOCATION	
INTERVIEWS	140	SAFETY	182
LIVE INSERTS	142		
SATELLITE NEWS GATHERING		SOUND	
(1)		PROGRAMME PRODUCTION	
SATELLITE NEWS GATHERING		AND AUDIO	184
(2)	146	THE NATURE OF SOUND	186
		AUDIO RECORDING TRACKS	188
EDITING		BASIC AUDIO KIT	190
CAMERAWORK AND EDITING	148	CHOICE OF MICROPHONE	192
CONTINUITY EDITING	150	RADIO MICROPHONES	194
PERENNIAL EDITING	100	AUDIO LEVELS	196
TECHNIQUES	152	RECORDING LEVELS	198
NON-LINEAR EDITING	154	DIGITAL AUDIO	200
EDITING TECHNOLOGY	156	USING AN AUDIO MIXER	202
EDITING REQUIREMENTS (1)	158	LOCATION SOUND	204
EDITING REQUIREMENTS (2)	160	RECORDING AN INTERVIEW	206
EDITING REQUIREMENTS (3)	162	STEREO	208
		ROAD CRAFT	
LIGHTING		ROAD CRAFT	210
LOCATION LIGHTING	164	OPERATIONAL CHECKS (1)	212
CHARACTERISTICS OF LIGHT		OPERATIONAL CHECKS (2)	214
CONTROLLING LIGHT	168	CAMERA MOUNTS	216
LIGHTING A FACE	170	BATTERIES	218
LIGHTING LEVELS	172	PRE-RECORDING CHECKLIST	
	174		222
COLOUR CORRECTION	176	GLOSSARY OF PRODUCTION	
MOOD AND ATMOSPHERE	178	TERMS	224

Acknowledgements

The author wishes to acknowledge the help and assistance in compiling this manual from many television colleagues and equipment manufacturers. In particular, Alan Bermingham, Chris Wherry, Robin Boyd, Alex Bodman, Anton/Bauer Inc., Avid Technology, Cannon (UK) Ltd, JVC, OpTex, Panasonic, Sony Corporation, Thomson Broadcast Systems and Vinten Broadcast Ltd. My thanks for their help and co-operation, especially to an ex-film student Edmund Ward – for whom the book was written.

Various figures have been reproduced courtesy of: Anton/Bauer Inc. (pages 169 and 219); Cannon (UK) Ltd (page 45); OpTex (page 105); Panasonic Broadcast (page 29); Sony Corporation (pages 21, 23, 24, 31, 33, 35, 37, 48, 49, 57, 61, 63, 89, 91, 189, 199, 213, 215, 217 and 221) and Thomson Broadcast Systems (page 38).

Introduction

This is the third edition of *Basic Betacam Camerawork* and it has been extensively revised to accommodate the continuing changes in broadcast technology. It describes analogue and digital beta format camerawork. Other digital formats are covered in my book *Digital Video Camerawork* (Focal Press, 2000).

Despite the drift from analogue to digital, linear tape editing to non-linear storage, single portable camera operations remain a mixture of TV and film technique. The material acquired by a portable camera/recorder can be edited or it can be used live via satellite or terrestrial links. Whichever one of the new recording formats is used, perennial standard camerawork technique is still employed to record programme material. To competently employ the video/film hybrid technique, a basic knowledge of video recording, sound, lighting, video editing and TV journalism needs to be added to the primary role of the cameraman. This manual aims to give the basic instruction required in these additional skills as well as the fundamentals of ENG/EFP camerawork in news and location production.

With such a diversity of recording formats and camera design, choosing the appropriate camera/recorder format will depend on budget and the production requirements. Technique is dependent on technology and therefore an understanding of different production techniques and the variation in shooting styles is required for each genre. Each production type requires some specialist technique and possibly a specific format. It is essential to have an understanding of all the controls on the camera and how to record a technically acceptable image (e.g. exposure, gain, shutter, etc.). Also the programmemaking importance of camera peripherals such as batteries, camera mounts, microphones and video tape.

An important innovation with digital camerawork is that the digital camera is in some ways similar to a computer. Digital signal processing allows data to be easily manipulated and settings memorized. This ensures continuity of image appearance over production days and location. The electronic variables on the camera can be stored as digital values in a memory and can be controlled via menu screens displayed in the viewfinder. These values can be recalled as required or saved on a removable storage file. This provides for greater operational flexibility in customizing images compared to analogue camerawork.

Good production technique is understanding and exploiting the basic skills of camerawork, lighting and sound to serve the specific needs of a production. Providing a story structure and shot variety, to enable flexibility in editing, are basic standard techniques required from the ENG/EFP cameraman. Editing in the field is a useful time-saver for news bulletins, as is SNG. There is an essential need to shoot with editing in mind and to have a working knowledge and familiarity with different production styles and their requirements.

The manual does not assume that the reader will have a knowledge of TV engineering fundamentals. With multiskilling expanding, many production

people will be handling cameras for the first time and therefore a basic introduction to camerawork is provided.

The responsibility for acquiring and editing television material often rests with a number of people. Sometimes a single person will shoot and cut an item. On other programmes there will be many more people involved in getting the material 'on-air'. Traditionally there has been a division of 'production' labour shared between different craft skills. In this manual, camerawork and editing are descriptions of production activities and need not necessarily refer to a particular craft skill. Throughout the manual, terms such as 'cameraman' are used without wishing to imply that any production craft is restricted to one gender. 'Cameraman' for example is the customary title to describe a job practised by both men and women and 'he' where it occurs, should be read as 'he/she'.

This manual offers basic guidelines to the beginner but the novice should be careful not to set the advice in tablets of stone. What needs to be developed is an intelligent understanding of the technology and the camera facilities so that good judgment can be made in any production situation. It is just as important to develop the ability to judge when to use automatic features of the camera as it is to judge when to override and manually take control. The aim of the inexperienced camera user is similar to a learner driver — to develop familiarity with all the controls so that any manoeuvre is instantly possible and to accumulate a wide knowledge of routes (methods of programme making) so that any journey can be accomplished.

Broadcasting is always in the process of change. New technology, new production techniques, new methods of delivering the programme to the viewer are constantly introduced. Innovation and change have been the lifeblood of an industry created less than seventy years ago. In addition to the instruction contained in this manual, the newcomer to camerawork should develop a critical approach to television conventions and continuously experiment with production methods. There is never a definitive way of making television.

Because 'obsolete' cameras continue to be in daily use, there are references to controls and facilities of camera models no longer manufactured. Many of the specific descriptions of controls in this manual are related to the Sony 300/400 series of analogue Betacams which are widely available in teaching establishments and the Sony Digital Betacam series of cameras. Other models and makes of cameras will obviously have differences in design but all share most of the facilities described. To use the car as a metaphor, the windscreen wiper switch will vary in its position with make and model of car but they all perform the same function.

The (non) standard TV signal

Converting a three-dimensional moving image into a video signal requires a method of accurately translating light into electricity and then back into an image viewed on a TV monitor. This translation involves adopting a standard signal with a method of synchronization of line and frame repetition at the point of production, transmission and reception/video replay. There are many variables in the way this translation is accomplished:

- The number of lines in the picture and the number of pictures per second in monochrome television broadcasting were historically chosen to be compatible with the frequency of the AC power supply. There were 50Hz countries and 60Hz countries and so there arose over time two major scanning standards of 625 line/50 frames per second and 525 line/59.94 frames per second.
- A further division was established with the introduction of colour when different regions of the world chose different colour encoding systems such as NTSC, PAL and SECAM.
- The colour signal can be passed through the production chain either as a composite signal or as a component signal (see page 15).
- The aspect ratio of the broadcast image (the ratio of the width of the image to its height) added another variable with ratios varying between 4:3, 16:9 and 14:9. Also methods of transmitting film images with other aspect ratios were evolved.
- The conversion of an analogue signal into a digital signal introduced other variables depending on the sampling rate and the degree of compression employed.

There is therefore not one but many 'standard signals' depending on region, production requirements and recording format. Fortunately, a programme originating in one standard can usually be converted into another standard with minimum loss of quality. Conversion between aspect ratios however often requires either a compromise on ideal picture framing or viewing conditions or special provision when originating the image.

Subjectivity

Number of lines, interlace and frame rate, transmission system, design of the camera, compression and sampling all affect how accurately the viewer sees the original event. The TV monitor imposes its own restraints. All these factors including resolution, contrast range, colour rendering etc., are dependent on engineering decisions, budget restraints and statuary control and regulation. The translation between light and electricity is therefore influenced by choice and at each stage of the process, subjective decisions are made. In one sense electronic engineering 'standards' are no more objective than programme production. Most of this manual is concerned with the subjective choices available in video acquisition.

The television scanning system

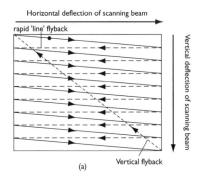

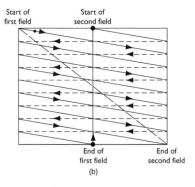

The television picture is made up of a series of lines, which are transmitted with synchronizing pulses to ensure that the display monitor scans the same area of the image as the camera. In the PAL 625 line system, each of the 25 frames per second is made up of two sets of lines (fields) that interlace and cover different parts of the display. The picture is scanned a line at a time and at the end of each line a new line is started at the left-hand side until the bottom of the picture is reached (a). In the first field the odd lines are scanned, after which the beam returns to scan the even lines (b). The first field (odd lines) begins with a full line and ends on a half line. The second field (even lines) begins with a half line and ends on a full line.

Television line waveform (625 system)

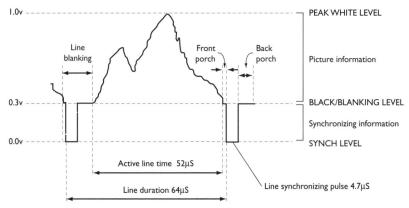

The waveform of the 1 V television signal divides into two parts at black level. Above black, the signal varies depending on the tones in the picture from black (0 V) to peak white (0.7 V). Below black, the signal (which is never seen) is used for synchronizing the start of each line and frame. A colour burst provides the receiver with information to allow colour signal processing.

Colour

Colour vision is made possible by cones on the retina of the eye, which respond to different colours. The cones are of three types sensitive to certain bands of light — either green, red or blue. The three responses combine so that, with normal vision, all other colours can be discerned. There is a wide variation in an individual's receptor response to different colours but many tests have established an average response. Colour television adopts the same principle by using a prism behind the lens to split the light from a scene into three separate channels. The amplitude of these individual colour signals depends on the actual colour in the televised scene. Colours that are composed of two or more of these primary colours produce proportional signals in each channel. A fourth signal called the luminance signal is obtained by combining proportions of the red, green and blue signals. It is this signal which allows compatibility with a monochrome display. The amplitude of the signal at any moment is proportional to the brightness of the particular picture element being scanned.

Colour vision

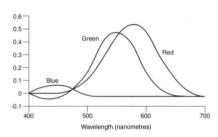

Thomas Young (1773–1829) was one of the first people to propose the three colour theory of perception. By mixing three lights widely spaced along the spectrum he demonstrated that he could produce any colour (and white) visible in the spectrum by a mixture of three, but not less than three, lights set to appropriate intensities. The choice of suitable wavelengths to achieve this is quite wide and no unique set of three wavelengths has been established. The average three colour sensitive cones in the eye have the response curve on the left, and all spectral colours are seen by a mixture of signals from the three systems.

A TV colour signal is an electrical representation of the original scene processed and reproduced on a TV display monitor. The fidelity of the displayed colour picture to the original colours will depend on:

- identifying and accurately reproducing the average perceptual response to colour:
- the choice of primaries and the processing circuits employed to combine the colour signals;
- the phosphor characteristics of the display tube.

In practice, the available phosphor compounds that are employed in tube manufacture determines the selection and handling of the television primary colour signals needed to provide accurate perceptual response to a displayed colour picture.

Additive colour system

Nearly the whole range of colours can be produced by adding together, in various proportions, light sources of the three primary wavelengths. This is known as additive colour matching. Some colours that the eye can perceive can not be combined by the use of the three chosen primaries unless the application of 'negative' light is employed in the camera processing circuits, (see topic Linear matrix, page 97). Given that the tube phosphor and the 'average' perceptual response to colour remains unchanged, the fidelity of colour reproduction will be determined by the design of the circuits handling the mixture of the three colour signals.

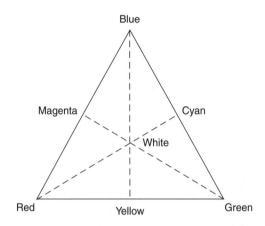

To avoid transmitting three separate red, green and blue signals and therefore trebling the bandwidth required for each TV channel, a method was devised to combine (encode) the colour signals with the luminance signal (see page 15). The ability of the eye to see fine detail depends for the most part on differences in luminance in the image and only, to a much smaller extent, on colour contrast. This allows the luminance (Y) information to be transmitted at high definition and the colour information at a lower definition resulting in another saving on bandwidth.

White balance

In colorimetry it is convenient to think of white being obtained from equal amounts of red, green and blue light. This concept is continued in colour cameras. When exposed to a white surface (neutral scene), the three signals are matched to the green signal to give equal amounts of red, green and blue. This is known as white balance. The actual amounts of red, green and blue light when white is displayed on a colour tube are in the proportion of 30% red lumens, 59% green lumens and 11% blue lumens.

Although the eye adapts if the colour temperature illuminating a white subject alters (see topic Colour temperature, page 52), there is no adaptation by the camera and the three video amplifiers have to be adjusted to ensure they have unity output.

The digital signal

Limitation of analogue signal

The analogue signal can suffer degradation during processing through the signal chain particularly in multi-generation editing where impairment to the signal is cumulative. By coding the video signal into a digital form, a stream of numbers is produced which change sufficiently often to mimic the analogue continuous signal (see figure opposite).

The digital signal

Whereas an analogue signal is an unbroken voltage variation, a pulse coded modulated (PCM) digital signal is a series of numbers each representing the analogue signal voltage at a specific moment in time. The number of times the analogue signal is measured is called the *sampling rate* or sampling frequency. The value of each measured voltage is converted to a whole number by a process called *quantizing*. These series of whole numbers are recorded or transmitted rather than the waveform itself. The advantage of using whole numbers is they are not prone to drift and the original information in whole numbers is better able to resist unwanted change. The method of quantizing to whole numbers will have an effect on the accuracy of the conversion of the analogue signal to digital. Any sampling rate that is high enough could be used for video, but it is common to make the sampling rate a whole number of the line rate allowing samples to be taken in the same place on every line.

A monochrome digital image would consist of a rectangular array of sampled points of brightness stored as a number. These points are known as picture cells or more usually abbreviated to *pixels*. The closer the pixels are together, the greater the resolution and the more continuous the image will appear. The greater the number of pixels, the greater the amount of data that will need to be stored, with a corresponding increase in cost. A 625 line TV standard picture (576 active lines per picture) requires 829,440 pixels per picture. A colour image will require three separate values for each pixel representing brightness, hue and saturation for each individual sampled point of the image. These three values can represent red, green and blue elements or colour difference values of luminance, red minus luminance and blue minus luminance. A moving image will require the three values of each pixel to be updated continuously.

Advantages of the digital signal

When a digital recording is copied, the same numbers appear on the copy. It is not a dub, it is a clone. As the copy is indistinguishable from the original there is no generation loss. Digital TV allows an easy interface with computers and becomes a branch of data processing.

Analogue to digital

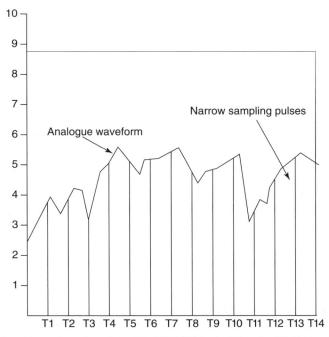

The continuously varying voltage of the TV signal (the analogue signal) is measured (or sampled) at a set number of positions per television line and converted into a stream of numbers (the digital signal) which alters in magnitude in proportion to the original signal.

Storing the signal as binary numbers (ones and zeros) has two advantages. It provides a robust signal that is resistant to noise and distortion and can be restored to its original condition whenever required. Secondly, it enables computer techniques to be applied to the video signal creating numerous opportunities for picture manipulation and to re-order the digital samples for standards conversion.

The colour signal

A **composite video signal** is an encoded combined colour signal using one of the coding standards – NTSC, PAL or SECAM. This can be achieved using the luminance (Y) signal and the colour difference signals of red minus luminance $(E_r - E_y)$ and blue minus luminance $(E_p - E_y)$. The signals are derived from the original red, green and blue sources and are a form of analogue compression. A **component video signal** is one in which the luminance and the chrominance remain as separate components, i.e. separate Y, Y and Y signals. Two colour difference signals are obtained, Y (red) – Y (luminance) and Y by electronically subtracting the luminance signal from the output of the red and blue amplifiers. These two colour signals are coded into the luminance signal Y and transmitted as a single, bandwidth-saving signal. Different solutions on how to modulate the colour information have resulted in each country choosing between one of three systems – NTSC, PAL and SECAM.

At the receiver, the signal can be decoded to produce separate red, green, blue and luminance signals necessary for a colour picture.

Why compression is needed

Compression, data reduction or bit-rate reduction, is the technique of filtering out some of the information that is contained in a digital video signal. By eliminating selected data, the signal can be passed through a channel that has a lower bit rate. The ratio between the source and the channel bit rates is called the compression factor. At the receiving end of the channel an expander or decoder will attempt to restore the compressed signal to near its original range of values. A compressor is designed to recognize and pass on the useful part of the input signal known as the *entropy*. The remaining part of the input signal is called the *redundancy*. It is redundant because the filtered-out information can be predicted from what has already been received by the decoder. If the decoder cannot reconstruct the withheld data, then the signal is incomplete and the compression has degraded the original signal. This may or may not be acceptable when viewing the received image.

What is redundant?

Portions of an image may contain elements that are unchanging from frame to frame (e.g. the background set behind a newsreader). Considerable saving in the amount of data transmitted can be achieved if, on a shot change, the entire image is transmitted and then with each successive frame only that which alters from frame to frame is transmitted. The image can then be reconstructed by the decoder by adding the changing elements of the image to the static or unvarying parts of the image. The degree of compression cannot be so severe that information is lost. For example, even if the newsreader background set is static in the frame, a shadow of the newsreader moving on the background must be preserved even if the shadow is undesirable.

Motion compensation

Passing on only the difference between one picture and the next means that at any instant in time, an image can only be reconstructed by reference to a previous 'complete' picture. Editing such compressed pictures can only occur on a complete frame. If there is significant movement in the frame there will be very little redundancy and therefore very little compression possible. To overcome this problem, motion compensation compression attempts to make even movement information 'redundant' by measuring successive areas of pictures that contain movement and producing motion vectors. These are applied to the object and its predicted new position reconstructed. Any errors are eliminated by comparing the reconstructed movement with the actual movement of the original image. The coder sends the motion vectors and the discrepancies along the channel to the decoder, which shifts the previous picture by the vectors and adds the discrepancies to reproduce the next picture. This allows a saving in the amount of data that needs to be transmitted along a channel even with movement.

Quantizing

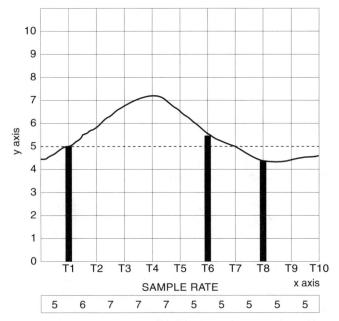

The data stored is transmitted as whole numbers. In the above diagram sample T1 = 5, T6 (although peaking at 5.5) would be stored as 5, and T7 (peaking at 4.5) would also be stored as 5.

The conversion of an analogue signal to a digital signal involves an element of averaging. If the interval between numbers (y axis) is large, the analogue level variations will be incorrectly stored as a digital signal. If the frequency of the sample rate (x axis) is low, there will be analogue signal variation between sampling which goes unconverted.

- Aliasing: This is caused by the sampling frequency being too low to faithfully reproduce image detail.
- Quantizing: In 8-bit video conversion there are 256 quantizing intervals because that is the number of codes available from an 8-bit number. With 10-bit conversion there are 1024 codes available.
- A full frame of digital television sampled according to ITU 601 requires just under 1 Mbyte of storage (829 kbytes for 625 lines, 701 kbytes for 525 lines).

Compression standards

4:2:2

A common sampling rate for 625/50 and 525/60 video is chosen to be locked to the horizontal sync pulses. For the luminance signal this is often 13.5 MHz. Only the active lines (576 lines in the 625 system) are transmitted or recorded. Each line consists of 720 pixels. The 49 field blanking lines are ignored and recreated when required.

In the Betacam recording format (see Betacam format, page 30) the colour difference signals have one half the luminance bandwidth and are sampled at half the luminance sample rate of 13.5 MHz (i.e. 6.75 MHz). The lowest practicable sampling rate is 3.375 MHz – a quarter of the luminance rate and identified as 1. Using this code convention:

- 1 = 3.375 MHz sample rate (3,375,000 samples per second)
- 2 = 6.75 MHz sample rate (6.750.000 samples per second)
- 4 = 13.5 MHz sample rate (13,500,00 samples per second)

Most component production equipment uses 4:2:2 sampling which indicates that 13.5 MHz (4) is the sample rate for luminance, 6.75 MHz (2) is the sample rate for red minus luminance and 6.75 MHz (2) is the sample rate for blue minus luminance.

Higher compression can be achieved (e.g. 4:1:1 or 4:2:0 sampling). In general, compression can be expected to impose some form of loss or degradation on the picture, its degree depending on the algorithm used as well as the compression ratio (ratio of the data in the compressed signal to data in the original version) and the contents of the picture itself. Applying greater and greater degrees of compression (i.e. eliminating more of the original) results in artifacts such as fast-moving subjects 'pixilating' or breaking up into moving blocks.

MPEG 2

The Moving Picture Experts Group (MPEG) compiled a set of standards describing a range of bitstreams which decoders must be able to handle. MPEG 1 was an earlier specification that is not adequate for broadcast TV. MPEG 2 recommendations for data compression of moving pictures can be abbreviated to a table containing five profiles ranging from Simple (minimum complexity) to High. Each profile can operate at four resolution levels ranging from 352×288 pixel image up to 1920×1152 pixel images. MPEG 2 is not a decoder technique or a method of transmitting bit streams but a series of benchmarks specifying different degrees of compression.

JPEG

The Joint Photographic Experts Group (JPEG) compiled a standard for the data compression of still pictures.

Compression and video editing

MPEG 2 interframe compression achieves data reduction by grouping a number of pictures together, identified as a GOP (group of pictures). When the MPEG compression process begins, an initial I (intraframe or intrapicture) is coded. This frame is complete and uncompressed and can be displayed without degradation. In the group of pictures associated with this I frame are P (predicted) frames which are based on the I frame and cannot exist without the I frame. Interleaved between the I frame and the P frames are B (bi-directional) frames, which are assembled from interpolated data from the closest I and P frames. A new I frame is usually created in response to a change of pixels in the incoming frames although this can occur without change approximately every half second. Compression is achieved because only the I frames require data to be forwarded.

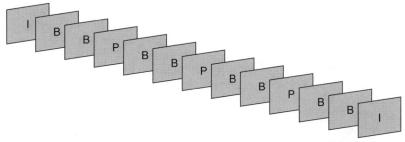

Because only I frames carry complete picture information, an edit point that occurs between a P and a B frame will start with a frame that cannot reconstruct itself as its reference I frame is missing. It is desirable for efficient compression to have the longest practical group of pictures before a new I frame is included whereas flexibility in deciding which frame to cut on requires the smallest practical GOP and still achieves some degree of compression. Dynamic random access memory (DRAM) chip sets perform I, P and B frame searches to identify an I frame edit.

Concatenation

Along the signal path from acquisition, up and down links, format change, editing and then transmission, a video signal can be coded and decoded several times. There are many different types of data compression. Degradation of the digital signal can occur if it is repeatedly coded and decoded whilst passing through two or three different manufacturer's processors.

Metadata

Metadata is the data that goes along with video and audio as it is networked digitally. It is data about data and each clip can carry with it detail of where and when it was shot, what format it was in, how it has been processed or compressed, who has the rights to it, when and where it has been aired, and any other information that might be needed. This information can be downloaded into an archive database to allow indexing and searches.

Charge-coupled devices (CCDs)

MOS capacitors

A MOS capacitor (see figure opposite) is a sandwich of a metal electrode insulated by a film of silicon dioxide from a layer of P-type silicon. If a positive voltage is applied to the metal electrode, a low energy well is created close to the interface between the silicon dioxide and the silicon. Any free electrons will be attracted to this well and stored. They can then be moved on to an adjacent cell if a deeper depletion region is created there.

The ability to store a charge is fundamental to the operation of the chargecoupled device plus a method of transferring the charge.

Charge-coupled device

If a photosensor replaces the top metal electrode, and each picture element (abbreviated to pixel) is grouped to form a large array as the imaging device behind a prism block and lens, we have the basic structure of a CCD camera. Each pixel (between 500 and 800 per picture line) will develop a charge in proportion to the brightness of that part of the image focused onto it. A method is then required to read out the different charges of each of the half a million or so pixels in a scanning order matching the line and frame structure of the originating TV picture. Currently there are three types of sensors in use (see Frame interline transfer, page 22) differing in the position of their storage area and the method of transfer:

Frame transfer: The first method of transfer developed was the frame transfer (FT) structure. The silicon chip containing the imaging area of pixels is split into two parts. One half is the array of photosensors exposed to the image produced by the lens and a duplicate set of sensors (for charge storage) is masked so that no light (and therefore no build up of charge) can affect it. A charge pattern is created in each picture field, which is then rapidly passed vertically to the storage area during vertical blanking. Because the individual pixel charges are passed through other pixels, a mechanical shutter is required to cut the light off from the lens during the transfer.

An important requirement for all types of CCD is that the noise produced by each sensor must be equivalent, otherwise patterns of noise may be discernible in the darker areas of the picture.

Interline transfer: To eliminate the need for a mechanical shutter, interline transfer (IT) was developed. With this method, the storage cell was placed adjacent to the pick-up pixel, so that during field blanking the charge generated in the photosensor is shifted sideways into the corresponding storage element. The performance of the two types of cell (photosensor and storage) can be optimized for their specific function although there is a reduction in sensitivity because a proportion of the pick-up area forms part of the storage area.

MOS capacitors

- After a positive voltage (e.g. 5 V) is applied to the electrode, a low-energy well is created below the oxide/semiconductor surface, attracting free electrons
- If 10 V is applied to the adjacent electrode, a deeper low-energy well is created, attracting free electrons which now flow into this deeper bucket.
- 3: If the voltage on the first electrode is removed and the second electrode voltage is reduced to 5V, the process can be repeated with the third cell. The charge can be moved along a line of capacitors by a chain of pulses (called a transfer clock) applied to the electrodes.

By replacing the electrode with a lightsensitive substance called a 'photosensor' a charge proportional to the incident light is transferred using the above technique.

Schematic of frame transfer CCD

The imaging area of a frame transfer CCD is exposed to the subject (X) and each photosensor is charged in proportion to the incident light intensity. A mechanical shutter covers the photosensors during vertical blanking and each photosensor transfers its charge to the sensor below until the storage area duplicates the imaging area. The shutter is opened for the next field whilst each sensor in the storage area is horizontally read out in turn. What was a two dimensional grid of variations in light intensity has been converted into a series of voltage variations.

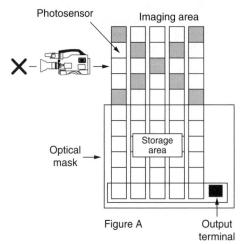

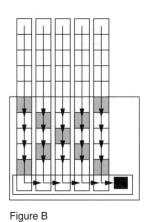

Frame interline transfer (FIT)

Vertical smear

One problem with interline transfer is vertical smear. This occurs when a very strong highlight is in the picture and results in a vertical line running through the highlight. It is caused by the light penetrating very deeply into the semi-conductor structure and leaking directly into the vertical shift register. Since only longer wavelength light is able to penetrate deeply into the silicon, the vertical smear appears as a red or a pink line.

Frame interline transfer

In an attempt to eliminate the vertical smear the frame interline transfer (FIT) was developed. This combines the interline method of transferring the charge horizontally to an adjacent storage cell but then moves the charge down vertically at 60 times line rate into a frame store area. This takes the charge away or reduces it to a sixtieth of the time it could be corrupted by a highlight overload which may affect the whole of one vertical line.

Resolution

To reproduce fine detail accurately a large number of pixels are needed. Increasing the number of picture elements in a $\frac{2}{3}$ -in pick-up device results in smaller pixel size, which decreases sensitivity.

Aliasing

Each pixel 'samples' a portion of a continuous image to produce a facsimile of scene brightness. This is similar to the analogue-to-digital conversion and is subject to the mathematical rule established by Nyquist, which states that if the input signal is to be reproduced faithfully it must be sampled at a frequency greater than twice the maximum input frequency. Aliasing, which shows up as a moiré patterning, particularly on moving subjects, is caused by a high input frequency causing a low 'beat' frequency. It is suppressed by offsetting the green CCD by half a pixel compared to red and blue. Another technique is to place an optical low pass filter in the light path to reduce the amount of fine detail present in the incoming light.

HAD

The hole accumulated diode (HAD) sensor allows up to 750 pixels per line with an improvement in the photo-sensing area of the total pick-up. Increasing the proportion of the surface of the photo sensor that can collect light improves sensitivity without decreasing resolution. The HAD chip also helps to avoid vertical smear.

Interline transfer

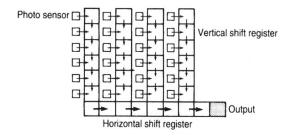

Resolution v. sensitivity

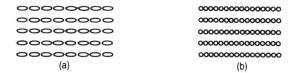

Doubling the number of pixels in (b) improves resolution by increasing total picture elements, but decreases sensitivity as each pixel in (b) now captures half the light available to the pixel in (a).

The Hyper HAD

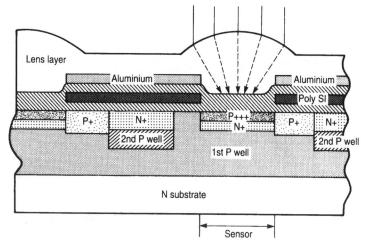

The Hyper HAD has a microlens positioned on each pixel which increases the light-capturing ability of each photosensor area, doubling the camera sensitivity.

CCD integration

Switched output integration

A PAL television picture is composed of 625 interlaced lines. In a tube camera, the odd lines are scanned first then the beam returns to the top of the frame to scan the even lines. It requires two of these fields to produce a complete picture (frame) and to synchronize with the mains frequency of 50 Hz, the picture or frame is repeated 25 times a second.

CCD frame transfer (FT) devices use the same pixels for both odd and even fields whereas interline transfer (IT) and frame interline transfer (FIT) CCDs use separate pixels with a consequent increase in resolution. There are two methods to read out the stored charge:

Field integration: This reads out every pixel but the signals from adjacent lines are averaged. Although this decreases vertical resolution, motion blur will be less.

Frame integration: This reads out once every frame (two fields) and therefore will have more motion blur as the signal is averaged over a longer time span than field integration but may have better vertical resolution on static subjects.

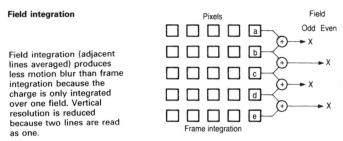

Enhanced vertical definition system

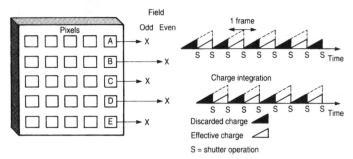

Charges from adjacent pixel rows are not combined. An electronic shutter removes the charge from unused lines at readout time. Discarding unwanted charge reduces camera sensitivity by one f-stop if EVS is used.

Enhanced vertical definition system

The enhanced vertical definition system (EVS) offers the higher resolution of frame integration without the same motion blur. It is obtained by blanking off one field with the electronic shutter, reducing camera sensitivity by one stop.

Colorimetry

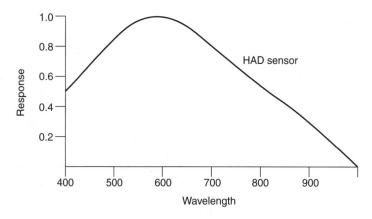

The transparent polysilicon covering the photosensor of the IT chip progressively filters out the shorter blue wavelength and therefore is less sensitive to the blue end of the spectrum compared to its red response. On HAD sensors there is no polysilicon layer and therefore the spectral response is more uniform.

Flare

Each element in a zoom lens is coated to reduce surface reflections but stray light reaching the prism causes flare, lightening the blacks, and a consequent reduction in contrast of the optical image. Flare is to some extent a linear effect and can be compensated for electronically. Flare can also occur at the surface of CCD devices where light is reflected between layers or scattered by the etched edges of sensor windows.

Recording formats

ENG format cameras

The portable video/recorder broadcast camera was developed in the early 1980s. Amongst the many technological innovations in the design since then has been the replacement of pick-up tubes with CCDs, a move from analogue recording to digital recording combined with a move from analogue signal processing to digital processing (although a CCD is an analogue device). The introduction of television stereo audio was followed by the development of the dual-format camera in response to the move towards a 16:9 widescreen television system. One-piece camera/recorders have always been available but two-piece camera/recorders allow the user a choice of which recording format to attach to the camera. A variety of digital recording formats has been developed, particularly the upgrading of hitherto domestic digital video recording formats to facilitate cheaper and less complex cameras/recorders to match the different production requirements of video acquisition. In the interests of speed and convenience, many organizations need to acquire and edit all production material on the same format coupled with the need for universal technical back-up support for crews working a long way from base.

There is continuous market demand for cheaper, broadcast-quality, nonlinear editing, especially in news and magazine programme production. This is combined with the development of multiskilling in acquisition and editing and the pressure to find solutions to edit video material at journalist work stations.

To summarize, the changes have tended towards:

- smaller, cheaper camera/recorders able to be operated by one person to record video, audio and edit
- because of the less specialized knowledge of multiskilling personnel, equipment is designed to be less complex (which sometimes means less flexible) and without some of the standard production facilities of the past (e.g. limited manual override of auto controls, audio from built-in mics, etc.)
- the development of compact, lightweight, location editing equipment to produce a finished package that is either fed via portable satellite equipment into a bulletin, or sent to base station for later transmission.

Standard camera controls

Because of the expansion of recording formats and the many hundreds of camera models available, it is not possible to provide a specific guide to the many variations of operational controls to be found. In general, whatever make of camera or individual model, most broadcast cameras have similar facilities. There is a core of camera controls that are standard on nearly every broadcast quality camera. What may change from camera to camera is the positioning of individual operational controls. The section in the manual headed 'Camera controls', identifies the standard controls.

Camera controls

Most broadcast cameras will have the following facilities:

- manual control of zoom and focus of the lens plus the ability to use smooth, variable speed servo controls
- good viewfinder quality with basic display of essential indicators (battery life, remaining tape time, etc.)
- methods of controlling exposure and in-camera filter position
- white balance
- black balance
- · variable shutter speed
- · time code
- menus
- · set-up cards
- · audio monitoring
- · audio channel inputs for external mics
- · genlock and time code lock
- a tripod adaptor plate to attach to a broadcast quality pan/tilt head.

Format and production budget

Consumer formats

In the mid-1990s there was a tendency for the demarcation between broadcast quality and consumer cameras to break down. Some camera formats that had been initially marketed for domestic use were pressed into service for documentary and news production. Not all of this new range of cameras provided for the standard requirements of broadcast camerawork and often required modification to provide for the professional accessories needed for programme production. Digital technology and de-regulation produced a proliferation of broadcast channels and an escalation in the competition for viewers. The expansion of services created a need to find ways of cutting costs and reducing programme budgets. This also followed the production fashion for less intrusive shooting techniques and the use of small cameras for the coverage of documentary and news. All these changes resulted in the development of digital video recording formats and cameras that were small, cheap (relative to previous broadcast 'quality' cameras) and easy to operate.

Button pressing

In the rush to market the new recording formats, the ability to produce a technically acceptable image from a video camera often became confused with the craft of camerawork. Marketing hype suggested that anyone could be a 'cameraman' once they understood the automatic features of the new compact video camera. But broadcast camerawork is not simply producing technically competent pictures. Communication with images requires the same understanding of visual conventions and visual potentials as the understanding of language, structure and vocabulary is needed when communicating with words. The ability to assess a well framed picture and the knowledge of the techniques available to achieve this follows on from the ability to manipulate the camera controls.

Economic choice

The development of journalist computer workstations and the trend towards a 'tapeless' newsroom highlighted the problems of back libraries and archive material on a different format to the current operation. There was also the cost to an organization in choosing to have a different format for its news operation than it had for its normal programme acquisition. The economic gain in time saved in acquisition in one format could be outweighed by the cost/time of dubbing across other formats for editing or transmission plus the cost of duplicating a range of post-production equipment able to handle the different formats. But ranged against these considerations were the savings in camera and tape costs and the potential for lap-top editing systems on location when using the smaller digital recording formats. Some recording formats were conceived chiefly as an acquisition option and were not (in the first instance) intended for general use in broadcasting.

Satellite news gathering

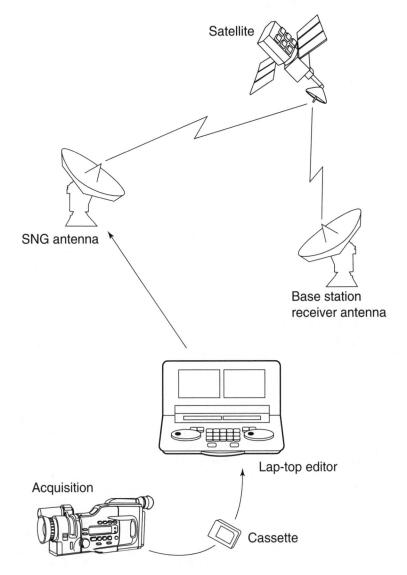

News material can be edited on location and relayed back to base saving time and reducing the cost of the use of the satellite compared to uncut footage.

Betacam format

The Betacam format was introduced in 1982 primarily as a news-gathering camera/recorder. It superseded the use of reversal film in news bulletins and the portable video camera with separate U-matic recorder. With an upgrading of vision and sound quality made possible by the use of metal particle tape, Betacam SP was introduced and was used in almost all categories of programme production. The compact design of the Betacam format enabled a broadcast quality camera, for the first time, to be combined with a video recorder and operated by one person. Its lightweight and robust construction allowed it to be carried on the shoulder for rapid and flexible news coverage. Many of the operational controls were automated and its low power requirement allowed extended operating time.

Format specification

The picture is recorded on a $\frac{1}{2}$ -in Beta tape cassette using two adjacent video heads. The luminance signal (Y) is recorded on one track and on the other track the chroma consists of a compressed time division multiplex of the colour difference signals (R-Y) and B-Y. Two audio longitudinal tracks are recorded at the top of the tape with longitudinal control and time code tracks at the bottom of the tape. Betacam SP recording on metal particle tape provides two additional audio FM channels recorded with the chrominance signal. They allow improved sound quality but cannot be edited independently of the video and must be layed-off to be edited.

Production advantages

The new video camera technologies allowed for quick adjustment in balancing colour temperature. The improvement in signal-to-noise ratios allowed additional gain to be used in low light situations and automated controls such as auto-iris provided faster operational use. Changes in television production methods quickly followed. Before the mid-1980s, video drama and other nonnews programmes were either studio based or were limited by bulky cameras tethered to an OB control room by cable. High quality camera/ recorders allowed the flexibility of film shooting with greater mobility and a greater refinement in post-production editing. The small, portable camera also allowed the use of remote-controlled cameras on cranes and created a new versatility in hand-held pop music coverage. Many manufacturers designed cameras to bolt on to Beta recorders and the Betacam format became a world-wide standard for most types of video location acquisition. Video production technique became significantly different to the existing multi-camera continuous recording/transmission styles. This investment in analogue Beta production, editing and transmission play-out equipment began to be replaced in the mid-1990s by the development of digital signal processing. A number of alternative digital recording formats began to emerge.

1/2-in Betacam tape recording tracks

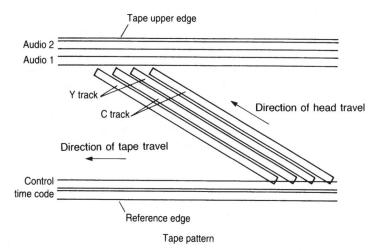

Checking chrominance signal on playback

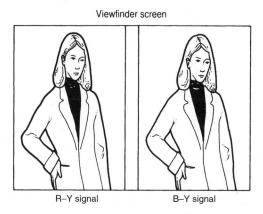

If the CTDM (compressed time division multiplex) button is pressed, the chrominance signals of the picture will be reproduced in monochrome as illustrated. The double picture is created because Beta format records the R-Y (red minus luminance signal) and the B-Y (blue minus luminance signal) on the same TV line and requires an adaptor to replay as a normal TV picture. In monochrome reproduction, the appearance of the two pictures may differ depending on the colour content of the subject. Their reproduction as a double image in the viewfinder is available as a confidence check to confirm the colour content of the picture has been recorded.

Digital Betacam format

With the introduction of digital processing and recording of the video and audio signal additional operational controls were made available. Many of the digital design features were intended to help with faster acquisition and more compatible digital editing although no format was considered ideal for all programme production applications. There are two digital versions of the Betacam format. The Betacam SX format is designed to replace the ENG analogue cameras whilst the Digital Betacam format with 2:1 DCT compression and an 85 Mbps video data rate has a higher specification to meet more complex programme making requirements.

Digital Betacam

Digital processing permits the development of new camera techniques. There is a greater range of adjustment of all camera parameters plus the ability to digitally store the settings either internally or on a removable set-up card. In effect the camera becomes computer controlled. It is programmed from menu pages selected in the viewfinder and also, via the camera's video output, to an external monitor (see Menus, page 94).

Digital working provides greater control over the look of the picture with the ability to alter gamma, knee point, skin tone, detail enhancement, matrix, etc. Also the ability for precise colour matching in a multi-camera shoot using a wide range of gamma curves programmed into the camera. Linear matrix coefficients can be varied and two sets of the coefficients stored in memory. Additional control over image appearance is now possible with such variables as horizontal detail enhancement to match scene content, detail clip level to avoid excessive highlight detail and stepped lines along slanted picture edges. A skin tone detail function allows selective reduction to be applied to face tones. This can reduce or eliminate facial imperfections while maintaining detail enhancement to the rest of the image.

Greater control over exposure and contrast range can be achieved using a variable knee point and knee slope controlled through the viewfinder menu display plus adjustment of the onset of dynamic contrast control to increase the contrast range. Automatic iris control has an iris override provision that can be set to provide -0.5, -0.25, +0.25 and +0.5 f-stop exposure reading plus a two-level zebra video indication which can be adjusted and memorized. Three gain values can be programmed to the low/mid/high gain switch selected from -3, 0, 3, 6, 9, 12, 18, 24, 30 dB. There are separate filter wheels for neutral density and colour correction filters plus a clear scan facility (operating above $50.2\,\mathrm{Hz}$) and extended clear scan facility (operating below $25.4\,\mathrm{kHz}$ to $48.7\,\mathrm{kHz}$) to eliminate 'banding' when shooting computer displays. The shutter speed of the camera can be accurately matched to the computer screen scanning frequency.

Digital Betacam tape format

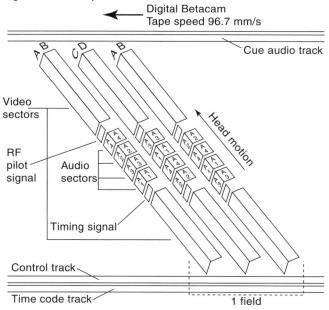

Betacam SX tape format

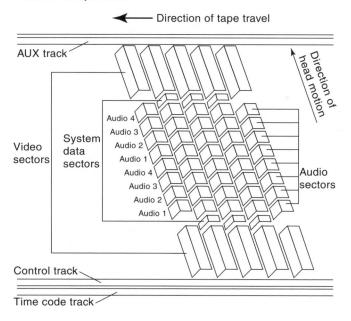

Betacam SX

Switchable formats: There are digital Betacam and Betacam SX models which allow 16:9/4:3 switchable aspect ratio. The design of the chip will either favour 16:9 or 4:3 CCD (see Dual format cameras, page 46), and in the digital Betacam the chip favours 16:9 working. The viewfinder aspect ratio is automatically switched when the camera is switched between 16:9 and 4:3 modes of operation and separate detail correction files for 16:9 and 4:3 can also be stored.

Digital audio: Two uncompressed digital audio channels can be recorded in duplicate on four audio channels. When connected to an add-on adaptor, four independent audio channels are available for recording simultaneously and playback plus the option of using a 5-inch viewfinder. The standard audio output is either one of the recorded channels or a mix of both. A 1 kHz audio tone generator provides a reference signal to be recorded with the colour bars. Two longitudinal audio cue tracks give access to audio in shuttle when the digital audio is of limited use and also allow users additional, lower quality, audio channels if required.

Digital recorder: Unlike analogue Betacam, digital Betacam requires no adaptor to replay video (or audio). A composite analogue signal output is available for location video playback or for direct microwave transmission. The camera recorder has a 5× high speed search mode in colour and a review function which replays the last recorded shot and parks at the precise point for the next recording. Unlike analogue Betacam, the narrow side of the Betacam cassette is inserted into the cassette compartment.

Betacam SX

The Betacam SX format has the following additional features. Auto-tracing white (on B position), which will white balance when moving between different colour temperature light (e.g. moving between interior and exterior). Its automatic selected value cannot be stored. Pressing 'return' on the lens during a recording places a 'good shot' marker on the tape which can be picked up by the edit machine. The camera operator can identify and code up to 198 selected shots while shooting. These codes are stored on the tape and can be read out during the edit. In addition to the selectable three gain positions positioned on the side of the SX range of cameras, there is an instant turbo gain button providing an immediate 36 dB gain (equal to six stops). Time code regeneration facility (in record run) can pick up on the existing recorded time-code of any tape placed in the camera. There is an extra cue light under a sliding cover below the viewfinder that can be seen when working away from the monocular viewfinder. A battery power saving facility switches on/off an Anton/Bauer camera lamp at the start and end of recording. Dockable Betacam SX recorders can be used with analogue cameras.

Betacam SX editing

In the field: a portable off-line editor storing off-line quality video on removable 3.5-inch MO disks. Each disk can store up to 40 minutes of off-line quality video and audio material. In this mode the operator can off-line edit a programme and generate an edit decision list. This EDL can then be used to play out the on-line material from either the hybrid recorder on location or the edit decision list could be sent back to base, via a modem, to play out the on-line material from a separate video server. It can be mains or internally battery powered.

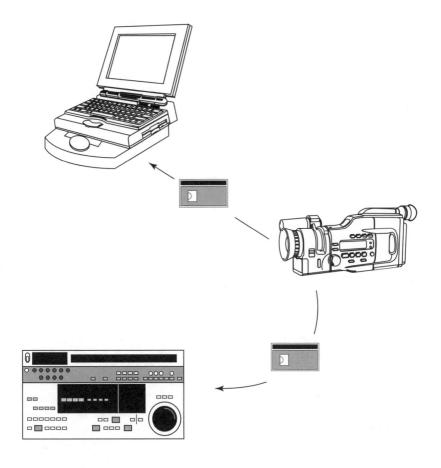

At base: a high-speed hybrid recorder downloads from a cassette up to four times normal play speed. 'Good shot' markers and record 'start' markers can be read and downloaded into the hard disk. Nonlinear editing is possible from the front panel. The hard disk drive can hold up to 90 minutes of video and audio material.

The DV and DVCAM format

In the early 1990s, a consortium of camera manufacturers collaborated on the development of a new, small, digital tape format. The intention was to reach agreement on a single international format. This was achieved with a consumer digital video (DV) format which had a compression standard, a mechanism and tape format, a chip set and a standard family of cassettes. Originally intended for the domestic camcorder market, the DV format cameras did not meet the basic ENG requirements of operational features and ruggedness. The picture quality, however, was good enough for broadcasters to use the format in productions that required small, inexpensive lightweight kit that could be operated by journalists.

Broadcast operational weaknesses

There are a number of inherent weaknesses in the format when the cameras are used for standard broadcast production. Apart from the lower specification, the cameras are much lighter and extended hand-held work invariably means unsteady camerawork as arms get tired. To overcome unsteady pictures, 'anti-wobble' devices or picture stabilizers are fitted, some of which affect picture quality. Most of the cameras have colour viewfinders and sometimes the viewfinder menu allows the colour option to be deselected to aid focusing. There is also the debatable value of an auto-focusing facility. Exposure can be set by auto-exposure or manually although some camera models have no zebra facility. The biggest weakness for broadcast camerawork applications is the sound provision. Apart from the lack of manual adjustment of sound level on some cameras, there is often only provision for a single audio input usually using a mini-jack microphone socket when the conventional broadcast audio input is via XLR sockets. Another minor inconvenience is a power save function that switches off the camera after five minutes of inaction.

DV can be edited by transferring straight onto disc for non-linear editing or to analogue or digital Beta for Beta transmission. The initial transfer across to another format adds to the editing time but this is often preferred by picture editors because the DV format records sound on the FM tracks combined with the pictures. There is no longitudinal sound track and therefore editors cannot hear the digital sound as they shuttle through the tape. There is no regen facility on DV and placing a cassette into the camera resets the time code to zero. This could possibly result in several shots on the same tape having the same time code. This can be avoided by either recording 'black and burst' (continuous time code and black tape) on tapes prior to use or prior to editing, replacing the original time code with a continuous edit code for the edit machine. The DV cameras are designed for occasional domestic use by one careful owner and lack the rugged design necessary for hard ENG usage on location. To overcome some of these production limitations, a 'professional' version of the DV format was developed.

DVCAM format

DVCAM is an upgrade of the DV format primarily designed for news acquisition. The format has improved recording specification and a number of broadcast operational facilities not found on consumer DV cameras. The camera/recorders are smaller, lighter and cheaper, and with less power consumption than previous ENG formats, coupled with smaller cassettes, allow longer recording times. The lightweight cameras allow easier handling in ENG work and have the ability to provide colour playback. With low power consumption, a two-machine editor can provide rapid, portable editing on location and stories can be put to air more quickly.

DVCAM has a 4:1:1 compression, 25 Mbps data rate recorded on metal evaporated tape and four channels of uncompressed audio to achieve a 40 minute recording on DVCAM camera mini-cassette or 184 minutes on a standard cassette. A single DV compression system is used throughout the production process. Non-linear editing is facilitated by high-speed transfer at four times the normal speed to a disk recorder.

ClipLink

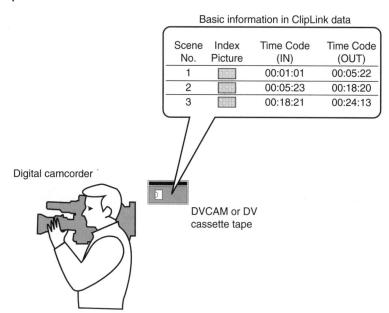

ClipLink is a Sony system which automatically records visual and time code information about each shot as it is recorded. During acquisition with a DVCAM camcorder, the time code data of the 'in-point' and 'out-point' of each shot is recorded in the cassette memory of the DVCAM tape. Also, a still frame of each in-point, called the 'index picture', is recorded on the DVCAM tape as a visual reference to the information associated with the shot data. When the tape is loaded into the DVCAM VTR all of the shot log information is loaded into the EditStation and appears on the display. This visual information enables shots to be quickly selected to upload to a hard disk for editing.

The zoom lens

The lens as a creative tool

A zoom lens fitted to broadcast camcorders is a complex, sophisticated piece of optical design. Its performance may be described in brochures in impenetrable techno-speak that many, at first glance, may feel has little or nothing to do with the 'real' business of making programmes. To take this view is a mistake as above all else, the lens characteristics are the most important visual influence on the appearance and impact of an image.

The following pages describe focal length, lens angle, zoom ratio, aperture and depth of field. Altering any one of these zoom settings will have a significant influence on the perspective, the depiction of space and composition when setting up a shot. It is a fallacy to believe that the camera will truthfully record whatever is in shot whenever you put your eye to the viewfinder and press to record. If you are unaware of how the choice of focal length, etc., will affect the chosen image then this important creative decision will be left to chance and accident.

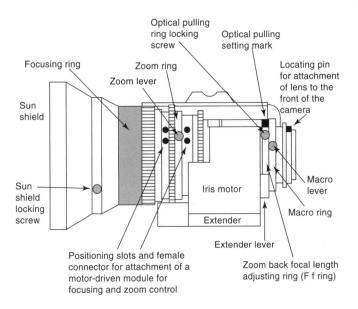

Image size

The image formed by the lens on the face of the CCDs is called the image size of the lens. This must match the size of the camera sensor. Lenses designed for different sized formats (pick-up sensor dimension see figure on page 41) may not be inter-changeable. The image size produced by the lens may be much smaller than the pick-up sensor and probably the back focus (flange back) will not have sufficient adjustment.

Focal length

When parallel rays of light pass through a convex lens, they will converge to one point on the optical axis. This point is called the focal point of the lens. The focal length of the lens is indicated by the distance from the centre of the lens or the principal point of a compound lens (e.g. a zoom lens) to the focal point. The longer the focal length of a lens, the smaller its angle of view will be; and the shorter the focal length of a lens, the wider its angle of view.

Focal length of single lens

Focal length of compound lens

Focal point

Focal length

Focal length

Calculating angle of view

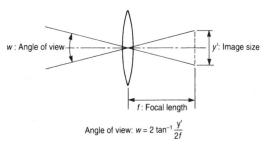

Zoom

Although there are prime lenses (fixed focal length) available for $\frac{2}{3}$ -in cameras, the majority of EFP cameras are fitted with a zoom lens which can alter its focal length and therefore the angle of view over a certain range. This is achieved by moving one part of the lens system (the variator) to change the size of the image and by automatically gearing another part of the lens system (the compensator) to simultaneously move and maintain focus. This alters the image size and therefore the effective focal length of the lens. To zoom into a subject, the lens must first be fully zoomed in on the subject and focused. Then zoom out to the wider angle. The zoom will now stay in focus for the whole range of its travel. If possible, always pre-focus before zooming in.

Angle of view

When a camera converts a three dimensional scene into a TV picture, it leaves an imprint of lens height, camera tilt, distance from subject and lens angle. We can detect these decisions in any image by examining the position of the horizon line and where it cuts similar sized figures. This will reveal camera height and tilt. Lens height and tilt will be revealed by any parallel converging lines in the image such as the edges of buildings or roads. The size relationship between foreground and background objects, particularly the human figure, will give clues to camera distance from objects and lens angle. Camera distance from subject will be revealed by the change in object size when moving towards or away from the lens (see Composition and the lens, page 124).

For any specific lens angle and camera position there will be a unique set of the above parameters. The internal 'perspective' of the picture is created by the focal length of the lens and camera distance except, of course, where false perspective has been deliberately created.

The approximate horizontal angle of view of a fixed focal length lens can be calculated by using its focal length and the size of the pick-up sensors of the camera.

For a camera fitted with $\frac{2}{3}$ -in CCDs the formula would be:

Horizontal angle of view =
$$2 \tan^{-1} \frac{8.8 \text{ mm (width of CCD)}}{2 \times \text{focal length (mm)}}$$

Zoom ratio

A zoom lens can vary its focal length. The ratio of the longest focal length it can achieve (the telephoto end) with the shortest focal length obtainable (its wide-angle end) is its zoom ratio.

A broadcast zoom lens will state zoom ratio and the wide-angle focal length in one figure. A 14×8.5 zoom can therefore be decoded as a zoom with a 14:1 ratio starting at 8.5 mm focal length (angle of view = $54^{\circ}44'$) with the longest focal length of 14×8.5 mm = 119 mm (angle of view = $4^{\circ}14'$).

Lenses with ratios in excess of 50:1 can be obtained but the exact choice of ratio and the focal length at the wide end of the zoom will depend very much on what you want to do with the lens. Large zoom ratios are heavy, often require a great deal of power to operate the servo controls and have a reduced f-number (see page 42). A 14:1 8.5mm zoom lens, for example, will give sufficient length at the narrow end to get good close-ups in sport or at the back of a conference hall, but still provide a reasonable wide angle for close interviewing work in crowds.

A zoom lens can be fitted with an internal extender lens system which allows the zoom to be used on a different set of focal lengths. A $2\times$ extender on the 14 \times 8.5 zoom mentioned above would transform the range from 8.5–119 mm to 17–238mm but it may also lose more than a stop at maximum aperture.

Image circle and image size

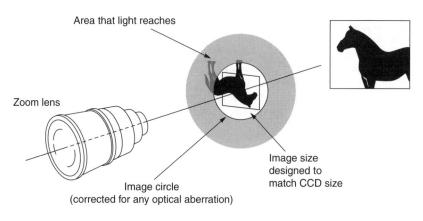

Image sizes for 4:3 aspect ratio TV and film (not to scale)

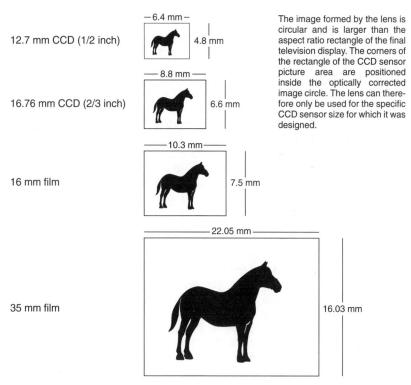

Depth of field

The depth of field, how much of scene in shot is in acceptable focus, is a crucial element in shot composition and controlling how the viewer responds to the image. Cinemagraphic fashion has alternated between deep focus shots (Greg Toland's work on *Citizen Kane* (1941)), to the use of long focal lenses with a very limited depth of field only allowing the principal subject in the frame to be sharp. The choice of focal length and f-number control depth of field.

F-number

The f-number of a lens is a method of indicating how much light can pass through the lens. It is inversely proportional to the focal length of the lens and directly proportional to the diameter of the effective aperture of the lens. For a given focal length, the larger the aperture of the lens the smaller its f-number and the brighter the image it produces. F-numbers are arranged in a scale where each increment is multiplied by $\sqrt{2}$ (1.414). Each time the f-number is increased by one stop, the exposure is decreased by half. A typical f-number series is:

1.4 2 2.8 4 5.6 8 11 16 22

The effective aperture of a zoom is not its actual diameter, but the diameter of the image of the diaphragm seen from in front of the lens. This is called the entrance pupil of the lens. When the lens is zoomed (i.e. the focal length is altered) the diameter of the lens which is proportional to focal length alters and also its entrance pupil. The f-number is small at the wide-angle end of the zoom and larger at the narrowest angle. This may cause f-number drop or ramping at the telephoto end when the entrance pupil diameter equals the diameter of the focusing lens group and cannot become any larger. To eliminate f-drop (ramping) completely the entrance pupil at the longest focal length of the zoom must be at least equal to the longest focal length divided by the largest f-number. This increases the size, weight and the cost of the lens and therefore a certain amount of f-drop is tolerated. The effect only becomes significant when working at low light levels on the narrow end of the zoom.

Depth of field

Changing the f-number alters the depth of field – the portion of the field of view that appears sharply in focus. This zone extends in front and behind the subject on which the lens is focused and will increase as the f-number increases. The greater the distance of the subject from the camera, the greater the depth of field. The depth of field is greater behind the subject than in front and is dependent on the focal length of the lens. F-number and therefore depth of field can be adjusted by altering light level or by the use of neutral density filters.

Minimum object distance

The distance from the front of the lens to the nearest subject that can be kept in acceptable focus is called the minimum object distance (MOD). A 14×8.5 zoom would have a MOD of between $0.8\,\mathrm{m}$ and $0.65\,\mathrm{m}$, whereas a larger zoom ratio lens (33:1) may have an MOD of over $2\,\mathrm{m}$.

Many zooms are fitted with a macro mechanism that allows objects closer than the lens MOD to be held in focus. The macro shifts several lens groups inside the lens to allow close focus, but this prevents the lens being used as a constant focus zoom. Close focusing (inside the MOD) can sometimes be achieved by using the flange-back adjustment.

Flange-back

Flange-back (commonly called back focus) is the distance from the flange surface of the lens mount to the image plane of the CCD. Each camera type has a specific flange-back distance (e.g. 48 mm in air) and any lens fitted to that camera must be designed with the equivalent flange-back. There is usually a flange back adjustment mechanism of the lens with which the flange back can be adjusted by about ±0.5mm. It is important when changing lenses on a camera to check the flange-back position is correctly adjusted and to white balance the new lens.

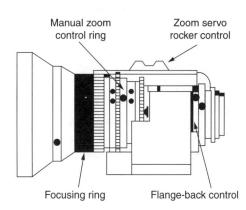

Adjusting the back focus

- 1 Open lens to its widest aperture and adjust exposure by adding ND filters or adjusting shutter speed.
- 2 Select the widest lens angle.
- 3 Adjust for optimum focus with the flange-back control on the lens.
- 4 Zoom the lens in to it narrowest angle on an object at a distance from the camera and adjust the zoom focus for optimum sharpness.
- 5 Zoom out and repeat steps 2–4 of the above procedure until maximum sharpness is achieved at both ends of the zoom range.
- 6 Lock off the flange-back control taking care that its sharpest focus position has not been altered.

Resolution

Resolving power and bandwidth

A television camera converts an image into an electrical signal that will eventually be transmitted. The resolving power required from a TV zoom lens will therefore be related to the maximum frequency of the bandwidth of the signal transmitted plus the specification of the imaging device and line structure. The finesse of detail transmitted will depend on the particular TV standard in use (e.g. 625 PAL; 525 NTSC).

Spatial frequency

Spatial frequency counts the number of black-white pairs of lines contained in 1 mm and is a method of quantifying fine detail in a TV picture.

Modulating transfer function

Modulating transfer function (MTF) measures the range of spatial frequencies transmitted through the lens by focusing on a chart on which black-white lines become progressively more closely spaced until the contrast between black and white can no longer be detected. The modular transfer function is 100% when the transition between white and black is exactly reproduced and zero when the image is uniformly grey and no contrast can be detected. The MTF curve plots reproducibility of contrast against spatial frequency.

Fluorite and infinity focusing

Fluorite is used in the manufacture of zoom lenses to correct chromatic aberrations at the telephoto end. As the refractive index of fluorite changes with temperature more than the refractive index of glass, there is provision when focusing on infinity at low temperatures (e.g. below 0°C) to allow the focus point to go beyond the infinity marking on the lens.

Lens centring

The optical axis of the lens must line up with the centre of the CCDs to ensure that the centre of the frame is identical when zooming from the widest to the narrowest angle without camera pan/tilt compensation.

The MTF curve

On the vertical axis is plotted the ability of two lenses, A and B, to distinguish between black and white lines which start at 1 line per mm on the left and increase to 100 lines per mm on the right.

100 on the vertical axis equals exact reproduction.
0 represents no distinction between black and white.

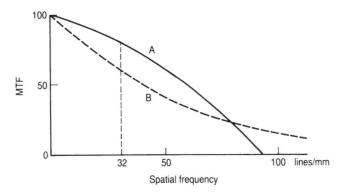

Lens B has better resolving power with detail in the 80–100 lines per mm, whereas lens A fails to resolve lines at approx. 95 lines per mm. However, as the transmission bandwidth is limited, it is the contrast at 32 lines per mm which is more important for a \S -in CCD lens. Lens A has better resolving ability at this point and therefore would be a better TV lens.

The EIJA test chart

The EIJA test chart is used for checking horizontal and vertical resolution.

Dual format cameras

The transition between 4:3 aspect ratio television and the conversion to 16:9 has produced an interim generation of dual format cameras. Different techniques are employed to use the same CCD for both formats.

If a CCD block design is optimized for the 4:3 shape and is then switched to the 16:9 format, lines are discarded at the top and bottom of the frame in order to convert the image area to a 16:9 shape (Fig. 1a). As 4:3 working occupies the same area of the CCD as a standard 4:3 camera there is no change in angle of view or resolution. When switched to 16:9, however, there is a reduction in resolution and a decrease in vertical angle of view.

If the CCD block is optimized for 16:9 format working (Fig. 1b) and is then switched to a 4:3 aspect ratio, the image area now occupies a smaller area than a standard 4:3 CCD image (Fig. 1a) and therefore has a reduced resolution and a reduction in horizontal lens angle.

Some camera manufacturers claim that it is not possible to satisfy the competing demands of both formats; one of the formats will be compromised in resolution or change in lens angle. Other camera manufacturers claim that they can offer a switchable camera that retains the same number of pixels in both formats.

The horizontal angle of view is related to the focal length of the lens and the width of the CCD image. In a dual format camera, if the CCD is optimized for 16:9 format, the angle of view will be smaller working in the 4:3 format compared to working in 16:9 using the same focal length of the lens. At the shortest focal length the loss is about 20%. When switched to 4:3 working, there will be a 9 mm diameter image (see Fig. 2c) compared to the 11 mm diagonal image when working in 16:9 or the 11 mm diameter image of the conventional 4:3 format camera (see Fig. 2a).

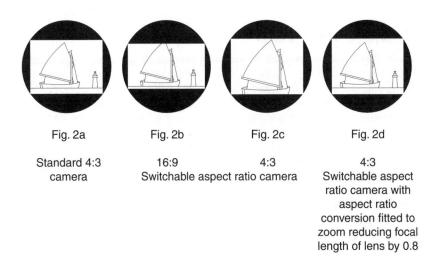

This change in horizontal lens angle when switching formats can be remedied by employing an optical unit in the zoom (similar to an extender but producing negative magnification) that shortens the focal length when working in the 4:3 mode (see Fig. 2d). This 0.8 reduction of focal length produces the same range of angles of view as a conventional 4:3 camera using the equivalent zoom lens.

It is not essential when working in 16:9/4:3 dual aspect ratio camera to fit a lens with a 0.8 convertor, only an awareness that the lens angle will be narrower than its equivalent use with a standard 4:3 camera.

T-number

The T-number is a formula that takes into account the transmittance of light and therefore lenses with similar T-numbers will give the same image brightness. This precision may be necessary when inter-changing prime lenses on film cameras. Nevertheless, exposure can still be controlled by altering the lens aperture – the f-number. This will also alter depth of field and it may be preferable to control excessive light by using neutral density filters, which uniformly reduce light of all wavelengths.

Camera controls

There are a number of mechanical and electronic controls that are found on most broadcast camcorders. The position on the camera of some of these controls will vary between make and model but their function will be similar. The essential operational controls have a significant effect on the recorded image and their function must be understood if the operator is to fully exploit the camcorder's potential. Each switch and function is discussed as a separate topic in the following pages but their effects may interact with other control settings (e.g. white balance and colour temperature filters). The newcomer to digital camerawork should experiment with a range of settings and observe the effect on the recorded image. Camerawork is a craft not a science and a video camera is simply a means to a production end.

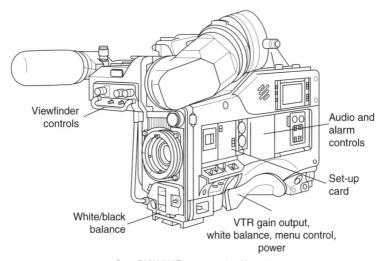

Sony DVW-700P camera control layout

Exposure, for example, can be described as a procedure that satisfies certain technical requirements. In those terms it appears to be a mechanical procedure that is objective and unaffected by the person carrying out the operation. But quite often exposure is customized to a specific shot and the engineering quest to produce a perfect electronic reproduction of a subject may be ignored to satisfy more important subjective criteria. Subjective production choices influence whether a face is in semi-silhouette or is fully lit and exposed to see every detail in the shadows

It is this 'subjective' element that often confuses someone new to camerawork in their search for the 'right way' to record an image. A useful first aim is to achieve fluency in producing television pictures that are sharp, steady, with a colour balance that appears normal to the eye and with a contrast range that falls within

the limitation of a television display. The pictures should be free from noise and with a continuity in skin tones between shots of the same face. Similar basic aims are required in recording audio. When this is achieved, the means of customizing an image or audio to serve a specific production purpose can be learnt. Quite often the standard basic picture can be produced with the aid of the auto features on the camera. To progress beyond this point an understanding of how to manipulate the operational controls needs to be gained.

LCD display panel

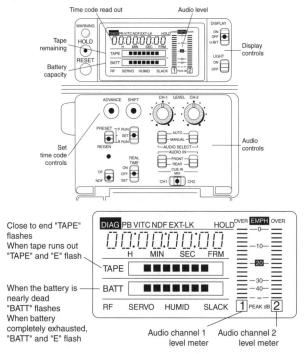

Operational controls

There are a few controls that need adjustment or at least checking on their existing setting before every shot. These include:

- tape remaining and state of battery charge;
- focus, exposure, colour temperature correction filter position, white balance setting;
- gain, shutter speed and time code;
- adjustment of audio recording level.

The camera set-up controls such as gamma, onset of zebra setting, auto-exposure settings etc., are unlikely to be regularly adjusted unless there is a production need. They can be left at their factory setting until more experience is gained in video recording.

Lens controls

The three main operational controls on the lens are focus, zoom and the lens aperture (f-number).

Focus: Sharp focus of the image is achieved by looking at the viewfinder image and either manually adjusting the focusing ring on the lens or by connecting a cable to the lens and controlling the focus by servo control mounted on a pan bar. Usually there is a switch on the zoom rocker module marked M (for manual control) and S (for servo control).

As we have discussed on page 39, the zoom must be pre-focused on its narrowest angle before recording a zoom into a subject, and the back focus of the lens must be correctly aligned (see page 43) for the sharpest focus to be maintained throughout the zoom.

If the required object in frame is closer to the lens than its minimum object distance (MOD), it may be possible to bring the subject into sharp focus by adjusting the macro ring on the back of the lens. The macro device alters several lens groups inside the lens and prevents the zoom operating as a constant focus lens. The macro after use should always be returned to its detente position and locked.

Zoom: Altering the variable lens angle on the zoom (zooming) can be achieved either by means of the rocker switch servo (or a pistol grip if fitted beneath the lens), or manually by using the zoom lever on the lens. Switching between the two methods of use is by a switch marked S (servo) and M (manual). In a similar way to control of focus, the zoom servo can also be controlled by a hand control attached to a pan bar. Pan bar servo control of zoom and focus is used when a larger viewfinder (possibly 5-inch display) replaces the monocular viewfinder.

Aperture: Opening up or closing down the lens aperture changes light level reaching the CCDs and therefore is the prime method of controlling exposure. Control of the aperture is via a switch marked M (manual control), A (autoexposure which is electronically determined) or R (remote – when the camera's image quality is adjusted remotely from the camera to match the pictures produced by other cameras at the event).

Extender: If the lens is fitted with an extender, the range of focal lengths from widest to narrowest lens angles can be altered dependent on the extender factor.

Operating with a remote servo zoom control positioned on the pan bar

Record button/lens electrics: The cable connecting the lens to camera varies between makes and models of equipment. It is important to match the correct lens cable to the camera it is working with so that the correct drive voltages are connected to avoid lens motors being damaged. Conversion cables are available if lens and camera cable pins do not match.

Lens hood: A ray shield is essential for limiting the affect of degradation from flares. It is designed for the widest lens angle of the zoom but can be augmented on a narrower lens angle by the judicious use of gaffer tape if flare on this angle is a problem. Matte box and effects filters are discussed on pages 100 and 101.

UV filter/skylight filter: This absorbs short wavelength ultraviolet (UV) rays that the eye cannot see. On a clear day these rays produce a bluish green cast to foliage. A zoom lens has so many lens components that almost all ultraviolet light is absorbed inside the lens. A UV filter is still advisable as a protection filter screwed on to the front of the lens to prevent damage or dirt reaching the front element.

Colour temperature

Two sounds cannot be combined to produce a third pure sound but as we have discussed in Colour (page 12), by combining two or more colours a third colour can be created in which there is no trace of its constituents (e.g. red + green = yellow). The eye acts differently to the ear. The eye/brain relationship is in many ways far more sophisticated than a video camera and can be misleading when attempting to analyse the 'colour' of the light illuminating a potential shot.

A 'white' card will appear 'white' under many different lighting conditions. Without a standard reference 'white', a card can be lit by pink, light blue or pale green light and an observer will adjust and claim that the card is 'white'. The card itself can be of a range of pastel hues and still be seen as white. The brain continually makes adjustments when judging colour. A video camera makes no adjustment when the colour of light illuminating a subject varies. It accurately reproduces the scene in the field of view. Therefore unless there is a procedure for standardizing a video reference 'white', a recording of the same face under different lighting conditions will appear to change colour.

Colour temperature

Because of the fidelity with which the camera reproduces colour, it is important to have a means of measuring colour and changes in colour. This is achieved by using the Kelvin scale – a measure of the colour temperature of light (see figure opposite). Across a sequence of shots under varying lighting conditions, we must provide continuity in our reference white. Just as the brain makes the necessary adjustment to preserve the continuity of white, we must adjust the camera when the colour temperature of the shot illumination changes (see White balance, page 56).

Colour video cameras are designed to operate in a tungsten environment. Processing of the output from the red, green and blue sensors is normalized to signal levels produced by a scene lit with tungsten lighting (3200K). When the camera is exposed to daylight, it requires significant changes to the red channel and blue channel gains to achieve a 'white balance'.

Colour temperature

A piece of iron when heated glows first red and then, as its temperature increases, changes colour through yellow to 'white hot'. The colour of a light source can therefore be conveniently defined by comparing its colour with an identical colour produced by a black body radiator (e.g. an iron bar) and identifying the temperature needed to produce that colour. This temperature is measured using the Kelvin scale* (K) which is equivalent to the Centigrade

*Kelvin scale: The physicist William Thomson, 1st Baron of Kelvin, first proposed an absolute temperature scale defined so that 0K is absolute zero, the coldest theoretical temperature (-273.15°C), at which the energy of motion of molecules is zero. Each absolute Kelvin degree is equivalent to a Celsius degree, so that the freezing point of water (0°C) is 273.15K, and its boiling point (100°C) is 373.15K.

unit plus 273, (e.g. $0^{\circ}C=273$ Kelvin). This is called the colour temperature of the light source although strictly speaking this only applies to incandescent sources (i.e. sources glowing because they are hot). The most common incandescent source is the tungsten filament lamp. The colour temperature of a domestic 40–60 watt tungsten bulb is 2760K, while that of a tungsten halogen source is 3200K. These are not necessarily the operating temperatures of the filaments but the colour temperature of the light emitted. Although we psychologically associate red with heat and warmth and blue with cold, as a black body radiator becomes hotter, its colour temperature increases but the light it emits becomes bluer.

Blue skylight Overcast sky HMI lamps Average summer sunlight Fluorescent daylight tubes* Early morning/late afternoon Fluorescent warm white tubes Studio tungsten lights 40–60 watt household bulb Dawn/dusk Sunrise/sunset Candle flame Match flame 9500–20,000K 6000–7500K 5000K 5000K 5000K 3000K 3000K 3200K 3200K 2760K 7000K 2000K 1850–2000K		
	Overcast sky HMI lamps Average summer sunlight Fluorescent daylight tubes* Early morning/late afternoon Fluorescent warm white tubes Studio tungsten lights 40–60 watt household bulb Dawn/dusk Sunrise/sunset Candle flame	6000-7500K 5600K 5500K 5000K 4300K 3000K 3200K 2760K 7000K 2000K 1850-2000K

^{*}All discharge sources are quoted as a correlated colour temperature, i.e. it 'looks like', for example, 5000K.

In-camera filters

Many cameras are fitted with two filter wheels that are controlled either mechanically, by turning the filter wheel on the left-hand side at the front of the camera, or by selecting the required filter position from a menu displayed in the viewfinder. The filter wheels contain colour correction and neutral density filters and possibly an effects filter.

The output from the red, green and blue CCDs is normalized to signal levels produced by a scene lit with tungsten lighting (3200K). When the camera is exposed to daylight, it requires significant changes to the red channel and blue channel gains to achieve a 'white balance'.

The 3200K is a clear glass filter whereas a 5600K filter (with no ND) is a minus blue filter to cut out the additional blue found in daylight. All colour correction filters decrease the transmission of light and therefore the minus blue filter cuts down the light (by approximately one stop) where most light is available – in daylight. A white balance is required after changing filter position.

Variation in colour temperature could be compensated without the use of colour correction filters by adjusting the gains of each channel. With some colour combinations this would require a large increase in gain in one channel and increase noise to an unacceptable level (see page 82 for the relationship between gain and noise).

Filter selector

On the Sony 700 Digi-Beta series cameras, the filter selector is a two-part knob. The outer ring selects the colour correction filter:

Position B 3200K Position C 4300K Position D 6300K

Position A is not a colour correction filter but an effects filter (cross hatch), which produces a star effect on highlights.

The inner knob on the filter control selects a grade of neutral density (ND) filter.

Position 1 clear glass – no light loss Position 2 1/4 ND

Position 3 1/16 ND Position 2 1/64 ND

Filter selection

On the 300/400 SP cameras the following combinations of colour correction and neutral density filters are available:

1 3200K

2 5600K + 1/4ND (neutral density)

3 5600K

4 5600K + 1/16ND (neutral density)

sunrise/sunset/tungsten/studio

exterior – clear sky

exterior/cloud/rain exterior exceptionally bright.

Neutral density filters are used when there is a need to reduce the depth of field or in circumstances of a brightly lit location.

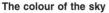

Earth's atmosphere

Sunlight is scattered as it passes through the atmosphere and combined with clouds and the orbit of the earth around the sun; the human perception of the 'colour' of the sky is constantly changing. At midday, visible solar radiation is scattered by air molecules, particularly at the blue end of the spectrum where 30%–40% of blue light is dispersed producing a 'blue' sky. The scattering decreases to a negligible amount at the red end. At sunrise/sunset when light from the sun passes through a greater amount of atmosphere, light scattering occurs across the whole of the spectrum and the sky appears redder. The amount of sunlight scattered by the earth's atmosphere depends on wavelength, how far light has to travel through the atmosphere, and atmospheric pollution.

Neutral density filters

Density		% transmission	Stop loss
0	0	100	0
0.3	½ ND	50	1
0.6	½ ND	25	2
0.9	1/8 ND	13	3
1.2	1 ND	7	4
1.5	1/32 ND	3.5	5
1.8	1/64 ND	1.75	6

White balance

Because the colour temperature of different light sources and mixtures of light sources varies, it is essential to select the correct filter and white balance the camera whenever you suspect a change has occurred.

Daylight to tungsten

A common example of changing colour temperature occurs during an evening football match. The game may begin in evening sunshine. The camera will be balanced to a white which, lit by an evening sun, will have a lower colour temperature than at midday. As the football match progresses, the sun goes down and the floodlights come on. If the camera is not white balanced to cover this colour temperature transition, edited highlights of the match will have a different colour cast when cut together.

Whenever there is a change in the colour temperature of the light illuminating a potential shot it is necessary to adjust the white balance of the camera. Some cameras will compensate for colour temperature variation but often it is necessary to carry out a white balance set-up. The white balance switch may be marked 'auto white balance' but this does not mean the camera will automatically compensate unless the specified white balance procedure is carried out. To successfully white balance, a simple routine needs to be followed:

- Select the correct filter for the colour temperature of light being used (e.g. tungsten 3200K or daylight 5600K).
- Select either white balance position A or B. These positions memorize the setting achieved by the white balance. On each filter position there can be two memories (A or B). If preset is selected no setting will be memorized. This position always provides the factory default setting of 3200K.
- Fill the frame with a white matte card that is lit by the same lighting as the
 intended shot. Make sure the card does not move during the white balance
 and that there are no reflections or shading on the card. Avoid any colour
 cast from surrounding light sources and ensure that you white balance
 with the main source of shot illumination and that the card is correctly
 exposed.

A progress report may appear in the viewfinder during white balance including a number indicating the colour temperature that has been assessed. If this is much higher or lower than your anticipated estimate of the colour temperature then check the white card position and the other requirements of white balance. It could also indicate the camera is either not properly lined-up or malfunctioning. During the white balance procedure, the camera adjusts the output of the three signal amplifiers so that their gain is unity. This establishes the 'white' of the card held in front of the lens as the reference 'white' and influences all other colour combinations. The fidelity of colour reproduction is therefore dependent on the white balance procedure.

Conditions for white balance

- Zero gain or as low as possible for exposure.
- Select white balance memory position (A or B).
- · Select auto-exposure.
- Select the appropriate filter to match the colour temperature of the light illuminating the white object.
- White test card or object must be illuminated by the same lighting conditions as the subject to be recorded.
- The reference white must be near the centre of the frame and not less than 70% of the frame area. It should be evenly lit with respect to colour and shading and contain no bright highlights.
- Push the AUTO W/B BAL switch to WHT and release the switch.
- Check in the viewfinder that the white balance has been successfully completed (e.g. a message stating 'WHITE: OK').

700 series error messages

WHITE: NG LEVEL TOO LOW	Increase light level, gain or aperture
WHITE: NG COLOUR TEMP HIGH	Wrong filter selected for colour temperature of light
WHITE: NG COLOUR TEMP LOW	Wrong filter selected for colour temperature of light
WHITE: NG TIME LIMIT	Adjustment could not be completed within the standard number of attempts
WHITE: NG POOR WHITE AREA	Wrong choice of 'white' object or card
WHITE: NG LEVEL TOO HIGH	Over-exposed. Stop down iris or add ND filter

Note that on the 700 series cameras the white balance cannot be adjusted if the set-up menu is displayed on the viewfinder. Switch menu off.

White balance viewfinder progress report (300/400 series cameras)

White balance memory

A factory preset white balance for each colour correction filter is available if the white balance memory selector is switched to PRST (pre-set).

Values stored after a white balance (position A or B) will be memorized for a week even when camera is turned off. If the settings are lost, an error message will be flashed on the viewfinder when the camera is switched on stating 'MEMORY: NG'.

Black balance

Black balance sets the black levels of the R, G and B channels so that black has no colourcast. It is normally only required:

- when the camera is first used or if the camera has not been in use for some time
- if the camera has been moved between radically different temperatures or the surrounding temperature has significantly altered
- on DVW-700 cameras when the gain selector values are altered.

First, white balance to equalize the gains and then black balance; then white balance again. In automatic black balance (e.g. on the DVW-700), the black balance is adjusted after the black set is adjusted. The black shading will then be adjusted if the automatic black balance switch is held down during the black balance adjustment. Alternatively, manual black balance adjustments can be selected from the set-up menu.

Auto-black balance

The automatic black set/black balance adjustment consists of five phases starting with black set adjustment for red, then blue, green, red and ending with blue. Viewfinder messages will report the progress and results of the auto black balance in display mode selected 2 or 3. Typical black balance procedure would be:

- Select camera output; gain to 0; push down the AUTO W/B BAL to the BLK position.
- Messages may appear in the viewfinder reporting the progress of the black balance, which will take a few seconds.
- During the balance, the iris will close automatically, and, if it was set to manual iris, will need to opened again after completion. The GAIN will also be changed but will return to its zero setting.
- On the DVW-700, the black balance cannot be adjusted while the set-up menu is displayed on the viewfinder.
- If successful, the adjusted black balance value will be stored in memory otherwise a message will appear in the viewfinder (see table opposite).
- For many cameras, values stored in memory are saved for about one week
 when the camera/recorder is turned off. If when the camera is turned on an
 error message is displayed in the viewfinder 'MEMORY: NG' the black
 balance content has been lost. The above black balance procedure will need
 to be activated.

Camera output selector

There are usually one of three signals that can be selected on the camera which are routed to the VCR and displayed in the viewfinder. They are colour bars or the vision output of the camera (any exposed subject in the field of view

of the lens) or, the vision output of the camera as above but modified by a variable contrast control circuit (see Electronic contrast control, page 72).

Viewfinder black balance error messages (Sony DVW-700P)

If the black balance adjustment cannot be completed normally, an error message will appear for about 3 seconds on the viewfinder screen (in display mode 2 or 3).

BLACK: NG IRIS NOT CLOSED	The lens iris did not close; adjustment was impossible
BLACK: NG R (or G or B): TIME LIMIT	Adjustment could not be completed within the standard number of attempts
BLACK: NG R (or G or B): OVERFLOW	The difference between the reference value and the current value is so great that it exceeds the range. Adjustment was impossible

If any of the above error messages are displayed, retry the black balance adjustment. If the error message occurs again an internal check is necessary.

The black balance cannot be adjusted while the set-up menu is displayed on the viewfinder screen. Always set the MENU ON/OFF/PAGE switch to OFF before starting these adjustments. Black balance values stored in memory are saved for about one week when the camcorder is turned off.

Colour bars

Colour bars are a special test signal used as a video reference to adjust monitors and playback level. Although designed as a standard reference, there are variations in the method of generating the signal (e.g. 100% bars, EBU bars, SMPTE bars) and therefore it is essential to understand what type of bars are being generated when using them as a reference signal in equipment line-up.

When *Bars* are selected, the iris automatically closes and the output of the camera will be a line-up test signal created in the camera. Check in the viewfinder that the frame is divided into 8 equal vertical sections of varying contrast. Each section in the monochrome viewfinder represents a different colour which are from left to right – white; yellow; cyan; green; magenta; red; blue; black.

Colour bars are customarily recorded at the start of a new tape (usually 30 seconds) as a reference signal in editing. Some cameras will also allow a message to be inserted into the bars for easy identification of the tape and contents.

The bars may also be available on the BNC Video Out connector and can be used to adjust an external monitor and the viewfinder. Equipment is available to accurately set up the monitor picture to a standard reference.

Viewfinder

The 1.5-in monochrome viewfinder is the first and often the only method of checking picture quality for the camera/recorder cameraman. The small black and white image has to be used to check framing, focusing, exposure, contrast and lighting. The indicating lamps around the viewfinder provide warning of video recording, sound level, filter position, tape length remaining, battery condition. It is essential, as the viewfinder is the main guide to what is being recorded, to ensure that it is correctly set up. This means aligning the brightness and contrast of the viewfinder tube. Neither control directly affects the camera output signal. Indirectly, however, if the brightness control is incorrectly set, manual adjustment of exposure based on the viewfinder picture can lead to under- or over-exposed pictures. The action of the brightness and contrast controls therefore needs to be clearly understood (see page 213).

Setting up the viewfinder

- 1 Select aspect ratio if using a switchable format camera. Check that the viewfinder image is in the selected aspect ratio.
- 2 Switch CAMERA to BARS.
- 3 Check the picture in the viewfinder and then reduce contrast and brightness to minimum.
- 4 Increase brightness until just before the raster (line structure) appears in the right-hand (black) segment of the bars.
- 5 Adjust contrast until all divisions of the bars can be seen.
- 6 Use the bars to check viewfinder focus and adjust the focus of the viewfinder eyepiece to produce the sharpest picture possible.
- 7 With CAMERA switched to ON re-check CONTRAST with correctly exposed picture. Although CONTRAST control may occasionally need to be adjusted depending on picture content and ambient light change, avoid altering BRIGHTNESS control.
- 8 Set PEAKING control to provide the minimum edge-enhancement that you require to find focus and adjust the eyepiece focus to achieve maximum sharpness of the viewfinder image. Adjust the position of the viewfinder for optimum operating comfort.

Viewfinder status display (DVW-700/DVW-790)

The viewfinder displays not only the picture produced by the camera but also messages indicating camera settings, and operating status. The viewfinder menu page can be programmed to provide you with a great deal of information but it is obviously not good practice to have too much of the viewfinder image obscured by text. When the MENU ON/OFF/PAGE is switched to OFF the selected messages appear along the top and bottom of the frame and can include indications of extender, zoom position, self-diagnosis, battery state, time code, iris setting, remaining tape, audio level, shutter speed, gain, white balance indicator, filter indicator, centre marker, safety zone marker, etc. Which information is required to be displayed can be programmed when the MENU is switched to ON and the PAGE switch is repeatedly toggled until VF DISPLAY

page appears. Information after changes to settings (e.g. gain, etc.) can be made to appear for about 3 seconds. Customize the standard display to provide only vital indicators for your normal course of work or when a 'non-standard' setting has been selected (e.g. 'lens extender warning').

Aspect ratios and safety zones

With the introduction of widescreen digital TV and the use of dual format cameras, productions may be shot in 16:9 aspect ratio but transmitted and viewed on 4:3 television receiver. To ease the transition between the two aspect ratios, many broadcasters use a compromise 14:9 aspect ratio for nominally 4:3 sets, but transmit the whole of the 16:9 frame to widescreen sets.

This requires the cameraman to frame up a 16:9 picture with these competing requirements in mind. Any essential information is included in the 14:9 picture area although the whole of the 16:9 frame may be transmitted in the future. A 14:9 graticule superimposed on the 16:9 viewfinder picture reminds the cameraman of this requirement. For the foreseeable future, actuality events such as sport may be covered for dual transmission – 16:9 and 14:9 – and therefore framing has to accommodate the smaller format if some viewers are not to be deprived of vital action (see Protect and save, page 110).

Viewfinder indicators

On some models of analogue cameras (e.g. Sony BVP300/400), the viewfinder indicators are selected from one of three modes of operation. With the OUTPUT/DCC selector to BARS push the AUTO W/B BAL switch to WHT. Each time you push the switch the viewfinder display mode changes.

Mode three provides the greatest number of indicators including amount of gain, dynamic contrast on or off, selected filter, white balance preset (A or B), and, if audio indicator is set to ON, the channel–1 audio level is displayed. Tape remaining time is also indicated with the 5–0 figure blinking when remaining tape is less than 2 minutes. Battery indicator will also warn a few minutes before the battery voltage drops below the minimum level needed to operate the camera/recorder and will remain continually lit when battery voltage is inadequate. On digital cameras, adjustment of these variables is accomplished by selecting a menu of options.

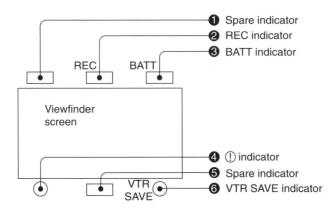

Monocular and 5-inch viewfinder

The viewfinder fitted to a broadcast camera/recorder can be mechanically adjusted to individual preferences. It can be positioned away from the body of the camera, moved backwards and forwards and swivelled into the optimum operating position. There is the facility for focusing the eyepiece and if a camera operator normally wears glasses, a correcting compensating dioptre can replace the supplied viewfinder lens. There are other specialist monocular viewfinders which can replace the standard issue such as the wide-angle viewfinder, which gives a larger image size allowing the cameraman to work with the camera off the shoulder and the extension viewfinder to allow an operating position further back from the lens. A fog proof filter can be fitted in the viewfinder to prevent condensation caused by rapid changes of temperature. There is also a left-eye extension kit.

Working with a 5-in viewfinder

The monocular viewfinder can be replaced by a top- or side mounted 5-in/7-in viewfinder. The zoom and focus controls are then remoted to pan bars to allow the cameraman to work behind the camera. This is worthwhile when covering continuous events such as sport or all-day conferences, to avoid the fatigue of one-eye operation. The behind camera zoom controls can be either mechanical linkage — Bowden cables — or servo driven. Both systems can suffer from backlash and insensitive response and they are not always as positive as the 'on-lens' control. A recurring problem is the servo zoom control may snatch on take-off or be difficult to zoom slowly. The motor clamped to the lens to provide servo focus may be slow to respond to the remote control, causing an overshoot of the required focus point. Check that the zoom servo systems have been properly aligned. The advantages of working from a larger viewfinder and behind the camera are:

- Incidents 'off-shot' can be more easily seen by looking past the viewfinder
- With a larger viewfinder, action and identification (picking out individuals, team shirts, etc.) is easier
- The camera can be mounted on the front of scaffolding to allow 180° camera coverage – this is difficult with a monocular side-mounted viewfinder.

The major disadvantage however is ambient light and power supply. A larger viewfinder uses more power, which means more batteries over the day and may only be viable if a mains adaptor can be used. Daylight falling on the face of the viewfinder and degrading the picture brightness is hard to avoid even with a well-designed viewfinder hood. Increasing contrast in order to see the picture may mean white crushing occurs in the viewfinder before actual over-exposure of shot. This sometimes makes the camera operation so difficult that the advantages of a 5-in viewfinder are cancelled out and the monocular viewfinder (where the head shields the picture from daylight) is the only option.

Adjusting the position of the viewfinder

Horizontal positioning:

- 1 loosen fixing lever
- 2 adjust viewfinder left or right
- 3 tighten fixing ring

Front or back positioning:

- 1 loosen fixing ring
- 2 move viewfinder forwards or back
- 3 tighten fixing ring

Eyepiece focus adjustment:

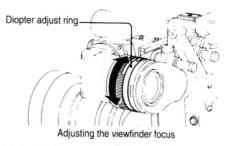

To adjust eyepiece focus, rotate adjust ring to achieve maximum sharpness of viewfinder image. If sharp focus cannot be obtained, a compensating dioptre can be obtained from an optician suitable for individual eyesight.

Exposure

When viewing a film or television production, it is often easy to assume that the two-dimensional images are a faithful reproduction of the original scene. There are many productions (e.g. news, current affairs, sports coverage, etc.) where the audience's belief that they are watching a truthful representation unmediated by technical manipulation or distortion is essential to the credibility of the programme. But many decisions concerning exposure involve some degree of compromise as to what can be depicted even in 'factual' programmes. In productions that seek to interpret rather than to record an event, manipulating the exposure to control the look of a shot is an important technique.

As we have discussed in Colour temperature (page 52), human perception is more complex and adaptable than a video camera. The eye/brain can detect subtle tonal differences ranging, for example, from the slight variations in a white sheet hanging on a washing line on a sunny day to the detail in the deepest shadow cast by a building. The highlights in the sheet may be a thousand times brighter than the shadow detail. The TV signal is designed to handle (with minimum correction) no more than approximately 40:1 (see Contrast range, page 66).

But there is another fundamental difference in viewing a TV image and our personal experience in observing a subject. Frequently, a TV image is part of a series of images that are telling a story, creating an atmosphere or emotion. The image is designed to manipulate the viewer's response. Our normal perceptual experience is conditioned by psychological factors and we often see what we expect to see; our response is personal and individual. A storytelling TV image is designed to evoke a similar reaction in all its viewers. Exposure plays a key part in this process and is a crucial part of camerawork. Decisions on what ranges of tones are to be recorded and decisions on lighting, staging, stop number, depth of field, etc., all intimately affect how the observer relates to the image and to a sequence of images. The 'look' of an image is a key production tool.

A shot is one shot amongst many and continuity of the exposure will determine how it relates to the proceeding and the succeeding images (see Camerawork and editing, page 148).

Factors which affect decisions on exposure include:

- the contrast range of the recording medium and viewing conditions;
- the choice of peak white and how much detail in the shadows is to be preserved;
- continuity of face tones and the relationship to other picture tones;
- subject priority what is the principal subject in the frame (e.g. a figure standing on a skyline or the sky behind them?);
- what electronic methods of controlling contrast range are used;
- the lighting technique applied in controlling contrast;
- staging decisions where someone is placed affects the contrast range.

Exposure overview

- An accurate conversion of a range of tonal contrast from light into an electrical signal and back into light requires an overall system gamma of approximately 1.08. (see Gamma and matrix, page 96).
- Often the scene contrast range cannot be accommodated by the five-stop handling ability of the camera and requires either the use of additional lamps or graduated filters or the compression of highlights is necessary.
- The choice of what tones are to be compressed is decided by the cameraman by altering the iris, by a knowledge of the transfer characteristics of the camera or by the use of highlight control.
- Automatic-exposure makes no judgement of what is the important subject in the frame. It exposes for average light levels plus some weighting to centre frame. It continuously adjusts to any change of light level in the frame.
- Exposure can be achieved by a combination of f-number, shutter speed and gain setting. Increasing gain will increase noise. Shutter speed is dependent on subject content (e.g. the need for slow motion replay, shooting computer displays etc., see Electronic shutters, page 84). F-number controls depth of field and is a subjective choice based on shot content (see below).

Depth-of-field

Choosing a lens aperture when shooting in daylight usually depends on achieving the required exposure. Depth-of-field is proportional to f-number and if the in-focus zone is a significant consideration in the shot composition (e.g. the need to have an out-of-focus background on an MCU of a person, or, alternatively, the need to have all the subject in focus) then the other factors affecting exposure may be adjusted to meet the required stop such as:

- neutral density filters;
- altering gain (including the use of negative gain);
- altering shutter speed;
- adding or removing light sources.

There is often more opportunity to achieve the required aperture when shooting interiors by the choice of lighting treatment (e.g. adjusting the balance between the interior and exterior light sources), although daylight is many times more powerful than portable lighting kits.

Sometimes there may be the need to match the depth-of-field on similar sized shots that are to be intercut (e.g. interviews). Lens sharpness may decrease as the lens is opened up but the higher lens specification required for digital cameras usually ensures that even when working wide open, the slight loss of resolution is not noticeable.

Contrast range

Every shot recorded by the camera/recorder has a variation of brightness contained within it. This variation of brightness is the contrast range of the scene. The ratio between the brightest part of the subject and the darkest part is the contrast ratio. The average exterior contrast ratio is approximately 150:1 but it can be as high as 1000:1. Whereas the contrast ratios of everyday locations and interiors can range from 20:1 to 1000:1, a video camera can only record a scene range of approximately 32:1. Peak white (100%) to black level (3.125%) is equivalent to five stops. The contrast range can be extended by compressing the highlights using a non-linear transfer characteristic when translating light into the television signal (see Contrast control, page 70).

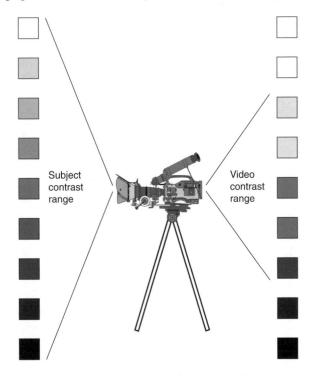

The result of recording a contrast range greater than the camera can handle is that highlights of the scene will appear a uniform white – details in them will be burnt-out and the darker tones of the scene will be a uniform black. The limiting factor for the reproduction of the acquired image is ultimately the display monitor on which it is viewed. The design, set-up and viewing conditions of the viewer's display monitor and the design of the signal path to the viewer all affect the final contrast range displayed. The darkest black that can be achieved will depend on the amount of light falling on the screen. The viewer also has the ability to increase the contrast on their set, which will distort any production preference of image contrast.

The majority of image impairment in discriminating between tones occurs in highlights such as windows, skies etc., but whether such limitations matter in practice will depend on how important tonal subtlety is in the shot. Loss of detail in a white costume may be noticeable but accepted as a subjective expression of a hot sunny day. A sports arena where a stadium shadow places half the pitch in darkness and half in bright sunlight may cause continuous exposure problems as the play moves in and out of the shadow. Either detail will be lost in the shadows or detail in sunlight will be burnt out.

Often, exposure is adjusted to allow the contrast range of the scene to be accurately reproduced on the recording. The aim is to avoid losing any variation between shades and at the same time maintaining the overall scene brightness relationships. Achieving the correct exposure for this type of shot therefore requires reproducing the detail in the highlights as well as in the shadows of the scene. Additionally, if a face is the subject of the picture then the skin tones need to be set between 70% and 75% of peak white (may be a wider variation depending on country and skin tones, (see Face tones, page 80).

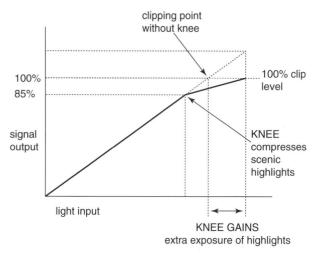

The limiting factor for highlight detail in high contrast scenes is the peak white clipper circuits and the 'knee' of signal amplification in the camera.

Peak white clippers: There are three peak white clippers, one in each colour channel and their function is to limit any part of the scene that would produce a signal greater than a pre-set value. Their effect is to render all gradations in brightness above the 'clip' level as white — to burn out any over-exposed parts of the picture. This can be difficult for the cameraman to see if his viewfinder is not correctly adjusted.

Knee: The 'knee', which is introduced into the camera head amplifier's, progressively compresses highlights which otherwise would be lost in the peak white clipper. It extends the camera's response to a high contrast range but with some loss of linearity.

Creating mood and atmosphere

Many productions require images that create a visual impression. The 'correct' exposure is less a matter of accurately reproducing a contrast range than the technique of setting a mood. Selecting the exposure for this type of shot is dependent on choosing a limited range of tones that creates the desired atmosphere that is appropriate to the subject matter.

Visual perception

There have been many theories about perception and many visual experiments. Most conclude that perception is instantaneous and not subject to extended judgement. It is an active exploration rather than a passive recording of the visual elements in the field of view and is selective and personal. It is not a simple mechanical process and the eye/brain can often be misled by a visual stimulus. The physiologist E.H. Weber established that a constant change in physical sensation like brightness or sound level becomes less noticeable if the brightness or sound levels increase at a constant rate. The brightness of an object must increase logarithmically for the eye to judge that change of brightness is increasing in equal increments. The same logarithmic scale applies to the ear's response to changes in sound level (see The nature of sound, page 186).

The eye: The eye perceives gradations of brightness by comparison. It is the ratio of one apparent brightness to another (and in what context) that determines how different or distinct the two appear to be. The just noticeable difference between the intensity of two light sources is discernible if one is approximately 8% greater/lesser than the other regardless of them both being of high or low luminous intensity (see Characteristics of light, Brightness, page 166). The amount of light entering the eye is controlled by an iris and it is also equipped with two types of cells: rods that respond to dim light, and cones, receptor cells that respond to normal lighting levels. For a given iris opening, the average eye can accommodate a contrast range of 100:1, but visual perception is always a combination of eye and brain. The eye adapts quickly to changing light levels and the brain interprets the eye's response in such a way that it appears as if we can scan a scene with a very wide contrast range (e.g. 500:1), and see it in a single glance.

The camera and the lens: In a television camera, the lens focuses an image on the face of the CCDs which is then processed electronically. Although many distortions can be introduced in the processing and in subsequent postproduction image manipulation, there is no subjective interpretation of the camera viewpoint equivalent to the process that occurs between eye and brain in human perception. A video image is composed of a number of measurable electrical parameters. In making visual judgments about picture quality and exposure continuity there is often the need to use additional measuring equipment other than the picture provided by the viewfinder. Human perception is in many ways more subtle, sensitive and flexible than a video image, but there are many occasions where it can easily misjudge change. There needs to be an objective way of measuring certain electronic image characteristics. As we have seen, the eye can automatically compensate for changes in brightness, contrast and colour temperature, therefore there is a need for an objective method of measuring some aspects of the electronic image (see opposite).

Assessment of picture quality

There are a number of video signal measurements that can be objectively checked with a vectorscope and waveform monitor, but picture monitor alignment is of critical importance if correct picture assessment is to be achieved.

Many monitors are designed with an automatic alignment system using a sensor placed against the face of the monitor. A method of checking chroma is by feeding colour bars to the monitor and switching the monitor to blue only. Under this condition, the three right-hand colour bars should appear to have the same brightness. Precise assessment can be improved by turning down the brightness control (to be reset later) and/or viewing the screen through a suitable ND filter. Another method of assessing monitor line-up is by feeding the monitor display with a special test signal from the external picture line-up generating equipment known as PLUGE.

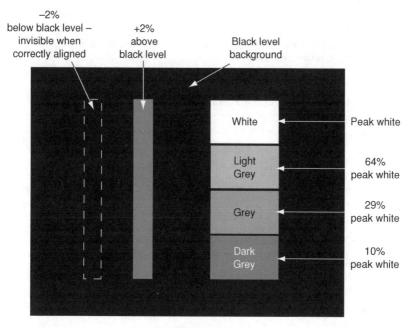

The PLUGE test signal

The PLUGE test signal allows accurate setting of brightness and contrast. Brightness is adjusted so that the lighter bar is just visible, but the darker bar is not visible. Using a spotmeter, the contrast is adjusted to give 25 foot lamberts off the peak white signal. The other 'steps' may be used to check the gamma of the monitor.

Portable waveform monitor

A portable waveform test measurement device will allow a waveform signal to be superimposed on a monitor screen. For example, a particular face tone signal level can be marked by a cursor. When the same signal level is required for another shot with the same face, the exposure, lighting etc., can be adjusted so that the signal level signifying the face tone matches up to the memory cursor.

Contrast control

The control of the contrast range can be achieved by several methods:

- The simplest is by avoiding high contrast situations. This involves selecting a
 framing that does not exceed the 32:1 contrast range the camera can handle.
 This obviously places severe restrictions on what can be recorded and is
 frequently not practical.
- A popular technique is to stage the participants of a shot against a background avoiding high contrast. In interiors, this may mean avoiding daylight windows or closing curtains or blinds, or, in exteriors, avoiding shooting people in shadow (e.g. under a tree) with brightly lit backgrounds or against the skyline.
- If luminaires or reflectors of sufficient power and numbers are available they
 can be used to lighten shadows and modify the light on faces. Even a lamp
 mounted on a camera can be a useful contrast modifier at dusk on an exterior
 or in some interior situations.

Staging

The rule of thumb that claims you should expose for the highlights and let the shadows look after themselves may give bright colourful landscapes but becomes very limited advice when shooting a face lit by sunlight under a cloudless summer sky. There may be more than three to four stops difference between the lit and the unlit side of the face.

Ways of controlling the contrast in a shot need to be found if there is to be no loss of detail in highlights or shadows. A simple but effective method is to frame the shot to avoid areas of high contrast. Stage people against buildings or trees rather than the sky if there are bright sunlight conditions. Avoid direct sunlight on faces unless you can lighten shadows. With interiors, use curtains or blinds to reduce the amount of light entering windows and position people to avoid a high-contrast situation.

The problem of a bright sky can be controlled by a ND graduated filter if the horizon allows and other important elements of the shot are not in the top of frame. Low contrast filters and soft contrast filters may also help (see Effects filters, page 100).

Avoid staging people, if possible, against an even white cloud base. Either the overcast sky is burnt out or the face is in semi-silhouette if exposure for detail in the clouds is attempted.

Methods of altering contrast range by additional lamps or reflector boards are discussed in Controlling light, page 168.

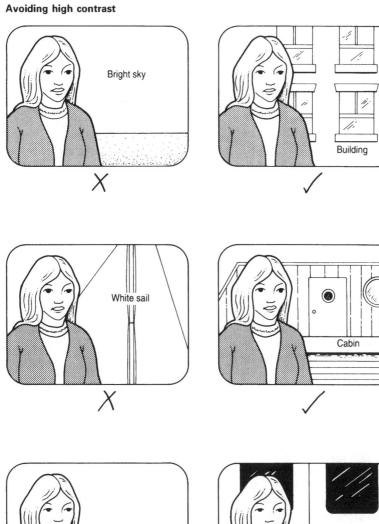

Electronic contrast control

As we discussed in charge-coupled devices (page 20), the CCDs in the camera respond to light and convert the variations of brightness into variations in the electrical signal output. There is a minimum light level required to produce any signal. Below this level the camera processing circuits produce a uniform black. This is called black clip (see figure opposite). As the intensity of light increases, the signal increases proportionally until a point is reached when the signal is limited and no further increase is possible even if the light intensity continues to increase. This point is called the white clip level and identifies the maximum allowable video level. Any range of highlight tones above this level will be reproduced as the peak white tone where the signal is set to be clipped. Variation in the brightness of objects will only be transferred into a video signal if they are exposed to fall between the black clip level and white clip level.

This straight line response to light is modified to allow a greater range of brightness to be accommodated by reducing the slope of the transfer characteristic at the top end of the CCD's response to highlights (see figure opposite). This is called the knee of the response curve and the point at which the knee begins and the shape of the response above the knee alters the way the video camera handles highlights. By reducing the slope of the transfer characteristic a greater range of highlights can be compressed so that separation remains and they do not go into 'overload' above the white clip level and become one featureless tone. If the shape of this portion of the graph is more of a curve, the compression of highlights is non-linear and the transition to overload is more gradual.

Modifying this transfer slope provides the opportunity to alter the gamma of the camera (see Gamma and matrix, page 96) and a method of handling contrast scenes which exceed the 32:1 contrast range of the standard video camera response.

Exposing for highlights

A highlight part of the shot (e.g. white sheets on a washing line in bright sun) which may produce a signal five times peak white level can be compressed into the normal video dynamic range. With the above example this means that the darker areas of the picture can be correctly exposed whilst at the same time maintaining some detail in the sheets.

If someone was standing in a room against a window and it was necessary to expose for exterior detail and the face, without additional lighting or filtering the windows, it would not be possible to reproduce detail in both face and exterior. Using highlight compression, the highlights outside the window would be squashed and although their relative brightness to each other would not be faithfully reproduced, the compression would allow the reproduction of detail across a greater range to be recorded.

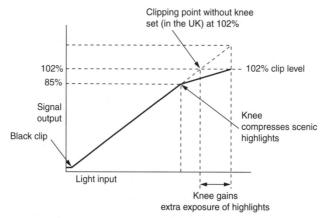

The 'knee' which is introduced in the camera head amplifiers, progressively compresses highlights which otherwise would be lost in the peak white clipper. It extends the camera's response to a high contrast range but with some loss of linearity. Many cameras also provide a black stretch facility will helps to reveal detail in the black areas, but will also introduce some extra noise.

Setting peak white clipper (DVW-790)

To set peak white clipper to limit the maximum video signal at 100%, adjust the zebra 2 detect level so that the patterning just appears on the white bar in the viewfinder when bars and zebra 2 are selected. So that there is no highlight compression before clipping occurs, leave zebra 2 on but switch bars and auto knee or dynamic contrast control off and then through the menu select a non-filmic gamma. On manual exposure, open up the iris to over-expose the camera when framing up a very bright object or light so that the peak white clipper is activated. Select white clip level on the menu and adjust until the zebra bars are just on the point of disappearing.

Transient highlights

One type of contrast control uses average feedback and avoids unnecessary compression by not responding to transient high intensity light such as car headlamps. If highlight compression is used with a normal contrast range scene (below 40:1) there is the risk that highlights will be distorted and the compression may result in a lower contrast reproduction than the original. Low contrast pictures have little impact and are visually less dynamic.

Adjusting exposure

There are various methods of adjusting exposure:

- using the zebra exposure indicator in the viewfinder (see page 76);
- manually adjusting the iris setting whilst looking at the viewfinder picture;
- using the auto-iris exposure circuit built into the camera.

Many cameramen use a combination of all three and some cameramen use a light meter.

Manual adjustment

The simplest method is to look at the viewfinder picture (make certain that it is correctly set up – see Viewfinder, page 60) and turn the iris ring on the lens to a larger f-number (this reduces the amount of light reaching the CCDs) if the brightest parts of the scene have no detail in them or to a smaller f-number (increasing the amount of light reaching the CCDs) if there is no detail in important parts of the subject. In some situations there may be insufficient light even with the iris wide open to expose the shot. Check that no ND filter is being used and then either switch in additional gain, change the shutter if it is set to a faster speed than 1/50th or 1/60th (depending on country) or add additional light.

If you are uncertain about your ability to judge exposure with this method (and it takes time to become experienced in all situations) then either confirm your exposure setting by depressing the instant auto-exposure button which gives the camera's auto-exposure estimation of the correct f-number. When the button is released you can either stay at the camera setting or return to your manual estimation.

The camera as light meter

A television camera has been called the most expensive light meter produced. If auto-exposure is selected, the feedback to the iris can be instantaneous and the auto circuit will immediately stop down the lens if any significant increase of scene brightness is detected. Auto-exposure works by averaging the picture brightness (see figures opposite) and therefore needs to be used intelligently. In some cameras, different portions of the frame can be monitored and the response rate to the change of exposure can be selected. In general, expose for the main subject of the shot and check that the auto-iris is not compensating for large areas of peak brightness (e.g. overcast sky) in the scene.

The lens iris is controlled by the highest reading from the red, green or blue channel and therefore the auto circuit reacts whenever any colour combination approaches peak signal. This auto decision-making about exposure may have disadvantages as well as advantages. The rate of response of the autoiris system needs to be fast enough to keep up with a camera panning from a bright to a dark scene, but not so responsive that it instantly over- or underexposes the picture for a momentary highlight brightness (e.g. a sudden background reflection).

Auto-exposure

The auto-exposure system measures the range of subject brightness and sets an f-number that will reproduce mid-tone grey at 50% of peak white. 50% of peak white is equivalent to reflected light from a subject with 18% reflectance. This basic auto-exposure assessment can be modified to give priority to certain areas of the frame or to the rate of change of exposure to changing light levels.

Variable slope highlight control

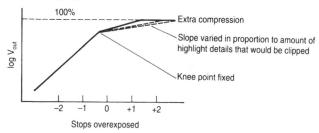

Variable knee point highlight control

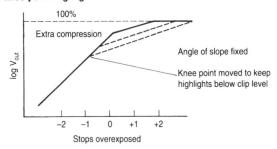

Auto-exposure problems

A common problem with auto-exposure occurs when an interview is being recorded and auto-exposure has been selected and left on. The interviewee may be correctly exposed at the start of the interview but if any highly reflective object enters the background of the frame then the auto-exposure circuit may be triggered and will stop down the iris to expose for detail. The interviewee's face will be under-exposed. Additionally, there may be a problem with changing light conditions such as intermittent sunlight requiring significant and rapid changes in face exposure, which may be intrusive and visible if controlled by an auto-exposure rapid exposure. If using auto-exposure, check that the rate of pan is in step with the auto-iris's ability to change exposure. If using a camera for the first time check that the auto-exposure is correctly set.

Zebra exposure indicator

The zebra pattern is a visual indicator in the viewfinder when areas of the picture have reached a certain signal level. If the zebra exposure indicator is switched on, those elements of the image that reach this preset level are replaced by diagonal stripes in the picture. The cameraman can respond by closing the iris to adjust the exposure until part or all of the zebra diagonals have been removed.

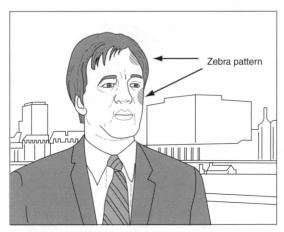

Stripes or patterning appear in the viewfinder on those parts of the image when the signal is above or between preset levels. With some models of digi-beta two zebras are available. Zebra 1 is commonly set to 67–68%, and Zebra 2 to 95–100%, indicating when signals are about to clip. Other cameras such as the DVW-700 (NTSC) cameras are factory preset at 70% IRE and the DVW-700P (Pal) cameras are set at 490 mV. Using these values (when zebra indicator is switched on), the highlight points on a face (in the above drawing camera-right cheek bone and forehead) will display zebra patterning when the face is correctly exposed. Other zebra trigger levels can be programmed via the menu.

Onset of zebra level

The level at which the zebra indicator is triggered is obviously a critical factor in this method of assessing exposure and can be adjusted to suit particular operational preferences. Some camera designs have their zebra stripe indicator driven by the luminance signal. The zebra stripe warning is then only valid for nearly white subjects and exposure of strongly coloured areas may go into over-exposure without warning. Other systems use any of the red, green or blue outputs, which exceed the selected signal level to trigger the zebra indicator.

Selecting zebra level

The exposure point at which the zebra indicator is triggered can be a personal operational preference but criteria to consider when setting that point are:

- if there is a 'pool' of cameras in use then that point should be standard on all cameras;
- the onset point should be close to full exposure but should warn before full burn out occurs;

 the zebra strip indicator should not obscure important picture information such as the face but it should indicate when flesh tones are in danger of going into overexposure.

Some UK zebra onset levels are 90–95% for RGB-driven systems and 68% for luminance systems, but the final limiting factor on exposure level is loss of detail, either to noise in the blacks or burn-out in the peak white clipper. Both losses are irrecoverable.

Establishing the zebra trigger value

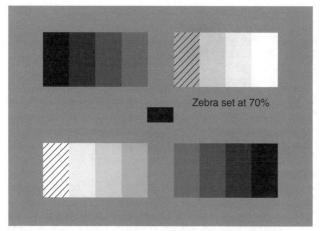

Using a properly lined-up and exposed camera on a grey scale will give a rough indication of how the zebra setting has been set up. The signal displayed on a waveform monitor will allow more accurate measurement. For example, with a zebra setting triggered by any part of the signal going above 70% (approximate reflectivity of the average Caucasian face tone) and 80%, the appropriate step wedge on the grey scale will display the diagonal pattern. On most cameras, the zebra setting can be adjusted to suit individual requirements.

Adjusting f-number

Controlling the light through the lens can be by aperture or ND filter. The f-number is defined as a ratio between focal length and the effective diameter of the lens aperture. The f-number is not an accurate indication of the speed of the lens because the f-number formula is based on the assumption that the lens transmits 100% of the incident light. Because of the variation in the number of elements in the lens and the variation in lens design, different lenses may have different transmittance. Two lenses with the same f-number may transmit different amounts of light to the prism block (see T-number, page 47).

White shirt - black suit

An everyday example of an exposure dilemma is the interviewee wearing a white nylon shirt and a black suit. If there is an attempt to expose for detail in the collar of the white shirt, the face tones will tend to look under-exposed and too dark. At the other end of the contrast range, exposing for the edge of lapel detail of the suit – black on black – will push the face tones up and make them look over-exposed.

Production requirements

It is easy to chase after the 'correct' exposure for a shot and lose sight of the purpose of the production. News and factual programmes have the fairly simple visual requirement of 'see it and hear it'. This usually requires a technique that produces a neutral record of the event with the least discernible influence of the cameraman's attitude to the material. The choice of exposure is based on the aim of providing the clearest possible image of the action. The 'correct' exposure in these circumstances is the one that produces clarity of image. Other programme genres have more diverse production aims. It is not simply a question of finding the 'correct' exposure but of finding an exposure that reflects a mood, emotion or feeling.

The appearance of the image has an important influence on how the audience reacts to the visual message. The choice of lens, camera position and framing play a crucial part in guiding that response. The choice of exposure and the resultant contrast of tones is another powerful way to guide the viewer's eye to the important parts of the frame.

The cameraman can manipulate contrast by the choice of exposure and gamma setting (see Gamma and linear matrix, page 96), to produce a range of different images such as:

- stark, contrasty pictures suggesting a brutal realism;
- pictures with no highlights or blacks simply a range of greys;
- low key pictures with a limited contrast range eliminating highlights;
- high key pictures with a limited contrast range but eliminating dark tones.

If the production is aiming at a subjective impression of its subject, then the choice of the style of the image will require a high degree of continuity. The viewer will become aware if one shot does not match and may invest the content of that shot with special significance as apparently attention has been drawn to it.

A television engineer may have a preference for pictures that have a peak white with no highlight crushing, a good black with shadow detail and an even spread of tones throughout the image. Along with other correct engineering specifications, this is often called a technically acceptable picture. Using a low contrast filter, flares and filling the shot with smoke may lift the blacks to dark grey, eliminate any peak white, cause highlights to bloom and definition to be reduced. It may also be the exact requirement for the shot at that particular production moment. Remember that the term broadcast quality comes from the engineering requirements for the video signal, not the way the picture looks. There are no hard-and-fast rules to be followed in the creative use of exposure. Although resultant images may lack sparkle because of low contrast and fail to use the full contrast range that television is capable of providing, if the pictures create the required mood, then the aims of the production have been satisfied.

Image enhancement and contour correction

As we have discussed, the resolution of the video image is partly limited by the CCD design (although this is continuously improving), and partly by the constraints of the video signal system. In most camera/recorder formats, image enhancement is used to improve picture quality. One technique is to raise the contrast at the dark-to-light and light-to-dark transitions, to make the edges of objects appear sharper, both horizontally and vertically. This is done electronically by overshooting the signal at the transition between different tones to improve the rendering of detail. This edge enhancement is often applied to high-frequency transitions and can be controlled by adjusting various processing circuits such as aperture correction, contour, detail correction, etc.

It is important to remember that the degree of artificial enhancement is controllable with for example, separate controls for vertical and horizontal enhancement. When overdone, artificial enhancement of picture resolution is often the main distinguishing characteristic between a video and a film image. Because an audience may connect this type of image quality with multicamera coverage of sport or actuality events, an electronic image is often paradoxically considered more realistic and credible. The amount of enhancement is a subjective value and will vary with production genre and production taste. It is difficult to remove image enhancement in post production although it may be added. In digital cameras, there are a number of 'edge enhancement' controls that can be adjusted through the menu. Each control alters a different aspect of the contrast transition detail in the image by adjusting the edges or outline which correspond to sharp changes in the video signal. Adjusting some controls produces very subtle changes and may only be noticeable with certain types of picture content.

Detail controls

- Aperture: this control boosts the finer detail in the image but without adding 'edge'.
- Overall master or detail level: controls detail through the image.
- Level dependent detail: adjusts detail enhancement dependent on luminance level.
- Crispening or noise coring: this control sets a threshold below which low
 contrast detail signals are cut off. Fine detail at all signal levels is gradually
 reduced, but edges between areas of large contrast are unaltered. With care,
 electronic noise can be reduced with little apparent reduction in image sharpness
 but if threshold is set too high, fine detail is lost and only coarse detail edges
 remain.
- Detail frequency: this control affects the width of edge enhancement around objects. Increasing the detail frequency value decreases the width of the edge enhancement.
- Detail white clip/detail black clip: edge enhancement is produced by over-shooting the signal at the transition between different luminance levels. The change in contrast produces signal 'spikes' which add an outline to part of the image. These 'spikes' can be clipped to limit their effect and prevent their effect from being too white (detail white clip control) or too black (detail black clip control). The very distinctive edgy 'video' look around high contrast transitions is often the result of the detail black clip setting.
- Skin tone detail: see page 103.

Face tones

A 'talking head' is probably the most common shot on television. Because the audience is usually more critical in their judgment of correct reproduction of skin tones, video pictures of faces are the most demanding in achieving correct exposure and usually require exposure levels that are high but are free from burn-out in highlight areas. The reflectivity of the human face varies enormously by reason of different skin pigments and make-up. In general, Caucasian face tones will tend to look right when a 'television white' of 60% reflectivity is exposed to give peak white. White nylon shirts, white cartridge paper and chrome plate for example have reflectivity of above 60 per cent, which is TV peak white. Without highlight compression, these materials would lack detail if the face was exposed correctly. Average Caucasian skin tones reflect about 36 per cent of the light. As a generalization, face tones are approximately one stop down on peak white. If a scene peak white is chosen that has a reflectivity of 100%, the face tones at 36% reflectivity would look rather dark. To 'lift' the face to a more acceptable level in the tonal range of the shot, a scene peak white of 60% reflectivity is preferable. This puts the face tone at approximately half this value or one stop down on the peak white.

Relationship between face tones and reflectance

Signal in millivolts	TV grey scale	% reflectivity	Typical surfaces	
700	TV White	60	White cloth	
			Newspaper	
	Light grey	40	Face tones	
476*		34	1 1	
		31	, p	
	Medium grey	20	Concrete	
		15	Blonde hair	
* Zebra setting of the 300 series cameras as delivered – 68% white Zebra setting of the 700 series as delivered – 70% peak white		7.5	Dark hair	
		4	Black paper	
		3		

Continuity of face tones

An important consideration when shooting the same face in different locations or lighting situations is to achieve some measure of continuity in face tones. There is a small amount of latitude in the colour temperature of light on a face. When white balanced to daylight sources (5500K), a 400K variation can be tolerated without being noticeable. There is a smaller latitude of colour temperature (150K) when white balanced to tungsten sources (3200K). As the viewer is unaware of the 'true' colour of the setting, a greater variation is acceptable in changes in colour temperature in this type of wide shot.

Continuity of face tone can be achieved if it is exposed to the same value in different shots. The problem comes with variation in background and a variation in what is chosen as peak white. For example, a person wearing dark clothing positioned beside a white marble fireplace in a panelled room in one shot could have an exposure that set the marble surround at or near peak white so that the face was one stop down on this with the surrounding panelling showing no detail. If a reverse shot was to follow of the same person now seen only against dark panelling, the exposure could be set to show detail in the panelling and 'lift' the picture but this would push the face to a lighter tone than the preceding shot. To maintain continuity of face tone the same exposure setting for the face would be needed as in the previous shot with no tone in the frame achieving peak white. It may be necessary to control or adjust the contrast range of the shot to preserve the priority of the face tone at an acceptable level. In the above example, a more acceptable picture would be to light the background panelling to a level that showed some detail and texture whilst maintaining face tone continuity.

Grey scale

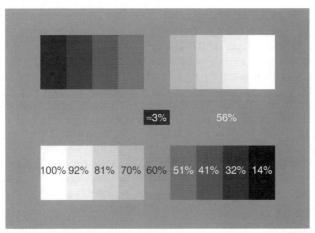

A 9-step wedge chart + a 'super black' in the centre hole. The peak white wedge has 60% reflectance. The wedge tones are graded as a % of peak white and form equal changes in signal output when displayed on a waveform monitor. The background tone is 56% of peak white representing a tone with 16% reflectivity. The wedges are displayed with a gamma correction of 0.4.

Gain, noise and sensitivity

Camera sensitivity is usually quoted by camera manufacturers with reference to four interlinking elements:

- 1 a subject with peak white reflectivity
- 2 scene illumination
- 3 f-number
- 4 signal-to-noise ratio for a stated signal.

It is usually expressed as being the resulting f-number when exposed to a peak white subject with 89.9% reflectance lit by 2000 lux quoting the signal/noise ratio. For most current digital cameras this is at least f8 or better with a signal/noise ratio of 60 dB. This standard rating is provided to allow different cameras' sensitivity to be compared and is not an indication of how much light or at what stop the camera should be used.

Noise

The sensitivity of the camera could be increased by simply greater amplification of weak signals but this degrades the picture by adding 'noise' generated by the camera circuits. The signal-to-noise ratio is usually measured without contour or gamma correction. As manufacturers vary in the way they state camera sensitivity, comparison between different models often requires a conversion of the specification figures. In general, with the same f-number, the higher the signal-to-noise ratio and the lower the scene illumination (lux), the more sensitive the camera.

Gain

The gain of the head amplifiers can be increased if insufficient light is available to adequately expose the picture. The amount of additional gain is calibrated in dBs. For example, switching in +6dB of gain is the equivalent of opening up the lens by one f-stop, which would double the amount of light available to the sensors. The precise amounts of switched gain available differ from camera to camera.

The 700 series digi-beta camera has a three position gain switch marked L (low), M (mid) and H (high). The value of each of these three gain positions can be set through the Master Gain page in the menu choosing from $-3\,dB$, $3\,dB$, $6\,dB$, $9\,dB$, $12\,dB$, $18\,dB$, $24\,dB$ or $30\,dB$. The factory setting is $0\,dB$, $9\,dB$ and $18\,dB$.

A negative gain setting (i.e. a reduction in gain) reduces noise and is a way of controlling depth of field without the use of filters. For example, an exposure is set for an aperture setting of f2.8 with 0 dB gain. If 3 dB of negative gain is switched in, the aperture will need to be opened to f2 to maintain correct exposure and therefore depth of field will be reduced.

Gain and stop comparison

- +3 dB is equivalent to opening up 0.5 stop
- +6 dB is equivalent to opening up 1 stop
- +9 dB is equivalent to opening up 1.5 stops

- +12 dB is equivalent to opening up 2 stops
- +18 dB is equivalent to opening up 3 stops
- +24 dB is equivalent to opening up 4 stops.

The extra gain in amplification is a corresponding decrease in the signal-tonoise ratio and therefore will increase the noise in the picture. For an important news story shot with insufficient light, this may be an acceptable trade-off.

Calculating the ASA equivalent for a video camera

A video broadcast camera/recorder with a good auto-exposure system is in effect a very reliable light meter. Most cameramen use a combination of manual exposure, instant auto-exposure and/or the zebra exposure indicator, but some cameramen with a film background often feel more comfortable using a light meter to check exposure level. In order to achieve this, the sensitivity of the camera requires an equivalent ASA rating which is logarithmic, e.g. doubling ASA numbers allows a decrease of 1 stop. There are several methods to determine the rating such as the following formula:

- The sensitivity of the video camera is quoted using a stated light level, signalto-noise level, a surface with a known reflectance value and with the shutter set at 1/50 (PAL working).
- Japanese camera manufacturers use a standard reflectance of 89.9% as peak white while UK television practice is to use a 60% reflectance value as peak white, therefore an illuminance level of 3000 lux must be used when transposing a rating of 2000 lux with 89.9% reflectance to 60% peak white working.

The formula below is for 60% reflectance, 1/50th shutter speed

$$ASA = \frac{(f \text{ number})^2 \times 1250 \text{ (a mathematical constant)}}{\text{illumination in ft candles}^*}$$

 $*(10.76 \, \text{lux} = 1 \, \text{foot candle} - 3000 \, \text{lux} / 10.76 = 278.81 \, \text{ft candles})$

Year on year video camera sensitivity has increased. In the last few years, a negative gain setting has begun to appear on cameras. Why not have the negative figure as 0 dB gain? One reason may be that manufacturers like to advertise their cameras as more sensitive than their competitors and a higher notional '0 dB' allows a smaller stop. Another suggestion, (see above) is that on a multi-camera shoot, lights can be set for a 0 dB exposure and thereafter, if a lower depth of field is required, negative gain be switched in and the iris opened without resorting to the use of an ND filter.

Image intensifiers

When shooting in very low light levels (e.g. moonlight) image intensifiers can be fitted between camera and lens to boost sensitivity. The resultant pictures lack contrast and colour but produce recognizable images for news or factual programmes.

Electronic shutters

The electronic shutter varies the length of the pulse that reads out the charge on the CCD. With the electronic shutter switched out, the PAL 'picture' exposure time is 1/50th second. The electronic shutter reduces this exposure time by switched steps, improving reproduction of motion but reducing sensitivity.

One complete frame of the standard PAL television signal is made up of two interlaced fields with a repetition rate of 50 fields per second (25 complete frames per second). The CCD scans the image 50 times a second which is the 'normal' shutter speed of a PAL video camera). CCDs can be adjusted to reduce the time taken to collect light from a field (see figure below), and reducing the length of the readout pulse is equivalent to reducing the shutter speed. This electronic shutter reduces the time the CCDs are exposed to the image by switched steps, improving reproduction of motion but reducing sensitivity.

Movement blur

The standard shutter speed (PAL) is set to 1/50th second. A fast-moving subject in front of the camera at this shutter speed will result in a blurred image due to the movement of the subject during the 1/50th of a second exposure. Reducing the time interval of exposure by increasing the electronic shutter speed improves the image definition of moving subjects and is therefore particularly useful when slow motion replay of sporting events is required. But reducing the time interval also reduces the amount of light captured by the CCD and therefore increasing shutter speed requires the aperture to be opened to compensate for the reduction in light.

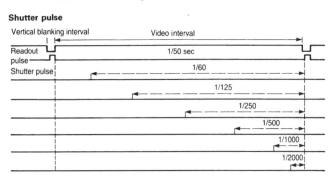

The shutter speed can be altered in discrete steps such as 1/60, 1/125, 1/500, 1/1000, 1/2000 of a second or – on some cameras – continuously varied in 0.5 Hz steps. Often, when shooting computer displays, black or white horizontal bands appear across the computer display. This is because the scanning frequencies of most computer displays differ from the (50 Hz) frequency of the TV system (PAL). Altering the shutter speed in discrete steps allows the camera exposure interval to precisely match the computer display

scanning frequency and reduce or even eliminate the horizontal banding. The Clear Scan system is in 157 steps within the range of 1/50.3 sec to 1/101.1 sec.

Shutter and relative stop loss

Shutter	F-number	Shutter	F-number	
1/50	1 =	1/500	Approx. 3 stops loss	
1/125	Approx. 1 stop loss	1/1000	Approx. 4 stops loss	
1/250	Approx. 2 stops loss	1/2000	Approx. 5 stops loss	

Pulsed light sources

In tungsten light sources, light is produced from the heating effect of an electric current flowing through the tungsten filament. The visible spectrum from these sources is continuous and produces a smooth transition of light output between adjacent wavelengths. The intensity of light output will vary if the current is altered (dimming), which also affects the colour temperature although this is usually kept to within acceptable limits.

A discharge light source produces light as a byproduct of an electrical discharge through a gas. The colour of the light is dependent on the particular mixture of gas present in the glass envelope or by the phosphor coating of the fluorescent tube. Discharge light sources that are designed for film and television lighting such as HMIs are not as stable as tungsten but have greater efficacy, are compact and produce light that approximates to daylight.

Fluorescent tubes, HMI discharge lamps and neon signs do not produce a constant light output but give short pulses of light at a frequency depending on the mains supply. Using a 625 PAL camera lit by 60 Hz mains fluorescent (e.g. when working away from the country of origin mains standard) will produce severe flicker. Some cameras are fitted with 1/60th shutter so that the exposure time is one full period of the lighting.

Normal eyesight does not register the high intensity blue and green spikes present in some fluorescent tubes but they give a bluish green cast to a tungsten-balanced camera. In recent years the development of improved phosphors has made the fluorescent tube (cold light) acceptable for television and film (see Cold light, page 174). Phosphors are available to provide tungsten matching and daylight matching colour temperatures.

Colour drift

If a high shutter speed is used with some types of fluorescent lighting, the duration of the pulsed red, green and blue parts of the light spectrum may not coincide with the 'shutter' open and a colour drift will be observed to cycle usually between blue and yellow. It can be eliminated by switching the shutter off. FT sensors have a mechanical shutter which cannot be switched off and therefore the problem will remain.

Time-lapse controls

Time lapse is a technique where at specified intervals the camera is programmed to make a brief exposure. Depending on the type of movement in the shot, the time interval and the time the camera is recording, movement which we may not be aware of in normal perceptual time is captured. The classic examples are a flower coming into bloom with petals unfolding, clouds racing across the sky, or car headlights along city streets at night shot from above, comet-tailing in complex stop/start patterns. Time lapse can also be used as an animation technique where objects are repositioned between each brief recording. When the recording is played at normal speed, the objects appear to be in motion. The movement will be smooth if sufficient number of exposures and the amount of movement between each shot has been carefully planned.

For most time-lapse sequences the camera is locked-off on its pan and tilt head for each shot although there are now specialist computer controlled heads often used in nature programmes, that pan or elevate the camera in predetermined movement to match the individual recorded shots. This produces a shot where the camera cranes or pans across a flowering shrub as the leaves form and blossom appears.

Duration

The crucial decisions when planning a time-lapse sequence are to estimate the duration of screen time required, how long the real-time event takes to complete the cycle that will be speeded up, and the duration between each discrete 'shot'. For example, do you shoot every minute, every hour, or once a day? These decisions will be influenced by the flexibility of the time lapse facility attached to the camera or the design of the camera in use and the subject. Some models will allow you to compile time-lapse sequences with shots lasting just an eighth of a second; others will only allow you to fit in three shots on each second of tape.

Another factor to consider is if the activity or change to be covered is linear or non-linear in time. The flowering of some plants is accelerated after sunrise and the flowers may close in response to the sun setting. The speed at which this happens will have to be timed in order to calculate if the interval between each recorded frame is linear or varied to match the non-linear activity in shot.

Another important element in deciding the interval between the recording of each frame is to determine how much movement detail will be observable with the chosen time-lapse setting. For example, a time interval between each recorded frame of an open air market could be chosen so that it was possible to see individual people moving at accelerated speed around the locked-off shot. If a longer time interval between each frame was chosen, the movement of people would simply be a blur. Time-lapse photography faces many of the same problems that animators solve in deciding the number of frames required to achieve smooth movement.

Time lapse - open air market

Sequence 1: Stall holders setting up (7.30am-8am)

Duration of activity - 30 minutes

Screen time duration - 5 seconds

5 second screen time consists of 125 frames

If 1 frame is exposed every 15 seconds the first 5-second sequence will cover a period of 125×0.25 minutes = 31 minutes and 15 seconds.

The time lapse would be set to bracket estimated time of deserted street through to trader activity.

(a) Early morning deserted street

(b) All traders open – customers have not arrived

Sequence 2: Busy market (8.45am-5pm)

Duration of activity - 6.25 hours

Screen time - 5 seconds

5 second screen time consists of 125 frames

If 1 frame is exposed every 3 minutes, the second 5-second sequence will cover a period of 125 \times 3 minutes = 6.25 hours.

The time lapse would be set to bracket estimated period of the beginning of trading through to no trade activity. If the speeded up activity was required at the same pace in each sequence, this sequence would bracket a representative 31 minutes 15 seconds trading duration during the day to expose 125 frames every 15 seconds.

(c) The first early shoppers

(d) The market street at peak capacity

Sequence 3: Early evening – market closing (5pm–5.30pm)

Duration of activity - 30 minutes

Screen time duration - 5 seconds

5 second screen time consists of 125 frames

If 1 frame is exposed every 15 seconds the third 5-second sequence will cover a period of 125×0.25 minutes = 31 minutes and 15 seconds.

The time lapse would be set to bracket estimated time of trader packing up through to deserted street.

The light level may well change within and between sequences and can be compensated by using auto-iris or, if the change in light is wanted, setting a compromise exposure to reveal the changing light levels.

Time code

Time code enables every recorded frame of video to be numbered. A number representing hours, minutes, seconds and frame (television signal) is recorded. There are 25 frames per second in the PAL TV signal and so the frame (PAL television signal) number will run from 1 to 25 and reset at the end of every second. In a continuous recording, for example, one frame may be numbered 01:12:45:22, with the following frame numbered 01:12:45:23. This allows precise identification of each frame when editing. The camera operator arranges, at the start of a shoot, the method of frame numbering by adjusting the time code controls, which are usually situated on the side of the camera on the video recorder part of the unit.

The choice is between numbering each frame with a consecutive number each time the camera records. This is called 'record run' time code. Alternatively, the camera's internal clock can be adjusted to coincide with the actual time of day and whenever a recording takes place, the time at that instant will be recoded against the frame. This is usually called 'time of day' or 'free run' recording. The decision on which type of time code to record will depend on editing and production requirements (see Time code and production, page 90).

Historically there have been two methods of recording this identification number:

- Longitudinal time code: Longitudinal time code (LTC) is recorded with a fixed head on a track reserved for time code. It can be decoded at normal playback speed and at fast forward or rewind but it can not be read unless the tape is moving as there is no replayed signal to be decoded.
- Vertical interval time code: Vertical interval time code (VITC) numbers are time-compressed to fit the duration of one TV line and recorded as a pseudo video signal on one of the unused lines between frames. Although they are factory set, if needed, some cameras can be adjusted to insert VITC on two non-consecutive lines. Unlike longitudinal time code, VITC time code is recorded as a pseudo TV signal and can be read in still mode, which is often required when editing. Longitudinal time code is useful when previewing the tape at speed. For editing purposes, the two time code recording methods have complemented each other.

Code word

Every frame contains an 80-bit code word that contains 'time bits' (eight decimal numbers) recording hours, minutes, seconds, frames and other digital synchronizing information. All this is updated every frame but there is room for additional 'user bit' information.

User bit allows up to nine numbers and an A to F code to be programmed into the code word, which is recorded every frame. Unlike the 'time bits', the user

bits remain unchanged until re-programmed. They can be used to identify production, cameraman, etc.

Time code tracks on Beta tape

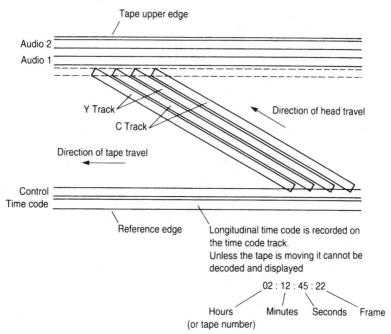

CTL: Control track

This is a linear track recorded on the edge of the tape at frame frequency as a reference pulse for the running speed of the replay VTR. It provides data for a frame counter and can be displayed on the camera's LCD (liquid crystal display). It is important for editing purposes that the recorded cassette has a continuous control track and it is customary to reset to zero at the start of each tape.

When CTL is selected to be displayed, the number signifying hours, minutes, seconds and frames are a translation of the reference pulse into a convenient method of displaying tape-elapsed time. Although equivalent, this time is not a readout of the recorded time code and if CTL is reset to zero in mid-cassette and the tape rewound, the displayed numbers would count backwards with a minus sign. One of the main purposes of striping a tape for editing purposes is to record a continuous control track (see Camerawork and editing, page 148). Also be aware that if CTL is selected in mid-cassette and the Reset button is depressed, the control track will reset to zero and will no longer indicate tape-elapsed time.

Time code and production

Time code is an essential tool for editing a programme. If a shot log has been compiled on acquisition or in post-production review, the time code identifies which shots are preselected and structures off-line editing. There are two types of time code available to accommodate the great diversity in programme content and production methods. The cameraman should establish at the start of the shoot which method is required.

Record run: Record run only records a frame identification when the camera is recording. The time code is set to zero at the start of the day's operation and a continuous record is produced on each tape covering all takes. It is customary practice to record the tape number in place of the hour section on the time code. For example, the first cassette of the day would start 01.00.00.00 and the second cassette would start 02.00.00.00. Record run is the preferred method of recording time code on most productions.

Free run: In free run, the time code is set to the actual time of day and when synchronized is set to run continuously. Whether the camera is recording or not, the internal clock will continue to operate. When the camera is recording, the actual time of day will be recorded on each frame. This mode of operation is useful in editing when covering day-long events such as conferences or sport. Any significant action can be logged by time as it occurs and can subsequently be quickly found by reference to the time of day code on the recording. In free run (time of day), a change in shot will produce a gap in time code proportional to the amount of time that elapsed between actual recordings. Discontinuous time code numbers can cause problems when using an edit controller.

Shot logging

An accurate log of each shot (also known as a dope sheet) with details of content and start and finish time code is invaluable at the editing stage and pre-editing stage. It requires whoever is keeping the record (usually a PA production assistant) to have visual access to the LCD display on the rear of the camera. As the time code readout is often situated behind the cameraman's head, it is often difficult for the PA to read, although the Hold button will freeze the LCD readout without stopping the time code. There are a number of repeat time code readers which are either attached to the camera in a more accessible position, or fed by a cable from the time code output socket away from the camera or fed by a radio transmitter which eliminates trailing cables. A less precise technique is sometimes practised when using time of day time code. This requires the camera and the PA's stopwatch to be synchronized to precisely the same time of day and the beginning of the shoot. The PA can then refer to her stopwatch to record time code shot details. It is not frame accurate and requires occasional synchronizing checks between camera and watch with the watch being adjusted if there has been drift.

Setting time code (700 series Digi-Beta cameras)

- If you are using time and user bits, set user bits first as time code will stop while user bits are set.
- Time code range for PAL is 00:00:00:00-23:59:59:24.
- Time code range for NTSC is 00:00:00:00-23:59:59:29.

Record run (time code only advances when the tape is recording)

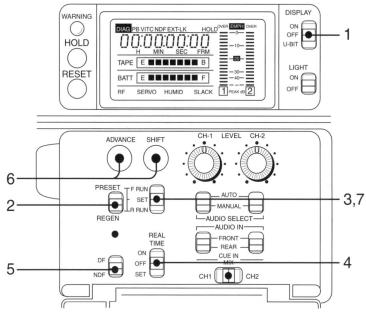

- 1 DISPLAY switch to TC.
- 2 Set the PRESET/REGEN switch to SET.
- 3 Set the F-RUN/R-RUN to SET.
- 4 Set the REAL TIME switch to OFF.
- 5 Switch to NDF for PAL operation. Switch to DF for NTSC operation.
- 6 If you wish to use the hour digit to identify each tape (e.g. 1 hour equals first tape, 2 hours equals second tape etc.), set the hour time code with the SHIFT & ADVANCE buttons.
 - SHIFT: Press to make the hour digit blink
 - ADVANCE: Press to increase the value of the blinking digit by one unit to equal the cassette tape in use.
- 7 Set the F-RUN/R-RUN to R-RUN (record run).
 - If you need to operate with real-time time code, set the time of day with the SHIFT & ADVANCE buttons until the time code reads a minute or so ahead of actual time. When real time equals time code 'time' switch to F-RUN and check that time code counter is increasing in sync with 'real' time.

If the time code is set to record run and the cassette is removed from the camera and then reinserted, time code will not be continuous unless you switch to REGEN on replacing the tape, rewind and find the point at which you want the next recording to start. Press RET on the lens which will read the previous recorded time code and then synchronize the new time code to follow on consecutively.

Time code lock

So far we have discussed setting the time code in one camera but there are many occasions when two or more camcorders are on the same shoot. If each camera simply recorded its own time code there would be problems in editing when identifying and synchronizing shots to intercut. The basic way of ensuring the time code is synchronized in all cameras in use is by cables connected between the TC OUT socket on the 'master' camera to the TC IN socket on the 'slave' camera. Another cable is then connected to the TC OUT of the first 'slave' camera and then connected to the TC IN of the second 'slave' camera and so on although in a multi-camera shoot, it is preferable to genlock all the cameras to a central master sync pulse generator. This is essential if, as well as each camera recording its own output, a mixed output selected from all cameras is also recorded.

The TC OUT socket provides a feed of the time code generated by the camera regardless of what is displayed on the LCD window. A number of cameras can be linked in this way but with the limitation of always maintaining the 'umbilical' cord of the interconnecting cables. They must all share the same method of time code (i.e. free run or record run) with one camera generating the 'master' time code and the other cameras locked to this. The procedure is:

- · Cable between cameras as above.
- Switch on the cameras and select F-Run (free run) on the 'slave' cameras.
- Select SET on the 'master' camera and enter the required time code information, (e.g. zero the display if that is the production requirement). Then switch to record-run and begin recording.
- In turn start recording on the first slave camera, and then the second and so
 on. Although recording can start in any order on the 'slave' cameras, the
 above sequence routine can identify any faulty (or misconnected!)
 cables.
- All the cameras should now display the same time code. Check by audibly counting down the seconds on the 'master' whilst the other cameramen check their individual time code readout.
- During any stop/start recordings, the 'master' camera must always run to record before the 'slave' cameras. If there are a number of recording sessions, the synchronization of the time code should periodically be confirmed.

Often it is not practical and severely restricting to remain cable connected and the cameras will need to select free-run after the above synchronization. Some cameras will drift overtime but at least this gives some indication of the time of recording without providing 'frame' accurate time code. Alternatively, a method known as 'jam synch' provides for a 'rough' synchronization over time with out cables.

Jam sync

The set-up procedure is:

- From the 'master' TC OUT socket connect a BNC cable to the 'slave' TC IN.
- Power up the cameras and select free-run on the 'slave' camera.
- On the 'master' camera select SET and enter 'time of day' some seconds ahead of the actual time of day.
- When actual time coincides with LCD display switch to free-run.
- If both cameras display the same time code, disconnect the cable.
- Because of camera drift, the above synchronization procedure will need to be repeated whenever practical to ensure continuity of time code accuracy.

Pseudo jam sync

Pseudo jam synch is the least accurate time code lock, but often pressed into service as a last resort if a BNC cable is damaged and will not work. The same time of day in advance of actual time of day is entered into all cameras (with no cable connections), and with one person counting down from their watch, when actual time of the day is reached, all cameras are simultaneously (hopefully) switched to F-run. This is obviously not frame accurate and the time code error between cameras is liable to increase during the shoot.

Reviewing footage

Broadcast camcorders are equipped with a memory, powered by a small internal battery similar to the computer eprom battery. It will retain some operational values for several days or more. There should be no loss of time code when changing the external battery but precautions need to be taken if the cassette is rewound to review recorded footage or the cassette is removed from the camera and then reinserted (see Setting time code, page 91).

Battery changes when time code locked

A battery change on the 'master' camera requires all cameras to stop recording if synchronous time code is an essential production requirement. A battery change on a 'slave' camera may affect any camera that is being supplied by its time code feed. If synchronous time code is critical, either all cameras use mains adaptors if possible, or arrange that a battery change occurs on a recording break at the same time on all cameras. Check time code after powering up.

Mini DV cameras

Note that DV time code circuitry is less sophisticated than many broadcast formats and may not be equipped with a regen facility. If a cassette is parked on blank tape in mid-reel, the camera assumes that it is a new reel and resets the time code to 00:00:00. There may not be an edit search/return facility and so after reviewing footage, park the tape on picture of the last recorded material and leave an overlap for the time code to pickup and ensure continuous time code. In all formats after rewinding and reviewing shots, inserting a partially used cassette, changing batteries or switching power off, use edit search/return facility to check at what point the tape is parked. Reset time code and zero CTL as required.

Menus

In nearly all digital camera/recorder formats, all the electronic variables on the camera can be stored as digital values in a memory. These values can be recalled as required or saved on a removable storage file.

Access to the current settings of the electronic values is by way of menus, which are displayed, when required, on the viewfinder screen. These menus are accessed by using the menu switch on the camera. Movement around the menus is by button or toggle switch that identifies which camera variable is currently selected. When the menu system is first accessed, the operation menu pages are usually displayed. A special combination of the menu controls allows access to the user menu, which, in turn, provides access to the other menus depending on whether or not they have been unlocked for adjustment. Normally only those variables associated with routine recording (e.g. gain, shutter etc.) are instantly available. Seldom used items can be deleted from the user menu to leave only those menu pages essential to the required set-up procedure. Menu pages are also available on the video outputs.

The values that can be adjusted are grouped under appropriate headings listed in a master menu. A typical set of sub-menus would provide adjustment to:

Operational values: The items in this set of menus are used to change the camera settings to suit differing shooting conditions under normal camera operations. They would normally include menu pages which can alter viewfinder display, viewfinder marker aids such as safety zone and centre mark etc., gain, shutter selection, iris, format switching, monitor out, auto-iris, auto-knee, auto set-up, diagnosis.

Scene file: These can be programmed to memorize a set of operational values customized for a specific camera set-up and read to a removable file.

Video signal processing: This menu contains items for defining adjustments to the image (e.g. gamma, master black level, contour correction etc.) and require the aid of a waveform monitor or other output device to monitor the change in settings.

Engineering: The engineering menu provides access to all of the camera setup parameters, but only selected parameters can be accessed in the master menu to avoid accidental changes to the settings.

Maintenance: This menu is mainly for initial set-up and periodic maintenance, and normally not available via the master menu.

Reference file (or system configuration): This file contains factory settings or initial customization of reference settings to meet the requirements of different users. It is the status quo setting for a standard operational condition. This menu is not usually accessible via the master menu and should never be adjusted on location except by qualified service personnel. Never try to adjust camera controls if you are unsure of their effect and if you have no way of returning the camera set-up to a standard operational condition.

Scene files

Scene files are used for the reproduction of camera adjustment values once created by the operator. Camera adjustment data such as master pedestal, gamma, detail level, knee point, iris, and camera gain can be stored for a number of types of shooting conditions. The memorized values of a scene can easily be recalled by inserting the corresponding scene file into the camera.

Scene files are effective when the camera is used in different shooting conditions. The operator can instantly reproduce the previously adjusted camera data created for scenes taken outdoor, indoor, or under other lighting conditions.

Each camera is supplied with one card but additional cards can be obtained. A useful procedure is:

- 1 The supplied card should be used to store the factory settings of the camera's operational parameters before the first operational use of the camera. This card should be labelled STANDARD or DEFAULT settings.
- 2 First menu page reads the set-up card.
- 3 Each regular user should have his/her personal set-up card with their preferred operational settings.
- 4 Once a camera has been programmed by a set-up card the settings remain in force until overridden either by the menu or another set-up card.
- 5 A camera with many users can obtain default settings with the original card.
- 6 Usually the card can be inserted with power on or off.
- 7 Frequently the card is inserted with the company logo facing outwards.
- 8 The pins of the cards should not be touched.
- 9 The card should stored and safeguarded against the normal hazards that computer files are protected against.

Menu controls on the Digital Betacam DVW-700P

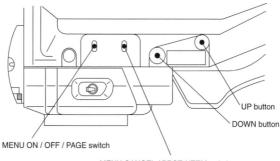

MENU CANCEL / PRST / ITEM switch

Gamma and linear matrix

Although the look of an image can be adjusted at the time of acquisition (see Customizing the image, page 98) or in post production, the picture the viewer will finally see depends on the characteristics of their TV set. The cathode ray display tube, however, has certain limitations. The television image is created by a stream of electrons bombarding a phosphor coating on the inside face of the display tube. The rate of change of this beam and therefore the change in picture brightness does not rise linearly, in-step with changes in the signal level corresponding to the changes in the original image brightness variations.

Gamma correction

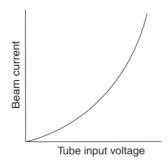

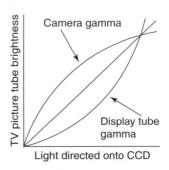

(a) Gamma due to tube characteristic

(b) Gamma correction

As shown in graph (a) the beam current, when plotted against the input voltage, rises in an exponential curve. This means that dark parts of the signal will appear on the tube face much darker than they actually are, and bright parts of the signal will appear much brighter than they should be. The overall aim of the television system is to reproduce accurately the original image and therefore some type of correction needs to be introduced to compensate for the nonlinear effect of the cathode ray tube beam. The relationship between the input brightness ratios and the output brightness ratios is termed the gamma of the overall system. To achieve a gamma of 1 (i.e. a linear relationship between the original and the displayed image - a straight line in graph (b)) a correcting signal in the camera must be applied to compensate for the distortion created at the display tube. Uncorrected, the gamma exponent of the TV system caused by the display tube characteristics is about 2.4. Thus the camera's gamma to compensate for the non-linearity of the TV system is about 0.44/0.45. This brings an overall gamma of approximately 1.1 (2.4 × 0.45) slightly above a linear relationship to compensate for the effect of the ambient light falling on the viewer's display tube. There is the facility to alter the amount of gamma correction in the camera for production purposes. The application of gamma correction to the signal in the camera also helps to reduce noise in the blacks. Some cameras have a multi matrix facility, which allows a user to select a small part of the colour spectrum and adjust its hue and saturation without affecting the rest of the picture.

Linear matrix

As detailed on page 12, all hues in the visible spectrum can be matched by the mixture of the three colours, red, green and blue. In the ideal spectrum characteristics of these colours, blue contains a small proportion of red and a small negative proportion of green. Green contains a spectral response of negative proportions of both blue and red. It is not optically possible to produce negative light in the camera but these negative light values cannot be ignored if faithful colour reproduction is to be achieved. The linear matrix circuit in the camera compensates for these values by electronically generating and adding signals corresponding to the negative spectral response to the R, G and B video signals. This circuit is placed before the gamma correction so that compensation does not vary due to the amount of gamma correction.

Matrix

The values chosen for the linear matrix determine the colour relationships and opinions of what the mix of RBG should be varies depending on which images need to be optimally presented by the broadcaster. Usually broadcast organizations choose the skin tones of presenters as the basis for the choice of matrix values. As the exact value of skin tones differ from country to country, each region has its own preferred rendering of skin-tone values, resulting in large variations amongst broadcast organizations. Digital cameras have a range of user-selectable possible matrices.

		EBU			SKIN	
	RED	GREEN	BLUE	RED	GREEN	BLUE
RED	1.22	-0.18	-0.04	1.1	-0.07	-0.03
GREEN	-0.05	1.11	-0.06	-0.04	1.15	-0.11
BLUE	0	-0.33	1.33	0	-0.2	1.2
						745
		BBC			RAI	
RED	0.89	0.04	-0.15	1.22	-0.18	-0.04
GREEN	-0.1	0.99	0.11	-0.05	1.14	-0.09
BLUE	-0.01	-0.21	1.22	0	-0.18	1

The table shows the different colour matrices chosen by the European Broadcast Union, the BBC (UK), RAI (Italy) and a standard camera matrix. The reds in the RAI choice are more brilliantly rendered than those of the others. The BBC matrix tends to produce softer colour rendition, whilst the EBU matrix is constructed to minimize the objective colour differences between a broad range of colours.

Customizing the image

From its early days, the development of television technology has been a constant quest to design equipment that would accurately reproduce the colour and contrast range of the subject in shot. For many years, video picture making avoided any technique that 'degraded' the image, i.e. altered the fidelity of the electronic reproduction. The aim was to light and expose for the full range of the video signal and transmit pictures which had good blacks, detail in the highlights, and with the highest resolution the TV system was capable of providing, particularly to viewers receiving pictures in poor reception areas. The technical constraints on both contrast range and resolution were the regulations governing the rationing of bandwidth. Attempts to improve resolution were made by adding enhancement which gave video pictures their characteristic 'edge' appearance on dark-to-light and light-to-dark tonal transitions.

Alongside the engineering 'sanctity' of faithful reproduction was the production methods of an industry that had to provide endless hours of live and recorded programming. The majority of such programmes were topical, instantly consumed and therefore had budgets to match the endless appetite of 24 hour television. Very fast shooting schedules and low budget production methods were added to the edgy, low contrast stereotypical TV image displayed on small sets watched in conditions of high ambient light.

Other conventions

In addition to the need for faithful reproduction, photographers have often attempted to customize the image to suit a particular emotional or aesthetic effect. In their hands the camera was not a 'scientific' instrument faithfully observing reality, but the means of creating a subjective impression. Up to the introduction of digital television, this technique, practised for many decades in film, had made little impact on television programme making. Either production content was unsuitable for subjective images or the degree that an analogue signal could be customized to express mood or atmosphere was limited by the needs of terrestrial broadcasting.

Digital video production provides the potential for manipulating the appearance of the image in post production, but there are also the opportunities, when appropriate, to refashion the recorded image at the time of acquisition. Digital signal processing allows data to be easily manipulated and settings memorized. This ensures continuity of image appearance over production days and location. In nearly all digital camera/recorder formats, all the electronic variables on the camera can be stored as digital values in a memory and can be controlled via menu screens displayed in the viewfinder. These values can be recalled as required or saved on a removable storage file. This provides for greater operational flexibility in customizing images compared to analogue work. Menus therefore provide for a greater range of control with the means to memorize a specific range of settings.

Default setting

With the opportunity to make adjustments that crucially affect the appearance of the image (e.g. gamma, matrix, etc.) it is obviously necessary that the only controls that are adjusted are ones the cameraman is familiar with. As the old cliché goes, if it ain't broke don't fix it. If you have the time and are not under recording pressure, each control can be tweaked in turn and its effect on the picture monitored. This may be a valuable learning experience that will help you customize an image should a special requirement occur. There is obviously the need to get the camera back to square one after experimenting. Fortunately there is a safety net of a factory setting or default set of values that if inadvertently (or not) a parameter is misaligned and the image becomes unusable, the default setting can be selected and the camera is returned to a standard mode of operation.

The effect of altering some menu items can be subtle and very difficult to assess using the camera viewfinder. When experimenting with different settings, use a high quality, correctly set up monitor in good viewing conditions to determine the effect on the image. Before experimenting, start by selecting the default setting on all controls to avoid interaction from other 'adjusted' levels.

The three main groups of picture control through the menu are:

- 1 Menu items that alter the transfer relationship between subject luminance and the resultant video signal (see Contrast range, page 66; Electronic contrast control, page 72; Gamma and linear matrix, page 96, etc.).
- 2 Menu items that alter the amount and application of enhanced electronic detail to different areas of the electronic image (see Production requirements, page 78).
- 3 Menu items that alter the depiction of colour. These include matrix (see page 96), white balance shift, which warms up or cools the overall image (see also Colour and mood, page 180), and saturation, which controls colour intensity.

Customizing by technique

As well as technological ways of creating the required image, lighting technique and choice of lens and filter also have a powerful effect on image appearance. As the American cinematographer Don Burgess, working on a low budget film suggested, 'We used a lot of long lenses, smoke, and nets. That's the best, maybe the only, way to make no money look interesting. You discount the background, focus on a long lens, and isolate the subject' (*Contemporary Cinematographers on their Art*, Pauline B. Rogers, Focal Press, Boston). Ingenuity, experience and sometimes a lucky accident are all crucial in achieving the 'look' that suits the subject.

Effects filters

One of the oldest methods of customizing the image is in the use of filters usually placed in a filter holder/matte box positioned in front of the lens. These are used for various reasons such as to control light, contrast or part of the subject brightness, to soften the image or to colour the image. Most camcorders also have one or two filter wheels fitted between lens and prism block carrying colour correction filters and/or neutral density filters.

Altering the appearance of the image

Filters fall into three main groups — colour correction filters, neutral density filters (used as a control in exposure), effects and polarizing filters. They all alter the quality of light reaching the CCDs, but whereas the first two groups attempt to invisibly make the correction, effects filters are intended to be visually obvious in their impact on the appearance of the image. They are employed to change the standard electronic depiction of a subject. Filters can be chosen to bring about a number of visual changes including reduction in picture sharpness, a reduction in picture contrast, lightning or 'lifting' blacks, to induce highlight effects such as halos or starbursts and to modify the rendition of skin tones. Many of these effects are not reversible in post production although improvement in picture matching can be attempted.

Factors that affect the filter influence

Many of the effects filters such as black and white dot, frosts, nets, fog, soft and low contrast achieve their results by introducing a varying degree of flare. The potential influence on the picture is identified by a grading effects filter on a scale of 1 to 5 where 1 has the smallest effect and 5 has the largest. Some filters are also available in smaller, more subtle increments and are graded as 1/8, 1/4 or 1/2. Choosing which grade and which filter to use is dependent on the shot, lens angle, aperture and the effects of underor over-exposure. In general, effects filters work more effectively on a longer lens and wider apertures (e.g. f2.0 and f2.8). To ensure continuity of image over a long sequence of shots it may be necessary to vary the grade of filter depending on lens angle, camera distance and aperture. It is prudent to carry out a series of tests varying the above settings before production commences. Filters mounted on the front of the lens are affected by stray light and flares which can add to the degradation.

Filters that affect the blacks in an image

A strong black makes a picture appear to have more definition and contrast. Diffusion filters reduce the density of blacks by dispersing light into the blacks of an image. This effectively reduces the overall contrast and creates an apparent reduction in sharpness. White nets provide a substantial reduction in the black density and whites or any overexposed areas of the image tend to bloom. If stockings are used stretched across the lens hood,

the higher their denier number (mesh size) the stronger the diffusion. A fog filter reduces black density, contrast and saturation. The lighter parts of the scene will appear to have a greater fog effect than the shadows creating halos around lights. A double fog filter does not double the fog effect and possibly creates less of a fog than the standard fog filter, but does create a glow around highlights. Because of lightening of the blacks, the picture may appear to be over-exposed and the exposure should be adjusted to maximize the intended effect. Low contrast filters reduce contrast by lightening blacks and thereby reducing the overall contrast. Strong blacks appear to give the image more definition and low contrast filters may appear soft. They are sometimes employed to modify the effects of strong sunlight. Soft contrast filters reduce contrast by pulling down the highlights. Because blacks are less affected, soft contrast filters appear sharper than low contrast filters and do not create halation around lights. As highlights are reduced the picture may appear under-exposed.

Effect on highlights

Some filters cause points of light, highlights or flare to have a diffused glow around the light source. The black dot filter limits this diffusion to areas around the highlights and avoids spreading into the blacks. Super frosts, black frosts, promist, black promists and double mists diffusion work best on strong specular light or white objects against a dark background. The weak grades leave the blacks unaffected providing an apparent sharp image whilst the strong grades cause a haze over the whole image, which leaks into the black areas of the picture. Black, white and coloured nets have a fine mesh pattern causing a softening of the image and a reduction in the purity and intensity of the image's colour. This 'desaturated' look is thought by some to give video images more of a film appearance.

- Neutral density filters: These reduce the amount of light reaching the lens and can be used to produce a specific f-number and therefore depth of field.
- Polarizing filters: These reduce reflections and glare, darken blue skies and increase colour saturation. They are useful in eliminating reflections in glass such as shop windows, cars and shooting into water. The filter must be rotated until the maximum reduction of unwanted reflection is achieved. This changes the colour balance (e.g. can affect the 'green' of grass) so a white balance should be carried out when correct filter position has been determined. Moving the camera (panning or titling) once the polarizing filter is aligned may reduce or eliminate the polarizing effect.
- Star and sunburst filters: These produce flare lines or 'stars' from highlights. Star filters are cross hatched to produce 2, 4, 6, 8 or 10 points whilst sunburst produce any number of points. They are more effective when placed between lens and prism block and can produce an unwanted degradation of definition when in front of the lens.

Scene files

A scene file is a method of recording the operational settings on a digital camera. In use it is like a floppy disk on a computer and can be removed from the camera with the stored values and then, when required, loaded back into the camera to provide the memorized values. The operational variables on a camera such as filter position, white balance, gain, speed of response of auto-exposure, shutter speed, electronic contrast control, the slope of the transfer characteristic (gamma), and its shape at the lower end (black stretch) or the upper end (highlight handling and compression), and the matrix, all affect the appearance of the image. The same shot can change radically when different settings of several or many of the above variables are reconfigured. If for production reasons these variables have been adjusted differently from their standard settings (e.g. a white balance arranged to deliberately warm-up the colour response), it may be necessary, for picture continuity, to replicate the customized appearance over a number of shots recorded at different locations, or on different days. The scene file allows an accurate record to be kept of a specific set of operational instructions.

An additional useful feature of a removable record of a camera set-up occurs when a number of cameras (of the same model) are individually recording the same event and their shots will be edited together. Normal multi-camera coverage provides for each camera's output to be monitored, matched and adjusted before recording or transmission. Individual camcorders, if they are not aligned, could produce very noticeable mismatched pictures when intercut. To avoid this, all cameras can be configured to the same set-up values by transferring a file card and adjusting each camera with the same stored values. A file card can be compiled, for example, that allows an instant set-up when moving between location and a tungsten lit studio.

Programming the camera

The flexibility of memorized values has led to the creation of a range of software cards for specific makes of cameras which provide a set 'look' instantly. Among the choices available, for example, are sepia, night scenes or the soft image of film. Other cards produce a warm ambience or a colder feeling atmosphere. Scene files that duplicate the appearance of front-of-lens filters are also available and these electronic 'gels' provide a quick way of adding an effect. There are also pre-programmed scene files that help to 'normalize' difficult lighting conditions such as shooting under fluorescent lighting or scenes with extreme contrast. Low contrast images can also be produced with the option to selectively control contours in areas of skin, offering more flattering rendition of close-ups. Fundamentally altering the look of an image at the time of acquisition is often irreversible and unless there is the opportunity to monitor the pictures on a high grade monitor in good viewing conditions, it may be prudent to leave the more radical visual effects to post production.

Black level

Blanking level is a fixed point of the standard television signal (see Fig. 2, page 11). Any black in the image can be raised or lifted above this point so that it is presented as dark grey. Conversely any dark grey can be sat down to this level so that it appears black. The signal blanking level never operationally changes but the black level of an image can be adjusted. A small adjustment of black level has a powerful effect on the picture. Reducing black level may lose shadow detail, which is non-recoverable. Dark greys are 'crushed' into black. Lifting black level will make 'black' appear dark grey and the image may appear to lose definition and contrast. Colour saturation is also affected and is decreased by selecting a higher black level and increased when 'sitting' the picture to a lower black level. If black level needs to be altered for production purposes, it is better to do this away from location in post production using a Grade A monitor where the appropriate setting for a specific shot or shots can be chosen from different black level settings.

Graduated filters

These can help to control bright skies by having a graduated neutral density from the top to clear filter at the bottom. The graduation can be obtained as a hard or a soft transition. There are also filters with a graduated tint to colour skies or the top part of the frame. They are positioned in the matte box for optimum effect but once adjusted the camera can rarely be tilted or panned on shot without disclosing the filter position.

Detail enhancement and skin tone detail

The degree of electronic manipulation of edge detail is variable but one limiting factor in the amount of enhancement that can be used is the adverse effect on faces. When pictures are 'over-contoured' skin detail can appear intrusive and unnatural; every imperfection is enhanced and becomes noticeable.

To overcome this problem, some cameras provide for selective reduction in skin detail to soften the appearance of faces. While variable electronic 'sharpening' or image enhancement may be applied to the overall shot, skin tone detail control allows for the separate handling of the specific degree of enhancement on any selected facial tones within that scene.

This is achieved by a circuit that separates facial skin colour from all other colours in a given shot, and its electronic detail level can be reduced without affecting other areas of the picture. The specific skin colour to be treated in this way is selectable and can be memorized to follow movement or recalled for subsequent shots. Some cameras have as many as three independent skin tone detail circuits.

The 'film' look

A cinema screen is a highly reflective surface and the audience watch the giant projected images in a darkened auditorium. A television set is a small light box that emits its picture usually into a well-lit room often provided by high intensity daylight. The initial brightness ratio between black and white tones of a subject before a video camera often exceeds the dynamic range of any display monitor. This problem is exacerbated (because of the regulations imposed on the design of the transmission path), by a lower contrast ratio handling ability than is theoretically possible and because television is viewed in less than favourable lighting conditions.

These are simply the differences in viewing conditions between film and video. There are also a number of inherent differences in technology and technique. When film is recorded on 35mm emulsion it can achieve (if desired) a much higher resolution and contrast range (e.g. some film negative can handle 1000:1) than is possible with standard video broadcasting. Video systems such as 24P 1080 lines are attempting to provide a transparent match between film and video but to date, HDTV systems are making slow progress with consumers.

Two of the key distinctions between film and video are the use of detail enhancement in video to compensate for lower resolution compared to film and video's handling of highlights and overloads. Digital acquisition and processing allows more selective and subtle control of detail enhancement and CCDs with 600,000 pixels have such good resolution they hardly need contour correction. Digital acquisition allows manipulation of the soft shoulder of the video transfer characteristic to mimic the D log E (density versus the logarithm of exposure) curve of a film negative transfer characteristic. Digital video acquisition also allows the manipulation of gamma and linear matrix to customize the image. A 'non-video' look is attempted by techniques such as adjusting aperture correction, contour, auto knee, gamma, detail correction and limited depth of field.

Although the artificial knee built into the transfer characteristic is useful in compressing highlights and therefore extending the video contrast range, video images often display exaggerated detail in highlight areas, most noticeably, for example, in background window frames in interior shots producing ugly 'electronic' edges. Knee aperture adjusts the level of detail added to the contrast changes in the highlight area above the knee point. A reduction of detail in the highlights using the knee aperture control can achieve a less obtrusive edge transition similar to that obtainable with film.

There are many attempts by video to imitate the film look. But which film? There are endless variations of style in the history of film making and contemporary fashion often dictates the 'look' at any particular time. Possibly there is a misunderstanding about the so called 'film look' and the standard video 'look' that ignores the link between production budget and working techniques. Many feature films made for cinema release have a much larger budget than a video programme made for one or two transmissions. Money and

customary film-making conventions, for example, allow a production technique that spends time staging action for a prime lens camera position developing a shot that is precisely lit, framed and with camera movement that is perfect or there is a retake. The stereotype multi-camera video production usually has 'compromise' written all over it basically because television requires 24 hours to be filled day on day across a wide range of channels in the most cost-effective way possible. The 'look' of film may be more about the techniques of acquisition than the technology of acquisition.

Follow focus rig

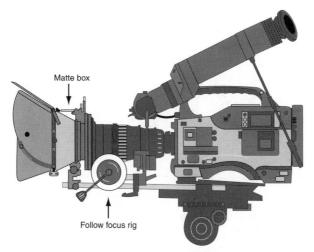

A follow focus rig is attached to the focus ring on the lens to provide controlled manual movement of focus. It usually consists of support bars that are fastened to the base of the camera and a hand-wheel with marker scale. The hand-wheel on the lens can be replaced by a remote control Bowden cable.

The focus rig may have interchangeable pitch gears (0.5 mm, 0.6 mm and 0.8 mm) to match the lens model. Also the support bars must be designed or be adjustable to the particular combination of lens and camera in use to correctly position the rig to the lens focus ring.

Matte box

A matte box is an adjustable bellows supported on bars attached to the camera and is used in front of the lens as a flexible lens hood to eliminate flares and unwanted light and to hold and position front of lens filters. There is usually one large pivoting ray shield (French flag) and two or more filter holders, one of which is rotatable so that polarizing filters can be positioned.

There are 3×3 (3 in or 75 mm square) or 4×4 (4 in or 100 mm square) filters available for camcorder lenses but the choice will be governed by the focal length range of the lens and whether the filter holder comes into shot on the widest angle. Some lenses have a moving front element when focused. Check for clearance between filter and lens at all points of focus when attaching a matte box.

Aspect ratio

At the same moment that we perceive the identity of an object within a frame, we are also aware of the spatial relationship between the object and the frame. These frame 'fields of forces' exert pressure on the objects contained within the frame and all adjustment to the composition of a group of visual elements will be arranged with reference to these pressures. Different placement of the subject within the frame's 'field of forces' can therefore induce a perceptual feeling of equilibrium, of motion or of ambiguity.

A field of forces can be plotted, which plots the position of rest or balance (centre and midpoint on the diagonal between corner and centre) and positions of ambiguity(?) where the observer cannot predict the potential motion of the object and therefore an element of perceptual unease is created. Whether the object is passively attracted by centre or edge or whether the object actively moved on its own volition depends on content. The awareness of motion of a static visual element with relation to the frame is an intrinsic part of perception. It is not an intellectual judgement tacked on to the content of an image based on previous experience, but an integral part of perception.

The *closed frame* compositional technique is structured to keep the attention only on the information that is contained in the shot. The *open frame* convention allows action to move in and out of the frame and does not disguise the fact that the shot is only a partial viewpoint of a much larger environment (see also page 125).

Frames within frames

The ratio of the longest side of a rectangle to the shortest side is called the aspect ratio of the image. The aspect ratio of the frame and the relationship of the subject to the edge of frame has a considerable impact on the composition of a shot. Historically, film progressed from the Academy aspect ratio of 1.33:1 (a 4×3 rectangle) to a mixture of Cinemascope and widescreen ratios. TV inherited the 4:3 screen size and then, with the advent of digital production and reception, took the opportunity to convert to a TV widescreen ratio of 1.78:1 (a 16×9 rectangle).

Film and television programmes usually stay with one aspect ratio for the whole production but often break up the repetition of the same projected shape by creating compositions that involve frames within frames. The simplest device is to frame a shot though a doorway or arch which emphasizes the enclosed view or by using foreground masking, an irregular 'new' frame can be created which gives variety to the constant repetition of the screen shape.

The familiar over-the-shoulder two shot is in effect a frame within a frame image as the back of the foreground head is redundant information and is there to allow greater attention on the speaker and the curve of the head into the shoulder gives a more visually attractive shape to the side of the frame. It has been used in feature film and later television productions since about 1910. Essentially it is a composition that allows the audience to have the same viewpoint as the foreground listener and adds emphasis to the speaker.

There are compositional advantages and disadvantages in using either aspect ratio. Widescreen is good at showing relationships between people and location. Sports coverage benefits from the extra width in following live events. Composing closer shots of faces is usually easier in the 4:3 aspect ratio but as in film, during the transition to widescreen framing during the 1950s, new framing conventions are being developed and old 4:3 compositional conventions that do not work are abandoned. The shared priority in working in any aspect ratio is knowing under what conditions the audience will view the image.

Widescreen

The last few years have seen a move to replace the 4:3 aspect ratio TV picture with a 16:9 ratio. Originally the change accompanied the proposed introduction of a high-definition television system but the difficulties in agreeing a world-wide standard, and the economics of running a parallel service to the existing national TV systems, has resulted in a shift to the promotion of 'widescreen' TV.

Transition

Although it would appear that there will be a short transition period before the 16:9 widescreen TV set replaces the older 4:3 receiver this emphasizes the technological change and ignores the effect on programme content. In effect there will never be a settled time of standard aspect ratio after the change from all 4:3 sets to all 16:9 sets. The sets may be widescreen but television continually uses older 4:3 material. There is a large backlog of 4:3 productions that have a very long shelf life (e.g. sitcoms, cartoons, feature films). Many documentary, news and TV history programmes use 4:3 archive material in 16:9 productions. Film and television material is probably the most powerful record of twentieth century history. Nearly all of it was shot in 4:3 aspect ratio. Just as monochrome productions are still watched and enjoyed, 4:3 material will still play a crucial part in television output.

The 'transitional' period of technical change world-wide could last for at least ten years and possibly much longer in many countries before all the viewing population will be equipped with 16:9 digital TV set. During much of this time programmes will be made in a compromise 14:9 'protect and save' mode, which does not take advantage of the full widescreen compositional potential of 16:9. These interim 14:9 composed programmes will take their place alongside the existing 4:3 programmes in the broadcasters' vaults to form a jumble of differently composed pictures that have to be squeezed into the 16:9 screen. Moving to 16:9 was not simply a technical change, it will have a significant and long term effect on the visual appearance of programmes.

Dual format

From a cameraman's point of view, the biggest difficulty during the transition period is attempting to find a compositional compromise between the two aspect ratios. If a 16:9 image is transmitted in a letter-box format (i.e. a black band at the top and bottom of the frame when viewed on a 4:3 TV set) then all shots can be framed with respect to the 16:9 border. Some companies, however, have adopted a half-way stage of transmitting the 16:9 format in a cropped format of 14:9 in an effort to make the letter-box effect less intrusive for 4:3 viewers.

Aspect ratio transformation at the receiver

Fig 1 4:3 Original framing

Fig 2 4:3 Picture on 16:9 receiver

Fig 3 4:3 Stretched to fill 16:9 receiver screen

Fig 4 4:3 Centre of frame zoomed to fill 16:9 receiver

Fig 5 4:3 Centre of frame zoomed to fill 16:9 receiver

It is a paradox that in some countries, viewers actively dislike the black band side curtains (Fig. 2) when watching a 4:3 picture on a 16:9 receiver and appear to prefer either the distortion introduced when stretching the 4:3 picture to fit the 16:9 screen (Fig. 3) or to crop the top and bottom of the transmitted image (Fig. 4). Unless the viewer constantly monitors and adjusts this last option (zooming) subsequent shots may suffer loss of essential information (Fig. 5).

Some 16:9 TV receivers have a progressive distortion (anamorphic) facility to stretch a 4:3 transmitted image. This progressive rate of expansion across the screen results in the snooker example above of the shape of the ball changing its shape as it travels across the frame. It is ironic that decades of research and development expended on producing perfect electronic images that are free from geometric distortion can be negated by the touch of a button on a channel changer. Weather presenters change shape from fat to thin as they walk across the frame, or shoot out their arm to double its apparent length when this aspect ratio conversion option is selected.

Aspect ratio conversion decisions are taken out of the viewer's control when 4:3 material is integrated into 16:9 productions. The director of the programme then has the choice either to show the inserted 4:3 material with black side curtains or force the 4:3 image to fit the 16:9 format by stretching or cropping the original framing.

The intention is that eventually there will only be 16:9 receivers, but the backlibrary of 4:3 programmes and films is enormous and valuable and will continue to be transmitted across a wide range of channels in the future. Aspect ratio conversion problems are now built into the television industry.

Protect and save

The world-wide change-over period from mass viewing on a 4:3 analogue set to mass viewing on a 16:9 digital monitor, and therefore mass programme production for 16:9 television, will take many years. The transition period will require a compromise composition and many broadcasters are adopting an interim format of 14:9 to smooth the transition from 4:3 to full 16:9.

Viewfinder set-up

Using the 14:9 aspect ratio as an interim standard, cameramen shooting in 16:9 follow a 'shoot and protect' framing policy. The viewfinder is set to display the full 16:9 picture (see figure opposite) with a graticule superimposed showing the border of a 14:9 frame and a 4:3 frame. Significant subject matter is kept within the 14:9 border or, if there is a likelihood of the production being transmitted in 4:3, within the smaller 4:3 frame. The area between 16:9 and 14:9 must be still usable for future full digital transmissions and therefore must be kept clear of unwanted subject matter. Feature film productions that were shot in 4:3 but were intended to be projected in the cinema with a hard matte in widescreen can sometimes be seen in a TV transmission with booms etc., in the top of the frame that would not have been seen in the cinema. 'Shoot and protect' attempts to avoid the hazards of multi-aspect viewing by centring most of the essential information. This does of course negate the claimed compositional advantages of the 16:9 shape because during the 'transitional' period (however long) the full widescreen potential cannot be used. 'Protect and save' loses a portion of the left- and right-hand edge of the frame and may destroy the balance of a 16:9 image. It is an experience that viewers, watching widescreen films shown on TV, have been subject to for many years modified by the limited remedial efforts of the widescreen image being panned and reframed via telecine on transmission. There is very little satisfactory compromise that can be made in an attempt to compose for both formats at the same time if they are viewed full screen on different aspect ratio screens.

For editing purposes, it is useful to identify within the colour bars, the aspect ratio in use. Some cameramen in the early days of widescreen video shooting would frame up a circular object such as a wheel or lens cap to establish in post production if the correct aspect ratio was selected.

The same size camera viewfinders used for 4:3 aspect ratio are often switched to a 16:9 display. This in effect gives a smaller picture area if the 14:9 'shoot and protect' centre of frame framing is used and makes focus and following distant action more difficult. Also, video cameramen are probably the only monochrome viewers still watching colour TV pictures. Colour is not only essential to pick up individuals in sports events such as football where opposing team shirts may look identical in monochrome, but in all forms of programme production, colour plays a dominant role in composition.

Protect and save

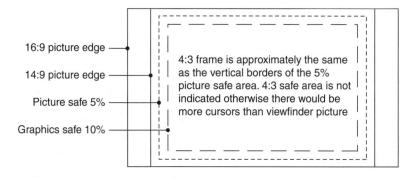

Composition problems will continue while 16:9 and 4:3 simultaneous productions are being shot during the analogue/digital changeover. They neither take full advantage of the width of 16:9 nor do they fit comfortably with the old 4:3 shape. Possibly ten years of dual format compromise production will then join the back library and be transmitted from then on. The only safe solution is the 'protect and save' advice of putting essential information in the centre of frame but that is a sad limitation on the compositional potential of the widescreen shape.

Fig. 2

Fig. 3

If the 'protect and save' viewfinder indicators are ignored when framing, for example, a golf shot in 16:9 aspect ratio (Fig. 2), viewers watching a 4:3 picture will have a poorly composed picture (Fig. 3) and no indication when the ball exits right on their viewed picture if the ball has entered the hole. With this framing, it is likely that even if the programme is transmitted in 14:9 aspect ratio, many viewers (with over-scanned TV receivers) will not be able to see the hole on the right of the frame present in the original 16:9 framing.

Viewing distance

There is a further consideration in the format/composition debate, which concerns the size of the screen. Someone sitting in a front row cinema seat may have as much as 58° of their field of view taken up by the screen image. This can be reduced to as little as 9.5° if he/she views the screen from the back row. The average television viewer typically sees a picture no wider than 9.2° . Dr Takashi Fujio at the NHK research laboratories carried out research on viewers' preference for screen size and aspect ratio and his findings largely formed the justification for the NHK HDTV parameters. His conclusion was that maximum involvement by the viewer was achieved with a 5:3 aspect ratio viewed at 3 to 4 picture height distance. Normal viewing distance (in Japan) was 2 to 2.5 metres, which suggested an ideal screen size of between $1 \text{ m} \times 60 \text{ cm}$ and $1.5 \text{ m} \times 90 \text{ cm}$. With bigger room dimensions in the USA and Europe, even larger screen sizes may be desirable. Sitting closer to a smaller screen did not involve the viewer in the action in the same way.

Estimating the compositional effect of space and balance in a widescreen frame is complicated by the concept that framing for cinema widescreen and television widescreen compositions are different because of the screen size. The accepted thinking is that what works on a large cinema screen may be unacceptable with TV. Cinema screens are very large compared to television sets but for someone sitting at the back of a cinema the size of the screen in their field of view (e.g. 9.2°) may be the same as someone watching a 36-in TV screen at normal domestic viewing distance. It is a mistake to confuse screen size with actual perceptual size, which is determined by viewing distance.

Transfer between film and television

Many television productions are shot on film and there is a continuous search for a world-wide video standard to allow a transparent transfer of film to video and video to film. There have also been many proposals for a high definition television format. Since the early 1970s, when NHK (the Japan Broadcasting Corporation) first began research into a high definition television system, there has been international pressure for agreement on a standard HDTV system. One solution suggested is to have a HDTV acquisition format of 24 frame, 1080 line, progressive scanning video system that would allow high definition video productions suitable for transfer to film for cinema presentation. It would be the video equivalent of 35mm film and allow a seamless translation to all other standard definition (SD) video formats.

Natural perspective

A shot can be set up with the camera at any distance from the subject and by varying the lens angle of the zoom the required framing can be achieved. But which lens angle will create natural perspective? Which combination of lens

Keep up-to-date with the latest books in your field, Visit our website and register now for our FREE e-mail update service, or join our mailing list and enter our monthly prize draw to win £50 worth of books. Just complete the form below and return it to us now! (FREEPOST if you are based in the UK)

- Sinail:	
Country:	Postcode:
	County:
Street:	
Business sector (if relevant):	
Job title:	
Name:	
Subject area of interest:	
Title of book you have purchased:	

FOR OFFICE USE ONLY

Butterworth-Heinemann, a division of Reed Educational & Professional Publishing Limited. Registered office: 25 Victoria Street, Registered in England 3099304. VAT number GB: 663 3472 30.

tion services on this and related subjects (V box if not required). This information is being collected on behalf of Reed Elsevier pic group and may be used to supply information about products by companies within the group.

□ Please arrange for me to be kept informed of other books and informa-

FOR CARDS
OUTSIDE
THE UK,
PLEASE
AFFIX A
POSTAGE STAMP

Ejemhen Esangbedo
Information Update Service
Butterworth-Heinemann
FREEPOST
Oxford
Oxon
OX2 8BR

angle and camera distance most closely resembles human perception if the camera was replaced by an observer at the same point as the lens? The usual attempt to answer this question starts with the concept of the displayed image as a 'window in the wall'. The viewer looks through the 'window' and sees precisely the same scene as depicted by the lens angle/camera distance image. In practical everyday programme production the quest for 'natural perspective' is not achievable because it depends on two unknown factors. The correct viewing distance for natural perspective depends on the size of image displayed and the viewing distance of that image. This combination will vary between viewer and viewer although averages could be deduced based on average size of TV set and average size of sitting rooms.

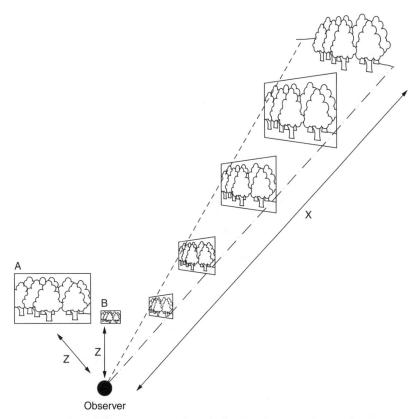

The screen size of the reproduced image will increase proportionally to the viewing distance if the original perspective experienced by the observer at distance 'z' from the subject is to be duplicated. The viewing distance 'z' of screen A is too close to reproduce a 'natural' perspective and would simulate a 'wide-angle' look at that viewing distance. Screen B would simulate a 'narrow angle' view point because the screen size is too small for viewing distance 'z'.

Invisible technique

The basic principles of camerawork

There are a number of basic visual conventions used by the majority of cameramen operating broadcast camera/recorders. Many of these standard camera techniques were developed in the early part of the twentieth century when the first film-makers had to experiment and invent the grammar of editing, shot-size and the variety of camera movements that are now standard. The ability to find ways of shooting subjects and then editing the shots together without distracting the audience was learnt by the commercial cinema over a number of years. The guiding concept was the need to persuade the audience that they were watching continuous action in 'real' time. This required the mechanics of film-making to be hidden from the audience; that is to be invisible. Invisible technique places the emphasis on the content of the shot rather than production technique in order to achieve a seamless flow of images directing the viewers' attention to the narrative. It allows shot change to be unobtrusive and directs attention to what is contained within the frame and to smoothly move the camera to a new viewpoint without distracting the audience.

Alternative technique

There are alternative conventions of presentation, which intentionally draw attention to the means of production. The production methods and camera movements are emphasized in order to simulate the realism of the unrehearsed shot or to remind the audience that they are watching a piece of fiction. Similar to news coverage, it appears as if the camerawork is surprised by the action. Camera movement in this alternative technique is often restlessly on the move, panning abruptly from subject to subject, making no effort to disguise the transitions and deliberately drawing attention to the means by which the images are brought to the viewer. This breaking down or subverting of the standard convention of an 'invisible' seamless flow of images has a number of different forms or styles. In general, television production has adopted the 'Hollywood' model of invisible technique.

A coherent technique

The point of this brief history of camerawork is rather than simply committing to memory a list of dos and don'ts about TV camerawork it is better for you to understand *why* these visual conventions exist. There is a coherent technique behind most TV camerawork. The way a shot is framed up, the way a zoom is carried out, the amount of headroom you give to a certain size of shot is not simply a matter of personal taste, although that often affects shot composition, it is also a product of 90 odd years of telling a story in pictures. The development of invisible technique created the majority of these visual conventions. Knowing why a camerawork convention exists is preferable to simply committing to memory a string of instructions. You can then apply the principles of invisible technique whenever you meet up with a new production requirement.

The aim of invisible technique is to convince the audience that they are watching a continuous event in 'real' time.

- shots are structured to allow the audience to understand the space, time and logic of the action
- each shot follows the line of action to maintain consistent screen direction so that the geography of the action is completely intelligible (e.g. camera positions on a football match)
- unobtrusive camera movement and shot change directs the audience to the content of the production rather than the mechanics of film/television production
- invisible technique creates the illusion that distinct, separate shots (possibly recorded out of sequence and at different times) form part of a continuous event being witnessed by the audience.

This is achieved by:

- unobtrusive intercutting (see Editing topics)
- camera movement motivated by action or dialogue (see Camera movement, pages 126–30)
- · camera movement synchronized with action
- · continuity of performance, lighting, atmosphere and action.

The basic aims of television camerawork can be summarized as:

- to produce a technically acceptable picture (e.g. correct exposure, white balance, in focus, etc.)
- to provide a shot that is relevant to the story or event in a style that is suitable for the genre (see Camerawork styles, page 132)
- to provide a shot that will hold the audience's attention (e.g. by the appropriate use of framing, camera movement, composition, lighting etc.)
- to provide shots that can be cut together (see Editing topics).

Programme production

Live multi-camera production technique uses a number of cameras that are switched to in turn to show different viewpoints of an event. This production method allows the material to be transmitted as it occurs or to be recorded for future transmission. If it is recorded then the material can be edited before transmission. Single camera coverage is usually recorded and the material receives extensive editing before transmission. This is similar to the film technique where one shot is recorded and then the single camera moved to another position or location to record another shot. The shots can be recorded out of sequence from their subsequent edited order. This type of production method is very flexible but does require more time in acquiring the material and in editing. An additional advantage of the single video camera is that it can be linked into a programme by satellite, land line or terrestrial link and be used as a live outside visual source. Pictures are nearly always accompanied by audio, either actuality speech, music, or effects of the subject in shot, or sound is added in post production. The old cliché that television is a visual medium is a half truth. In nearly every circumstance, the viewer wants to hear, as well as see, what is transmitted. Pictures may have a greater initial impact, but sound frequently adds atmosphere, emotion, and space to the image.

Two types of programming

Programmes can be roughly divided into those that have a content that has been conceived and devised for television and those with a content that cannot be preplanned, or are events that take place independent of television coverage. Many programmes have a mixture of both types of content.

If it is scripted for television, then the production is under the direct control of the production team who can arrange the content as they wish. The time scale of what happens on the screen is under their supervision and can be started and stopped as required. If it is an event that would happen independent of TV such as a sports event, then the production team will have to make arrangements to cover the event as it unfolds in its own time scale.

The creation of 'invisible' technique

As we discussed in the section on basic camera technique (page 114), the ability to find ways of shooting subjects and then editing the shots together without distracting the audience was learnt by the commercial cinema over a number of years. Television production mostly follows this technique. A number of standard conventions are practised by all members of the production team with a common aim of disguising their specific craft methods in order to maximize the audience's involvement with the programme content. If the audience becomes aware for example, of audio transitions, change of shot or the colour cast on a presenter's face, they are unlikely to be following developments in the programme.

Standard shot sizes

Because so much of television programming involves people talking, a number of standard shot sizes have evolved, centred on the human body. In general, these shot sizes avoid cutting people at natural joints of the body such as neck, elbows, knees.

BCU (big close-up)
Whole face fills screen. Top of frame cuts forehead. Bottom of frame cuts chin

CU (close-up)
Bottom of frame cuts where knot of tie would be

MCU (medium close-up)
Bottom of frame cuts where
top of breast pocket of a jacket would be

MS (medium shot)
Bottom of frame cuts at
the waist

LS (long shot) Long shot includes whole figure

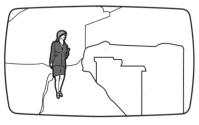

WS (wide shot)
Wide shot includes figure in a landscape or setting

Note: Precise framing conventions for these standard shot descriptions vary with directors and cameramen. One person's MCU is another person's MS. Check that your understanding of the position of the bottom frame line on any of these shots shares the same size convention for each description as the director with whom you are working.

Customary technique

Programme genres employ different production techniques. Sports coverage has shot patterns and camera coverage conventions, for example, different to the conventions used in the continuous coverage of music. Knowledge of these customary techniques is an essential part of the camerawork skills that need to be acquired. There is usually no time for directors to spell out their precise requirements and most assume that the production team is experienced and understand the conventions of the programme being made. The conventions can concern technique (e.g. news as factual, unstaged events; see page 134), or structure - how the programme is put together. A game show, for example, will introduce the contestants, show the prizes, play the game, find a winner and then award the prizes. The settings, style of camerawork, lighting and programme structure are almost predictable and completely different from a 30-minute natural history programme. It is almost impossible to carry over the same technique and style, for example of a pop concert to a current affairs programme. Each production genre requires the customary technique of that type of format although crossover styles sometimes occur.

Attracting the audience's attention

Whatever the nature of the programme, the programme makers want an audience to switch on, be hooked by the opening sequence and then stay with the programme until the closing credits. There are a number of standard techniques used to achieve these aims. The opening few minutes are crucial in persuading the audience to stay with the programme and not switch channels. It usually consists, in news and magazine style programmes, of a quick 'taster' of all the upcoming items with the hope that each viewer will be interested in at least one item on the menu. Either existing material will be cut to promote the later item or very often 'teasers' will be shot specifically for the opening montage. Whether in this fast opening sequence or in the main body of the programme, most productions rely on the well tried and trusted formula of pace, mystery and some form of storytelling.

Story

The strongest way of engaging the audience's attention is to tell them a story. In fact, because film and television images are displayed in a linear way, shot follows shot, it is almost impossible for the audience not to construct connections between succeeding images, whatever the real or perceived relationships between them. The task of the production team is to determine what the audience needs to know, and at what point in the 'story' they are told. This is the structure of the item or feature and usually takes the form of question and answer or cause and effect. Seeking answers to questions posed at the start of the programme, such as, 'what are the authorities going to do about traffic jams?' or 'how were the pyramids built?', involves the viewer and draws them into the 'story' that is unfolding. Many items are built around the classical structure of exposition, tension, climax and release.

Looking room

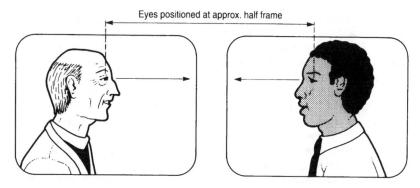

Balanced 'looking room' on intercut shots

One of the compositional conventions of camerawork with profile shots, where people are looking out of frame, is to give additional space in the direction of their gaze for 'looking room'. Similarly when someone is walking across frame, to give more space in front of them than behind.

Head room

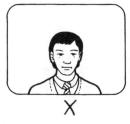

Presenter appears to be falling out of frame

Top of frame is crushing presenter

Match similar size shots with same size headroom

Headroom is the space allowed above the head when framing a face. The amount of headroom will vary depending on the size of shot. In close-ups and big close-ups there will be no headroom. In long shot the amount of headroom will depend on location and composition. In general, the wider the shot the greater the headroom. It is only feasible to match headroom in medium close-up and medium shot; other size shots will be framed on their individual merits.

Shot structure

As demonstrated in most holiday and wedding home movies, many people new to camerawork assume that a video of an event is simply shooting a collection of 'pretty' or informative images. It is only later when they view the unedited material that they may begin to understand that their collection of individual shots do not flow together and communicate the points they were hoping to make. Watching a sequence of random and erratic images soon becomes tedious and visually distracting if the elementary principle is forgotten or ignored that when viewed, each shot is connected with the preceding and succeeding shot. Good camerawork, as well as providing visually and technically acceptable pictures, is constantly thinking in shot structures. In broadcasting, each shot must help to advance the points being communicated. The collection of shots produced on location will be edited together and pared down to essentials. The editor can only do so much with the material the cameraman provides. Essentially the cameraman (or if present, the director) must impose an elementary structure to the material shot

Much of camera/recorder location work may not be scripted. There may be a rough treatment outlined by the presenter or a written brief on what the item should cover, but an interview may open up new aspects of the story. Without pre-planning or a shot list, camera technique will often revert to tried and trusted formulas. Telling a story in pictures is as old as the first efforts in film-making.

General to the particular

A safe rule-of-thumb is to move from the general to the particular – from wide shot to close-up. Use a general view (GV) to show relationships and to set the scene and then make the important points with the detail of close-ups. There must be a reason in editing to change shot and the cameraman has to provide a diversity of material to provide a cutting point.

Record of an event

Information shots are specific. They refer to a unique event – the wreckage of a car crash, someone scoring a goal, a political speech. They are often non-repeatable. The crashed car is towed away, the politician moves on. The camera technique must be precise and reliable, responding to the event with quick reflexes. There is often no opportunity for retakes.

Interpretative shots

Interpretative or decorative shots are non-specific. They are often shot simply to give visual padding to a voice-over. A typical example is a shot of an interviewee walking in a location before an interview to allow a dubbed voice-over to identify who the interviewee is. The shot needs to be long enough to allow information that is not featured in the interview to be added as a voice over.

Shooting ratios

Most magazine and news items will have a mixture of information and decorative shots. It is part of the camera operator's craft to provide the editor/ presenter with a variety of options but to keep the shooting ratio in proportion to the editing time available. Information shots are usually straightforward records of the incident or object. If it is technically competent, the information shot requires no more than variety in size and reasonable framing. Decorative shots require a knowledge of television technique and the ability to exploit video and lens characteristics.

Basic advice on structure

- When shooting an event or activity, have a rough mental outline of how the shots could be cut together and provide a mixture of changes in camera angle, size of shot and camera movement.
- Change of shot must be substantial either in camera position or in shot size.
- Avoid too restricted a structure in type of shot give some flexibility to the
 editor to reduce or expand the running time (e.g. do not stay on the same size
 shot of a speaker for the whole of his conference speech). Provide audience
 cutaways after the speech.
- Provide some type of establishing shot and some general views (GVs) that may be useful in a context other than the immediate sequence.
- Provide the editor with a higher proportion of static shots to camera movement. It is difficult to cut between pans and zooms until they steady to a static frame and hold.
- For news, keep camera movement short with a greater proportion of small significant moves that reveal new (essential) information. Avoid long inconsequential pans and zooms.
- When shooting unrehearsed events, steady the shot as soon as possible and avoid a sequence of rapid, very brief shots.
- Get the 'safe' shot before attempting the ambitious development.
- Try to find relevant but non-specific shots so that voice-over information (to set the scene or the report) can be dubbed-on after the script has been prepared.
- If you provide a shot of an interviewee 'walking' to the interview, let the
 interviewee leave frame at the end of the shot. Have the interviewee in
 medium-close-up facing in the same direction as the preceding walk to the
 interview.
- In general, wide shots require a longer viewing time than big close-ups.

Composition

One of the skills required in camerawork is the ability to provide shots that hold the interest and attention of the audience. Although the content of the shot such as a house, animal or personality may be the initial reason why a viewer's interest is captured by an image, the method of presentation, the composition of the shot, is also a vital factor in sustaining that interest.

What is composition?

Composition is the principal way of making clear the priorities of a shot. It emphasizes the main subject and eliminates or subdues competing elements of visual interest. There must be a reason for framing up any shot; good composition enables that reason to be transmitted to the viewer. Good visual communication is achieved by good composition.

'I see what you mean!'

There is usually a reason why a shot is recorded on tape or film. The purpose may be simply to record an event or the image may play an important part in expressing a complex idea. Whatever the reasons that initiate the shot, the cameraman should have a clear understanding of the purpose behind the shot.

After establishing why the shot is required, and usually this will be deduced purely from experience of the shot structure of the programme format, the cameraman will position the camera, adjust the lens angle, framing and focus. All four activities (including knowledge of programme formats) rely on an understanding of the visual design elements available to compose a shot within the standard television framing conventions. Effective picture making is the ability to manipulate the lens position and the lens angle within a particular programme context.

Primary decisions

The seven primary decisions to be made when setting up a shot are, camera angle, lens angle, camera distance, camera height, frame, subject in focus, depth of field. For example, a square-on shot of a house, (see figure (a) opposite), can have more visual impact if the camera is repositioned to shoot the building obliquely (b). Shooting two sides of a subject creates a more interesting dynamic arrangement of horizontal lines. This is changing the camera angle. The convergence of the horizontal lines can be emphasized by choosing the widest angle of the zoom, and repositioning the camera low and close to the subject. This is changing lens angle, camera distance and camera height. How the building is now framed, how much of the structure is within the depth of field of the chosen aperture, and which part of the building is chosen to be in focus will all affect the visual design of the shot. A building can have a radically different appearance by choosing how to employ the seven basic camera parameters. Lighting is another powerful design element in shot composition.

Positioning the lens

Physically changing the lens position and altering the lens angle controls the appearance and the information contained in a shot. One essential skill required by a cameraman is the ability to visualize a shot from a lens angle in any position in space without the need to move the camera to that position in order to discover its visual potential.

Composition summary

A shot is composed to emphasize the most important subject in the frame by placement using control of background, lens-angle, height, focus, shot size, movement, etc. The cameraman makes certain that the eye is a stracted to that part of the frame that is significant and seeks to avoid the main subject conflicting with other visual elements in the frame. Here is a partial checklist of the 'dos and don'ts' of composition:

- The camera converts three dimensions into two dimensions. Try to compensate for the loss of the third dimension by looking for ways to represent depth in the composition.
- Avoid dividing the frame into separated areas by strong vertical and horizontal elements unless this
 is a specific required effect.
- Check the overall image, particularly background details (e.g. no chimneys/posts growing out of foreground subjects' heads).
- Keep important action away from the edge of the frame, but avoid repeating square on, symmetrical
 eye-level centre-of-frame shots.
- . Offset the dominant interest and balance this with a less important element.
- Fill the frame if possible with interest and avoid large plain areas that are there simply because of the aspect ratio of the screen. If necessary, mask off part of the frame with a feature in the shot to give a more interesting composition.
- Emphasize the most important element in the frame by its position using control of background, lens-angle, height, focus, shot size, movement etc. Make certain that the eye is attracted to the part of the frame that is significant and avoid conflict with other elements in the frame.
- Selective focus can control the composition. Pulling focus from one plane to another directs attention without reframing.
- Attempt some visual mystery or surprise but the stronger the visual impact the more sparingly it should be used. Repeated zooming results in loss of impact and interest.

16:9 aspect ratio

- The rule of thirds proposes that an attractive balance can be achieved by placing the main subject
 on one of the intersections of two equally spaced lines horizontally in the frame and two lines equally
 spaced in the vertical.
- With profile shots, where people are looking out of frame, give additional space in the direction of their gaze for 'looking room'. Similarly when someone is walking across frame, give more space in front of them than behind.
- Give consistent headroom for the same sized shots decreasing the amount with CUs and BCUs.
 Always cut the top of the head rather than the chin in extreme close-up.
- The eyes are the centre of attention in shots of faces. A good rule-of-thumb is to place them onethird from the top of frame.

Composition and the lens

The composition of a shot is affected by the distance of the camera from the subject and the lens angle that is used. This will make a difference to the size relationships within the frame. The size relationship of objects in a field of view is known as the perspective of mass. Put simply, the closer an object is to us the larger it will appear and vice versa. The image of an object doubles in size whenever its distance is halved. This is a simple fact of geometric optics and it applies to a camera as it does to the eye. Adjusting the camera distance and the lens angle can provide the size relationships required for a composition.

The wide-angle/narrow-angle effect

Size relationships or the perspective of mass can be confused with the wide-angle effect and the narrow-angle effect. To increase the size of a background figure to a foreground figure it is common practice to reposition the camera back and zoom in to return to the original framing (see Camera distance, opposite). The size relationships have now altered. It is not the narrower angle that produced this effect but the increased distance from the camera. By moving away from the two figures we have altered the ratio between lens and first figure and lens and second figure. It is a much smaller ratio and therefore the difference in size between the two of them is now not so great. When we zoom in and revert to the original full frame for foreground figure we keep the new size relationships that have been formed by camera distance. The two figures appear to be closer in size. Choosing which combination of camera distance and lens angle is used therefore has a significant effect on the depiction of space within a shot.

Wide-angle effect: A wide-angle lens working close to the main subject allows more of the foreground subject to be in frame but increases the ratio between foreground and background object size. It this combination that produces distortion when used too close to the face (a 'Pinocchio' nose). A wide-angle zoom is very useful in confined surroundings especially if attempting to interview someone in a crowd of journalists and photographers. By being close to the interviewee, masking by other people (such as fellow photographers) is prevented as there is insufficient room between lens and subject.

Narrow-angle effect: A part of our perception of depth depends on judging size relationships. The smaller we perceive a known object, the further we judge it to be from us. The size relationships produced by a very narrow-angle lens at a distance from the subject, produces the illusion of squeezing the space between equal size figures. The camera distance from the subject produces the size relationships whilst the long focal length lens provides the magnification of the foreground and background. The space between the subjects in frame appears to be condensed. A common example is shooting a crowded pavement from a great distance on a long lens. The effect is that all people moving towards camera appear to be of equal size and the time taken for them to change size appears to be abnormal.

Camera distance

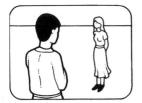

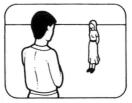

Mid-range

Wide-angle

Narrow-angle

The distance between the two figures remains unchanged in all three illustrations. The distance between foreground figures and camera has altered. With each re-position, the lens angle of the zoom has been adjusted to keep the foreground figure the same size in frame. The 'wide-angle' effect and the 'narrow-angle' effect is a product of the camera distance from the subjects. The important point to remember is that subject/ size relationship is a product of camera distance. How the subject fills the frame is a product of lens angle.

Lens height

Low angle

Lens at eye height

High angle

On a flat surface, the horizon line cuts similar size figures at the same point. The height of that point is the height of the lens.

Closed frame: One of the early Hollywood conventions was to compose the shot so that it contained the action within the frame and then by cutting, followed the action in distinct, complete shots. Each shot was self-contained and refers to only what is seen and shuts out or excludes anything outside of the frame. This is the *closed frame* technique and is structured to keep the attention only on the information that is contained in the shot. If there is any significant reference to a subject outside of the frame, then there is an additional shot to cover the referred subject. This convention is still followed in many different types of programme format. For example, in a television cooking demonstration, the demonstrator in medium close-up (MCU) may refer to some ingredient they are about to use which is outside the frame. Either the MCU is immediately loosened to reveal the ingredient or there is a need to record a cutaway shot of the ingredient later.

The open frame: The open frame convention allows action to move in and out of the frame. An example would be a character in a hallway who would be held on screen whilst in dialogue with someone who is moving in and out of frame entering and leaving various unseen rooms. Their movement while they are out of frame is implied and not cut to as separate shots. The open frame does not disguise the fact that the shot is only a partial viewpoint of a much larger environment. This convention considers that it is not necessary for the audience to see the reality beyond the shot in order to be convinced that it exists.

Camera movement (1)

There is the paradox of creating camera movement to provide visual excitement or visual change whilst attempting to make the movement 'invisible'. Invisible in the sense that the aim of the technique is to avoid the audience's attention switching from the programme content to the camerawork. This is achieved when camera movement matches the movement of the action and good composition is maintained throughout the move. The intention is to emphasize subject – picture content, rather than technique.

Intrusive and conspicuous camera movements are often used for specific dramatic or stylistic reasons (e.g. pop videos), but the majority of programme formats work on the premise that the methods of programme production should remain hidden or invisible to the viewer.

Motivation

A camera move is usually prompted either:

- to add visual interest
- to express excitement, increase tension or curiosity
- to provide a new main subject of interest
- to provide a change of viewpoint.

A camera move is therefore a visual development that provides new information or creates atmosphere or mood. If the opening and closing frames of a move, such as a zoom in, are the only images that are considered important, then it is probably better to use a cut to change shot rather than a camera move.

Match the movement to the mood or action

Two basic conventions controlling camera movement are, first, to match the movement to the action so that the camera move is motivated by the action and is controlled in speed, timing and degree by action.

Second, there is a need to maintain good composition throughout the move. A camera move should provide new visual interest and there should be no 'dead' area between the first and end image of the movement.

Movement that is not motivated by action will be obtrusive and focus attention on the method of recording the image. It will make the camera technique visible. It is sometimes the objective of obtrusive camera movement to invigorate content that is considered stale and lacking interest. If there is a lack of confidence in the content of a shot, then possibly it is better to rethink the subject rather than attempting to disguise this weakness by moving attention on to the camera technique employed.

Movement within the shot and lens angle

A small movement in a close-up can be the equivalent of a big movement in long shot. A full figure, three pace walk towards a wide-angle lens will create a

much bigger change in size than the equivalent full figure walk towards a 25° lens. The 'internal space' of the lens in use becomes a critical consideration when staging action for the camera.

The distinction between zooming and tracking

Wide shot

Zoom in

Camera static A 'zoom in' is the equivalent of cutting out a portion of the wide shot and enlarging it. There is no change in the size relationships in the frame.

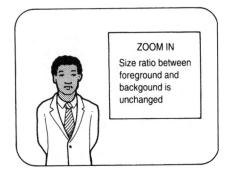

Track in

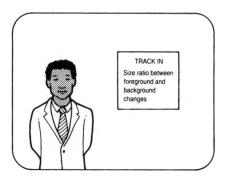

Altering camera position
Tracking the camera
changes the foreground and
the background size
relationships.

Camera movement (2)

There are broadly two types of camera movement: functional – the camera is moved to keep the subject in frame, decorative – the camera is moved to provide variety and interest or to explain an idea.

Functional movement

A common dilemma is when to re-frame a subject who is swaying in and out of reasonable framing. The shot may be too tight for someone who can only talk when they move or they may make big hand movements to emphasize a point.

The solution is loosen off the shot. It is seldom a good idea to constantly pan to keep someone in frame as inevitably you will be 'wrong-footed' and compensate for an anticipated movement that does not happen. If the shot cannot be contained without continuous re-framing then the incessant moving background will eventually become a distraction from the main subject of the shot.

Basic advice

- Try to disguise camera movement by synchronizing with subject movement.
 Start and stop the movement at the same time as the subject.
- When zooming, hold one side of the frame static as a 'pivot point' rather than zooming in to the centre of the frame.
- Try to find a reason to motivate the zoom and to disguise the zoom. Use a combination of pan and zoom.
- Panning and zooming are done to show relationships. If the beginning of the shot and the end of the shot are interesting but the middle section is not, it is better to cut between the start of the shot and the end frame rather than to pan or to zoom. Begin and end on a point of interest when panning. If the end of the shot is uninteresting why pan to it? Have a reason for drawing attention to the final image of a pan.
- Pace the pan so that the viewer can see what the camera is panning over. Hold the frame at the beginning and end of the pan.
- Use dominant lines or contours to pan across or along. Find some subject movement to motivate the pan.
- When panning movement, leave space in the frame in the direction the subject is moving.
- A 'zoom in' has the same effect as enlarging a section of a photograph. The perspective of the photograph is fixed and there is no change in the size relationships depicted between the whole photograph or a portion of it. The image is frozen an unchanging perspective whatever part we look at. This is contrary to our normal experience of a changing perspective when we move closer to a subject. Use the zoom with discretion to avoid increasing the two-dimensional quality of the TV image.

Pivot point

A common mistake with users of domestic camcorders is to centre the subject of interest in the frame and then to zoom towards them keeping the subject the same distance from all four sides of the frame. The visual effect is as if the frame implodes in on them from all sides. A more pleasing visual movement is to keep one or two sides of the frame at the same distance from the subject for the whole of the movement.

Preselect one or two adjacent sides of the frame to the main subject of the zoom and whilst maintaining their position at a set distance from the main subject of the zoom allow the other two sides of the frame to change their relative position to the subject.

Keep the same relationship of the adjacent frame edges to the selected subject during the whole of the zoom movement.

The point that is chosen to be held stationary in the frame is called the pivot point. Using a pivot point allows the subject image to grow progressively larger (or smaller) within the frame whilst avoiding the impression of the frame contracting in towards them.

Controlling composition

The choice of lens angle and resulting composition should not be accidental unless there is no alternative camera position. The internal space of a shot often underlines the emotional quality of the scene. 'Normal' perspective for establishing shots is often used where the intention is to plainly and straightforwardly describe the locale. A condensed or an expanded space on the other hand may help to suggest the mood or atmosphere of the action. A long lens positioned at a distance from a cramped interior will heighten the claustrophobia of the setting. Subject size ratios will be evened out from foreground to background and movement to and away from camera will show no significant change in size and therefore give a subjective impression that no distance has been traversed. A wide-angle lens close to the subject will increase space, emphasize movement and depending on shot content, emphasize convergence of line and accentuate the relative size of same size figures at different distances from the lens.

Control of background

Compositional priority can be given to a foreground subject by limiting the depth of field by ND (neutral density) filter or shutter but the greatest control is by choice of camera position, lens angle, camera distance and foreground subject position. Consideration must also be given to how the shot will be intercut and often a matching background of similar tonal range, colour and contrast has to be chosen to avoid a mismatch when intercutting. Too large a tonal difference between intercut backgrounds will result in obtrusive and very visible cuts. Visual continuity of elements such as direction of light, similar zones of focus and the continuity of background movement (e.g. crowds, traffic etc.) in intercut shots have also to be checked.

The subjective influence of camera height

Lens height will also control the way the audience identifies with the subject. Moving the horizon down below a person makes them more dominant because the viewer is forced to adopt a lower eyeline viewpoint. We are in the size relationship of children looking up to adults. A low lens height may also de-emphasize floor or ground level detail because we are looking along at ground level and reducing or eliminating indications of ground space between objects. This concentrates the viewer's interest on the vertical subjects. A high position lens height has the reverse effect. The many planes of the scene are emphasized like a scale model. Usually it is better to divide the frame into unequal parts by positioning the horizon line above or below the mid-point of the frame. Many cameramen intuitively use the rule of thirds (see page 123), to position the horizon. A composition can evoke space by panning up and placing the line low in frame. Placing a high horizon in the frame can balance a darker foreground land mass or subject with the more attention grabbing detail of a high key sky. It also helps with contrast range and exposure.

Perspective of mass

In shot A the camera is close to the presenter. In shot B, to make the background subject (Big Ben) more dominant the camera has moved back and zoomed in to match the presenter's size in shot A.

The 'internal space' has been rearranged by changing the camera distance to presenter and it now appears as if the subject and the clock are much closer together. This potentially creates a problem because it is very easy for members of the public to walk unwittingly between lens and presenter when working on a long lens. There will be a large gap between camera (20 ft+) and presenter for shot B.

With experience, it is unnecessary to check the focal length marked on the lens because it will be obvious from the image which part of the zoom range is selected. It is important to be able to recognize the visual effect of the chosen combination of camera distance/focal length. Do not just simply set up the camera from any viewpoint and zoom in to find the required framing. Think about how much depth you require in that specific shot and select the appropriate camera distance and adjust the zoom accordingly.

Camerawork styles

Anyone new to camerawork will face the same learning curve as someone new to driving a car. They will be preoccupied with acquiring the basic skills of being fully conversant with the camera controls, focusing, framing and making certain they produce a technically competent image. Beyond the 'L plate' stage comes the recognition that there are many different ways of shooting a story.

Visual conventions

TV and film camerawork technique does not operate in a vacuum – there are past stylistic influences, contemporary variations and innovations caused by new production equipment. Most of these influences affect how productions are made but are rarely analysed by the practitioners. There have been changes in technique styles over the years so that it is not too difficult to identify when a TV production was shot. Retro fashion is always popular in commercials production and often prompts mainstream programme makers to rediscover discarded 'old-fashioned' techniques.

Equipment innovation

Equipment and technique interact and many programme formats have been developed because new hardware has become available. Kitchen drama in the 1960s was shot in a different way from previous styles of TV drama when ringsteer pedestals were developed and were able to move into the small box sets required by the subject matter and able to navigate the furniture. Steadicam and the Technocrane introduced a whole new look to camera movement and hand-held cameras reshaped breakfast shows and pop music videos. The new small DV format cameras are now opening up different stylistic methods of documentary production.

Two types of camerawork

An objective representation of 'reality' in a news, documentary or current affairs production uses the same perennial camerawork techniques as the subjective personal impression or the creation of atmosphere in fictional films. A football match appears to be a factual event whereas music coverage may appear more impressionistic. In both types of coverage there is selection and the use of visual conventions. Football uses a mixture of close-ups and wide shots, variation of lens height, camera position, cutaways to managers, fans, slow motion replays, etc., to inject pace, tension and drama to hold the attention of the audience. Music coverage will use similar techniques in interpreting the music, but with different rates of pans and zooms motivated by the mood and rhythm of the music. If it is a pop video, there are no limits to the visual effects the director may feel is relevant. All TV camerawork is in one way or another an interpretation of an event. The degree of subjective personal impression fashioning the account will depend on which type of programme it is created for.

Invisible technique

to this shot . . .

you need this shot to show change of direction otherwise there would be a visual jump in the flow of shots.

Keeping the audience informed of the geography of the event is the mainstay of standard camera technique. Shots are structured to allow the audience to understand the space, time and logic of the action and each shot follows the line of action to maintain consistent screen direction so that the action is completely intelligible.

Alternative styles

There is an alternative camerawork style to the standard 'invisible technique' already discussed. Camera movement is often restlessly on the move, panning abruptly from subject to subject, making no effort to disguise the transitions and deliberately drawing attention to the means by which the images are brought to the viewer. This breaking down or subverting of the standard convention of an 'invisible' seamless flow of images was created from a number of different influences.

The camera surprised by events: When camcorders came into widespread use in broadcasting in the early 1980s, they were first used for news gathering before entering into general programme making. On the shoulder 'wobblyscope' became the standard trademark when covering impromptu action. War reporting or civil unrest was presented in news bulletins with the nervous 'tic' of a handheld video camera. Realism appeared to be equated with an unsteady frame. Cinema verité in the early 1960s linked on-the-shoulder camerawork with a new flexibility of movement and subject but many film directors adopted the uncertainty of an unsteady picture to suggest realism and authenticity (e.g. Oliver Stone in JFK (1991)). Many productions mimic the camera movement of ENG news coverage, which, because the subject matter is unknown and unstaged, is frequently 'wrong footed' when panning or zooming. Holding unpredictable action within the frame results in a different visual appearance to the calculated camera movement of a rehearsed shot. The uncertainty displayed in following impromptu and fast developing action has an energy that these productions attempt to replicate. Hand-held camerawork became the signature for realism.

Naiveté: Ignorance of technique may seem to be a curious influence on a style but the growth of the amateur use of the video camera has spawned a million holiday videos and the recording of family events which appear remarkably similar in appearance to some visual aspects of production shot in the 'camera surprised by events' style. The user of the holiday camcorder is often unaware of mainstream camera technique and usually pans and zooms the camera around to pick up anything and everything that catches their attention. The result is a stream of fast moving shots that never settle on a subject and are restlessly on the move (i.e. similar to the production style of 'NYPD Blue'). Video diaries have exploited the appeal of the 'innocent eye'. Many broadcast companies have loaned camcorders to the 'man in the street' for them to make video diaries of their own lives. The broadcasters claim that the appeal of this 'camcorder style' is its immediacy, its primitive but authentic image. It is always cut though, by professional editors who use the same conventional entertainment values of maximizing audience interest and involvement as any other programme genre.

Video news journalism

Video news journalism covers a wide spectrum of visual/sound reports that use a number of camerawork conventions. A loose classification separates hard news stories, which aim to transmit an objective, detached account of an event (e.g. a plane crash) in the next available news programme, from those soft news stories, which incline more towards accounts of lifestyle, personality interviews and consumer reports. Acceptable camera technique and style of shooting will depend on content and the aim of the report. A basic skill of news/magazine camerawork is matching the appropriate camerawork style to the story content. The main points to consider are:

- the need to provide a technically acceptable picture
- an understanding of news values and matching camerawork style to the aims of objective news coverage
- structuring the story for news editing and the requirements of news bulletins/ magazine programmes
- getting access to the story and getting the story back to base.

Operational awareness

It is easy to believe that all one requires to be a good news cameraman is an understanding of technology, technique and an appreciation of the news programme's customary styles. But news camerawork requires a fourth essential ingredient, the ability to professionally respond to sudden violent, unforeseen, spontaneous events and provide shots that can be edited to provide an informative news item. Keeping a cool head and providing competent coverage is the opposite to the often seen amateur video accounts of dramatic events where the camera is hose-piped all over the scene in a panic response to action that surprised the operator. News stories are often shot in real time with no opportunity (or requirement) to influence what is happening. The news cameraman must immediately respond to the occurrence in front of the lens and make split-second decisions about what to frame and where to capture the essential shots. Essentially news camerawork is looking for things moving or in the process of change. A shot of a closed door and curtained windows of a house where a siege is taking place can only be held on screen for a very short time and requires the supporting coverage of the flurry of activity that is taking place in the surrounding area.

News values

News values are usually related to its intended audience. People are more interested in news that either affects their lives, emotions or income. They give a higher priority to news that is local, immediate (i.e. it is 'new' to them), has dramatic content (crime, rescues, real life crisis), involves well known personalities, and is entertaining or humorous.

Access

One crucial requirement for news coverage is to get to where the story is. This relies on contacts and the determination to get where the action is. Civil emergencies and crisis are the mainstay of hard news. Floods, air/sea rescue, transport crashes, riots, fire and crime are news events that arise at any time and just as quickly die away. They require a rapid response by the cameraman who has to be at the scene and begin recording immediately before events move on. Equipment must be ready for instantaneous use and the cameraman must work swiftly to keep up with a developing story. Access may be denied unless you are in possession of a certified police pass, press pass and in the case of some civil disasters the appropriate safety clothing.

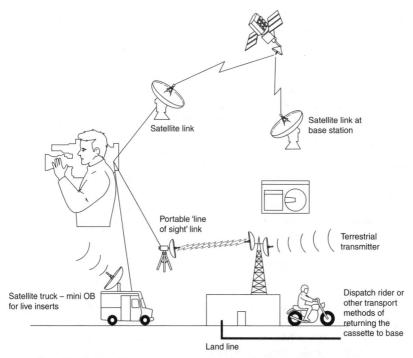

Returning the material: Getting the news material back to base can be by transport, land line, terrestrial or satellite link or foldaway SNG equipment. The important thing is to get the material to base fast with supporting information (if a reporter is not at the location) in a form (the cassette clearly marked) that can be rapidly edited. Use a separate tape for the reporter's voice-over and a 5-minute tape for cutaways to speed up editing. Use a new tape for each story so that the stories can be cut independently if required.

Objectivity

A television news report has an obligation to separate fact from opinion, to be objective in its reporting, and by selection, to emphasize that which is significant to its potential audience. These considerations therefore need to be borne in mind by a potential news cameraman as well as the standard camera technique associated with visual storytelling. Although news aims to be objective and free from the entertainment values of standard television story telling (e.g. suspense, excitement etc.) it must also aim to engage the audience's attention and keep them watching. The trade-off between the need to visually hold the attention of the audience and the need to be objective when covering news centres on structure and shot selection. As the popularity of cinema films has shown, an audience enjoys a strong story that involves them in suspense and moves them through the action by wanting to know 'what happens next'. This is often incompatible with the need for news to be objective and factual. The production techniques used for shooting and cutting fiction and factual material are almost the same. These visual story-telling techniques have been learned by audiences from a life-time of watching fictional accounts of life. The twin aims of communication and engaging the attention of the audience apply to news as they do to entertainment programmes.

Editing, selection and objectivity

Standard videotape editing technique avoids reminding the audience that they are watching an edited version. For example, a typical news item where a politician steps off a plane, is followed by a cutaway shot of cameramen, followed by the politician in the airport being interviewed. The news item ostensibly deals with fact, while the technique is derived from film fiction. Screen time and space has been manipulated and the technique employed is invisible to the audience. Whenever selection of material is exercised, objectivity is compromised. In news coverage a number of choices have to be made in subject, choice of location, choice of camera treatment and selection and arrangement of shots in editing.

Record versus comment

Whilst news camerawork aims to be simply a record of an event inevitably it becomes a comment on an event. It is comment or opinion because choices always have to be made whenever a shot is recorded. Apart from the obvious decision on the content of the shot, whether it be politician, building or a crowd, there are also the subtle influences on the viewers' perception of the event produced by camera position, lighting, lens angle, lens height and camera movement. The camera is not an objective optical instrument like a microscope. In setting up a shot, there is considerable scope for influencing the appearance and therefore the impact of the image. There is always the temptation to find the 'best' composition, even when shooting, for example, the effects of poverty and deprivation in city slums.

The above figures illustrate a news story reporting on a collision at sea between a container ship and a cruise ship. (a) shows the container ship on fire. Access is vital in news coverage and the cameraman must attempt to get to a position where the vital shot that summarizes the story can be recorded. (b) is shot on the container ship showing the 'geography' of the item of cargo and fire tender. (c) shows the damaged cruise ship in port and (d) is the disappointed holidaymakers leaving the ship while it is repaired. (e) is an interview with one of the passengers giving his experience of the collision and (f) is a piece-to-camera by the reporter (with an appropriate background) summarizing the story and posing questions of who/what was to blame.

What increases subjectivity?

Subjectivity is increased:

- by restaging the event to serve the needs of television (e.g. re-enacting significant action which occurred before the camera arrived)
- · selecting only 'action' events to record unless qualified by reporter
- use of standard 'invisible' technique editing can produce a partial account of an event.

Although there is an attempt to avoid these 'entertainment' aspects of storytelling in news reportage, they are often unavoidable due to the nature of the news item or the demands of attracting viewers.

Structure

Whether shooting news or documentaries, the transmitted item will be shaped by the editor to connect a sequence of shots either visually, by voice-over, atmosphere, music or by a combination of all of them. Essentially the cameraman or director must organize the shooting of separate shots with some structure in mind. Any activity must be filmed to provide a sufficient variety of shots that are able to be cut together following standard editing conventions (e.g. avoidance of jump cuts, not crossing the line, etc.) and to provide enough variety of shot to allow some flexibility in editing. Just as no shot can be considered in isolation (what precedes and what follows always has an effect), every sequence must be considered in context with the overall aims of the production.

The chosen structure of a section or sequence will usually have a beginning, a development, and a conclusion. Editing patterns and the narrative context do not necessarily lay the events of a story out in simple chronological order. For example, there can be a 'tease' sequence that seeks to engage the audience's attention with a question or a mystery. It may be some time into the material before the solution is revealed, and the audience's curiosity is satisfied.

Story telling

The story telling of factual items is probably better served by the presentation of detail rather than broad generalizations. Which details are chosen to explain a topic is crucial both in explanation and engagement. Many issues dealt with by factual programmes are often of an abstract nature, which at first thought, have little or no obvious visual representation (see 'inflation' story figure opposite). Because the story is told over time, there is often a need for a central motif or thread that is easily followed and guides the viewer through the item.

Communication and audience involvement

Communicate in an objective style without unduly 'colouring' the item.

- Identify the main 'teaching' points the audience should understand, i.e. What is this item about? What is the crucial point (or points) the audience should grasp?
- Find the appropriate method of presentation (shots, structure, narrative) to hold the audience's attention.
- Involve the viewer by pace, brevity (e.g. no redundant footage) and relevance (e.g. How does it affect me? Can I empathize with this situation?).
- Capture the attention by arresting images supported by lucid and appropriate narration and exposition.
- Although news is often an unplanned, impromptu shoot, the transmitted item should end up as a seamless flow of relevant shots spliced together to meet the standard conventions of continuity editing.

 Balance the shooting ratio (too much footage, and it cannot be edited in the time scale available) against sufficient coverage to provide flexibility as the story develops over time, to allow the editor to cut the item down to the required running time.

Structuring a sequence of shots when shooting

- When shooting an event or activity, have a rough mental outline of how the shots could be cut together and provide a mixture of changes in camera angle, size of shot and camera movement.
- Avoid too restricted a structure in type of shot give some flexibility to the editor to reduce or expand the running time.
- Keep camera movement short with a greater proportion of small significant moves that reveal new (essential) information.
- Avoid long inconsequential pans and zooms.
- When shooting unrehearsed events, steady the shot as soon as possible and avoid a sequence of rapid, very brief shots.
- Get the 'safe' shot before attempting the ambitious development.
- Provide some type of establishing shot and some general views (GVs) that may be useful in a context other than the immediate sequence.
- In general, wide shots require a longer viewing time than big close-ups.

Abstract news items

Some news items are abstract topics that have no concrete image. Appropriate visual 'wallpaper' needs to be shot to support voice-over information. For example, shots of high street shoppers to accompany a news story about inflation.

Checklist of questions before recording

- What is the purpose of the shot? Is the shot fact or feeling? Will the image attempt
 to be factual and objective and allow the viewer to draw their own conclusions or is
 it the intention to persuade or create an atmosphere by careful selection?
- . In what context will the shot be seen: what precedes and what follows?
- What will be the most important visual element in the shot?
- Has this specific lens angle and camera position been chosen to emphasize the principal subject, to provide variation in shot size, to give added prominence to the selected subject, to provide more information about the subject, to provide for change of angle/size of shot to allow unobtrusive intercutting, to allow variety of shot and shot emphasis, to create good shot composition, to favour the appearance of the performer, to alter the internal space in the shot by changing camera distance and lens angle, to alter size relationships in shot, to improve the eyeline or to comply with the lighting rig or natural light?

Interviews

The Interview is an essential element of news and magazine reporting. It provides for a factual testimony from a participant or witness to an event. Interviews can be shot in a location that reinforces the story and possibly gives more information to the viewer about the speaker (e.g. office, kitchen, garden etc.). The staging of an interview usually involves placing the interviewee against a suitable background that may echo the content or reinforce the identity of the guest. Exterior interviews are easier to stage when there is a continuity of lighting conditions such as an overcast day or where there is consistent sunshine. The natural lighting will have to cater for three shots and possibly three camera positions - an MCU of the interviewee, a similar sized shot of the interviewer and some kind of two-shot or 'establishing' shot of them both. If it is decided to shoot the interview in direct sunlight, then the interview needs to be positioned with the sun lighting both 'upstage' faces (i.e. the camera is looking at the shaded side of the face) using a reflector to bounce light into the unlit side of the face. The position of the participants can be 'cheated' for their individual close shots to allow a good position for modelling of the face by the sun. Because of the intensity of sunlight and sometimes because of its inconsistency, it is often preferable to shoot the interview in shade avoiding backgrounds that are in the full brightness of the sun. After the interview has been shot, there is often the need to pick up shots of points raised in the interview (e.g. references to objects, places or activity etc.). In order for normal 'invisible' editing to be applied, the shots should match in size and lens angle between interviewee and interviewer.

Crossing the line

There may be a number of variations in shots available depending on the number of participants and the method of staging the discussion/interview. All of these shot variations need to be one side of an imaginary line drawn between the participants. To intercut between individual shots of two people to create the appearance of a normal conversation between them, three simple rules have to be observed. Firstly, if a speaker in a single is looking from left to right in the frame then the single of the listener must look right to left. Secondly the shot size and eyeline should match (i.e. they should individually be looking out of the frame at a point where the viewer anticipates the other speaker is standing). Finally, every shot of a sequence should stay the same side of an imaginary line drawn between the speakers. Most interviews will be edited down to a fraction of their original running time. Be aware of the need for alternative shots to allow for this to happen. Make sure your two-shots, cutaways, reverse questions, noddies etc. follow the interview immediately. Not only does this save the editor time in shuttling but light conditions may change and render the shots unusable. Match the interviewee and interviewer shot size. If the interview is long, provide cutaways on a separate tape. Listen to the content of the interview, which may suggest suitable cutaways.

Setting up an interview

Camera position for MCU interviewee

A

Camera position for MCU interviewer and o/s 2 shot

- Set interviewee's position first, ensuring good background and lighting.
- Then set interviewer beside camera lens (A) to achieve a good eyeline on the interviewee.
- It is useful for editing purposes to precede the interview with details of name and title of the interviewee.
- Remind the reporter and interviewee not speak over the end of an answer.
- Do not allow interviewee to speak over a question.
- Agree with the journalist that he/she will start the interview when cued (or take a count of 5) when the camera is up to speed.
- Record the interviewee's shot first, changing size of shot on the out-of-frame questions.
- Reposition for the interviewer's questions and 'noddies' (B). An over-the-shoulder two-shot from this
 position can be useful to the editor when shortening the answers.
- · Match the MCU shot size on both participants.
- Do cutaways immediately after interview to avoid changes in light level.
- · Always provide cutaways to avoid jump cuts when shortening answers.
- A wide two-shot of the two participants talking to each other (without sound) can be recorded after the main interview if the shot is sufficiently wide to avoid detecting the lack of lip synch if the shot is used for editing purposes in mid-interview (C).
- Watch that the background to an establishing two-shot is from a different angle to any cutaway shot
 of the subject. For example, a wide shot of the ruins of a fire is not used later for the background to
 an interview about the fire. This causes a continuity 'jump' if they are cut together.
- Think about sound as well as picture, e.g. avoid wind noise, ticking clocks or repetitive mechanical sounds etc., in background.
- Depending on the custom and practice of the commissioning organization that cut the material, use track 1 for v/o and interview, and use track 2 for effects.
- Indicate audio track arrangements on the cassette and put your name/story title on the tape.

Live inserts

Probably the most frequent location shot in news, magazine and other topical programmes is the journalist/presenter speaking straight to camera. It is usually staged so that the keynote image of the item (Houses of Parliament, White House etc.) is the background to the shot. If it is shot during the day, then care must be taken to find a camera position that allows the reporter to speak to the camera comfortably whilst allowing an exposure balanced between face and background 'topic'. This can often be achieved with the sun at the three-quarter back position doubling as backlight and 'side kicker' to the face to provide some modelling. A reflector may be needed to lift the unlit side of the face depending on the intensity of the sun. Position the presenter so that the angle of their shoulder line is not straight to camera but points in to the background. It is often more visually pleasing if the presenter is placed on the right of the frame so that the eye in scanning the frame moves from left to right (the western convention for text reading). At night the exposure balance is between the background floodlit building and the foreground presenter. A battery light needs to be filtered or the camera distance adjusted so that a good overall exposure is achieved between face and building. The other point to consider is background traffic noise and, in a public place, freedom from the occasional eccentric passer-by who decides to stand in the background and divert attention from the presenter. With most public buildings, there is usually one favoured viewpoint marked out by 'tripod marks' from countless camera crews that have been there before.

Going live

The ability to broadcast live considerably increases the usefulness of the camera/recorder format. As well as providing recorded news coverage of an event, a single camera unit with portable links can provide live 'updates' from the location. As the camera will be non-synchronous with the studio production, its incoming signal will pass through a digital field and frame synchronizer and the reconstituted signal timed to the station's sync pulse generator.

Cameras with a dockable VTR can attach a portable transmitter/receiver powered by the camera battery in place of the VTR. The camera output is transmitted 'line of sight' to a base antenna (up to 1000 m) which relays the signal on by land line, RF link or by a satellite up-link. Other portable 'line of sight' transmitters are designed to be carried by a second operator connected to the camera by cable. When feeding into an OB scanner on site, the camera/recorder operator can receive a return feed of talkback and cue lights, whilst control of its picture can be remoted to the OB control truck to allow vision control matching to other cameras. It can therefore be used as an additional camera to an outside broadcast unit.

Microwave link

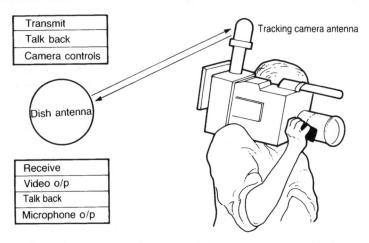

The microwave transmitter/antenna module replaces the VTR section of 'dockable' Beta format cameras and is powered by a battery attached to the unit. Typical portable microwave link frequencies are between 2.5 GHz and 13 GHz.

The camera antenna transmits to the location control truck, video and audio output plus camera operator talkback.

The tracking base antenna transmits production talkback, camera controls (iris, lift, gain, etc.) and a return video feed to allow the camera operator in the field to monitor on the camera viewfinder (if required) the 'on air' picture or any other video source that may be required.

Communications

Good communications are essential for a single camera operator feeding a live insert into a programme. Information prior to transmission is required of 'in and out' times, of duration of item and when to cue a 'front of camera' presenter. A small battery-driven 'off air' portable receiver is usually a valuable addition to the standard camera/recorder unit plus a mobile phone.

Focal length and angle of view

Focal length (mm)	6.5	8.5	10	20	50	100	200	300	400
Horizontal angle of view	68	54.7	46.5	24.8	10	5.04	2.5	1.7	1.2

Satellite news gathering (1)

Satellite news gathering (SNG) consists of a camera feeding into a small portable dish aerial transmitting a signal up to a satellite in geosynchronous orbit which relays the signal back to a base station and allows live coverage of events from locations inaccessible to normal land line or terrestrial links equipment. An SNG uplink system's primary component parts consists of baseband signal processing, a modulator, an upconvertor, a high-power amplifier (HPA), an antenna with mounting support that can be steered to align with the satellite and signal monitoring. Any or all of these components may be duplicated to ensure continuity of transmission should a component fail. The SNG package may be housed in a vehicle or broken down into a number of equipment cases that are dismantled for easy transportation and then reassembled on site (flyaway systems). The modulation may be analogue or digital. Although flyaways are sometimes operated out of the back of a vehicle, a safe zone has to be created in front of the antenna with some form of weather protection for equipment and operator. Flyaway units are difficult to operate quickly and safely in busy city streets. A microwave link to a receiver on a prominent building is often the preferred option.

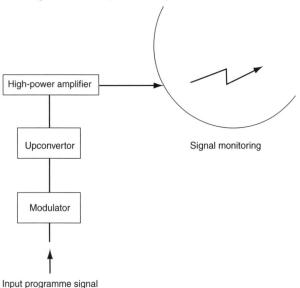

Simplified block diagram of analogue SNG units

Other facilities required to provide 'live' injects into a programme are a power generator when mains supply is unavailable, capable of delivering sufficient power to run lamps and all equipment; communication with the studio including two-way talkback, studio sound, phone lines; site VTR to play in material during the inject or for later transmission; portable vision mixing equipment to

'synchronously' switch between the output of the camera and the VTR and vision and audio monitoring. Often video editing equipment will accompany SNG equipment possibly in the form of a laptop editor.

Geosynchronous location

In order that an SNG unit can continuously transmit an unbroken signal without constantly realigning its dish aerial, the satellite must be placed in an orbit stationary above the earth. This is achieved by placing the satellite in an orbit 35,785 km from the earth where it is held in place by the balance between the opposing force of the gravity pull of earth against the centrifugal force pulling it out into space. Geosynchronous orbit (GEO) satellites revolve at the same rotational speed as the earth and appear stationary from the earth's surface. Signals can be transmitted to and from them with highly directional antennas pointed in a fixed direction. It is the satellites' fixed position in relation to earth that has allowed the growth of small, portable dish transmitters.

Geosynchronous orbit

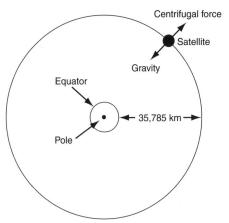

Orbital arcs: The number and position of the satellites located in this orbital arc 35,785 km above the earth are regulated by a number of world-wide authorities. The satellites are positioned, after the initial launch, by a gas thruster, which ensures they keep their position 2° from adjacent satellites. Frequencies used for communications transmission are grouped into C band (3.7–4.2 GHz) and Ku band. Ku band 'transmit' frequency is typically between 14.0 and 14.50 GHz and the 'receive' frequency is split into two bands 10.7–11.7 GHz and 11.7–12.75 GHz. The Ku band is almost universally used for portable SNG service because the antennas are smaller for a given beam width due to the shorter wavelength, and the freedom from interference to and from microwave systems.

Delay: The signal path from the uplink to the satellite is approximately 35,785 km above the earth. The signal, travelling at the speed of light, therefore takes a minimum of 238 ms (milliseconds) from an equator located uplink to base studio. This time delay will increase if the uplink and satellite are not positioned on the equator and if more than one 'hop' (uplink/downlink path) is required. In a 'live' two-way exchange between studio and location, there will be pauses between question and answer of the reatticinents.

Polarization: As well as choice of frequency band, the transmission signals to and from satellites have a property termed polarization — the geometric plane in which the electromagnetic waves are transmitted. There are two types of polarization. In general, circular polarization is used in C-band transmissions and linear polarization is used in Ku-band. Polarization allows maximum utilization of satellite frequency bandwidth by duplicating the use of the same frequency with different polarization without mutual interference.

Satellite news gathering (2)

A major task when setting up an SNG unit is 'acquiring the bird' – that is locking onto the booked satellite. The satellite occupies a fixed position relative to earth and its azimuth and elevation will be relative to the position of the uplink. To establish a link it is essential that the precise position of the SNG unit is fixed. Vehicle mounted SNG equipment and some flyaway units are equipped with automatic acquisition facilities. The position of the SNG unit can be calculated by one or a combination of three methods.

Global positioning system (GPS): This is a military system developed by the US using 24 satellites. They individually transmit a constant stream of timing information that the GPS receiver can process to calculate position. A commercial version of the system with less precision allows a position to be calculated to within 10 m.

Flux-gate compass: This is a piece of equipment that establishes location by comparing electromagnetic fields with the magnetic force from the North Pole.

Beacon receivers: Communication satellites used in SNG work continuously transmit a unique identifying beacon signal. A receiver on the SNG unit can sweep a narrow frequency range until it picks up the signal of the beacon identifier and aligns the dish to maximize the signal.

An essential part of operating an SNG unit is obtaining various authorizations and permission. These include permission from the appropriate authorities to operate in their country or area, registration with a satellite system operator, a space segment booked for the required time slot. Satellite systems operators will require evidence before registration and accepting bookings that appropriate designated equipment is being used and operated by competent, trained personnel. Considerable damage can be done to their satellite and to other users of the satellite by incompetent operational procedure.

Elevation angle

The elevation of the path to the satellite above the horizontal (the look angle) is critical to establishing an SNG link. A low elevation angle of the satellite just above the horizon can cause difficulty in clearing trees, buildings, pylons and other terrestrial objects, resulting in the attenuation of the signal by absorption or multipath reflection distortion; a low elevation path through the atmosphere before it emerges into space is much longer and this increases rain attenuation; electrical noise is generated by heat near the earth's surface, which can be picked up by the side lobes of the receiving antenna. Careful site selection is therefore important to ensure a clear line-of-sight to the designated satellite. The antenna requires protection against strong winds, which could shift the antenna's precise alignment to the satellite. Ku-band signal transmissions are subject to degradation from heavy rainfall, particularly in the tropics where cloud-bursts occur frequently; C-band transmissions, however, suffer negligible attenuation when passing through belts of high rainfall.

SNG set-up

A typical operational procedure for an SNG transmission would be for the uplink to call the satellite control centre and identify uplink registration and booking details including frequency and polarization. Five minutes before transmission the uplink 'brings up' a 'clean' carrier (unmodulated) to about 5–10% of full power. The control centre checks correct frequency and polarization. At this reduced power the control centre request modulation to be switched on, which is often a test signal with identifying caption. When the control centre has checked this signal it will agree that transmission can commence. It is from this point that the chargeable period commences. Test signal is removed and programme signal is now switched in. At the end of transmission the uplink 'brings down' the signal and end of transmission is agreed with control centre.

SNG safety

Because flyaway units and satphone antennas are often placed on the ground, there are essential safety procedures that must be complied with. Microwave transmitting equipment emits non-ionizing radiation at high power. This is a health risk that can burn the skin or internal organs. This must be avoided by rigging the antenna in a restricted location not accessible by the public or unauthorized broadcasting personnel; marking an exclusion zone in front of the antenna; checking the radiation levels around the perimeter of the safety zone and supervising and checking the danger area especially during transmission.

Operational points

Microwave radiation should not be operated near aircraft flight paths or military installations unless prior permission has been obtained. The antenna must be directed away from any vantage point to which the public have access by at least 5° and directed away from any mast on which radio equipment is installed by at least 10°. The SNG unit must not be positioned under power lines. No person must be able to get within 20 feet of the front of the antenna at the same height as the antenna. Avoid siting the SNG close to helicopter operating zones or radio transmitters. Make an assessment of wind strength. Strong winds can wobble the dish off satellite alignment and that is contrary to access regulations. Eutelsat specify no more than 0.3° of movement of beam angle. Check, with a radiation detector, the flexible waveguide at the bottom of the feed arm with power on for radiation leakage. Check that electrical connections and waveguide are protected from water ingress. There are also electrical hazards associated with SNG equipment due to the very high voltages required. One other important safety hazard is the weight of manual handling of flyaway SNG flight cases in transit and when setting up and de-rigging. Standard advice on lifting heavy weights should be observed.

Camerawork and editing

It is part of broadcasting folklore that the best place to start to learn about camerawork is in the edit booth. Here, the shots that have been provided by the cameraman have to be previewed, selected and then knitted together by the editor into a coherent structure to explain the story and fit the designated running time of the item in the programme. Clear story telling, running time and structure are the key points of editing and a cameraman who simply provides an endless number of unrelated shots will pose problems for the editor. A cameraman returning from a difficult shoot may have a different version of the edit process. A vital shot may be missing, but then the editor was not there to see the difficulties encountered by the news cameraman. And how about all the wonderful material that was at the end of the second cassette that was never used? With one hour to transmission there was no time to view or to cut it, claims the editor.

In some areas of news and magazine coverage this perennial exchange is being eliminated by the gradual introduction of portable field editing. It is no longer a case of handing over material for someone else 'to sort out'. Now the cameraman is the editor or the editor is the cameraman. This focuses under 'one hat' the priorities of camerawork and the priorities of editing. The cameraman can keep his favourite shot if he can convince himself, as the editor, that the shot is pertinent and works in the final cut.

Selection and structure

Editing is selecting and coordinating one shot with the next to construct a sequence of shots, which form a coherent and logical narrative. There are a number of standard editing conventions and techniques that can be employed to achieve a flow of images that guide the viewer through a visual journey. A programme's aim may be to provide a set of factual arguments that allows the viewer to decide on the competing points of view; it may be dramatic entertainment utilizing editing technique to prompt the viewer to experience a series of high and lows on the journey from conflict to resolution; or a news item's intention may be to accurately report an event for the audience's information or curiosity.

The manipulation of sound and picture can only be achieved electronically, and an editor who aims to fully exploit the potential of television must master the basic technology of the medium. To the knowledge of technique and technology must be added the essential requirement of a supply of appropriate video and audio material. As we have seen in the section on camerawork technique, the cameraman, director or journalist need to shoot with editing in mind. Unless the necessary shots are available for the item, an editor cannot cut a cohesive and structured story. A random collection of shots is not a story, and although an editor may be able to salvage a usable item from a series of 'snapshots', essentially editing is exactly like the well-known computer equation which states that 'garbage in' equals 'garbage out'.

Location shooting order before editing

Recording order of location shots before editing

Master shot showing bridge and damaged bus

Close-up of damage

Close-up of damage

Wide shot interior top deck Hold for 10 seconds Zoom into front seats of bus...

...hold for 5 seconds

Under bridge looking at front of bus

From top of bridge looking down onto bus

From top of bridge looking along rail track

Close up of 'height of bridge' sign

Close up of cracks in bridge brickwork

Interview with eyewitness

Piece to camera by reporter with bus/ bridge in background

A news story of a double-decker bus hitting a bridge may be shot in the above order. The shots of the bus stuck under the bridge are shot first as it may be released and towed away at any moment. This allows the reporter to find out the facts, talk to witnesses and prepare material for a piece to camera summing up the story.

Continuity editing

As well as the technological requirements needed to edit together two shots, there are subtle but more important basic editing conventions to be satisfied if the viewer is to remain unaware of shot transition. It would be visually distracting if the audience's attention was continually interrupted by every change of shot.

Moving images in film or television are created by the repetition of individual static frames. It is human perception that combines the separate images into a simulation of movement. One reason this succeeds is that the adjacent images in a shot are very similar. If the shot is changed and new information appears within the frame (e.g. what was an image of a face is now an aeroplane), the eye/brain takes a little time to understand the new image. The greater the visual discrepancy between the two shots the more likely it is that the viewer will consciously notice the change of shot.

A basic editing technique is to find ways of reducing the visual mismatch between two adjacent images. In general, a change of shot will be unobtrusive:

- if the individual shots (when intercutting between people) are matched in size, have the same amount of headroom, have the same amount of looking space if in semi-profile, if the lens angle is similar (i.e. internal perspective is similar) and if the lens height is the same;
- if the intercut pictures are colour matched (e.g. skin tones, background brightness, etc.) and if in succeeding shots the same subject has a consistent colour (e.g. grass in a stadium);
- if there is continuity in action (e.g. body posture, attitude) and the flow of movement in the frame is carried over into the succeeding shot;
- if there is a significant change in shot size or camera angle when intercutting on the same subject or if there is a significant change in content;
- if there is continuity in lighting, in sound, props & setting and continuity in performance or presentation.

As we have already identified, the basis of all invisible technique employed in programme production and specifically in continuity editing is to ensure that:

- shots are structured to allow the audience to understand the space, time and logic of the action so each shot follows the line of action to maintain consistent screen direction to make the geography of the action completely intelligible;
- unobtrusive camera movement and shot change directs the audience to the content of the production rather than the mechanics of production;
- continuity editing creates the illusion that distinct, separate shots (possibly recorded out of sequence and at different times), form part of a continuous event being witnessed by the audience.

New order of shots after editing

Recording order of location shots before editing

Master shot showing bridge and damaged bus

Close-up of damage

Close up of cracks in bridge brickwork

Close up of 'height of bridge' sign

...hold for 5 seconds

Close-up of damage

Wide shot interior top deck Hold for 10 seconds Zoom into front seats of bus...

Under bridge looking at front of bus

Interview with eyewitness

From top of bridge looking down onto bus

From top of bridge looking along rail track

SOUND

Piece to camera by reporter with bus/ bridge in background

Voice-over reporter describing circumstances

VISION

WS of bus stuck under bridge

CU damage

CU damage

CU sign - 'height of bridge'

WS of bus

MCU eyewitness WS interior of bus

CU interior of bus

Front of bus

Eyewitness

From top of bridge looking down on bus

Rail track on bridge

V/o reporter

Eyewitness description

WS of bus under bridge

Reporter to camera, bridge & bus background

Perennial editing techniques

The skills and craft employed by the film editor to stitch together a sequence of separate shots persuades the audience that they are watching a continuous event. The action flows from shot to shot and appears natural and obvious. Obviously the craft of editing covers a wide range of genres up to and including the sophisticated creative decisions that are required to cut feature films. However, there is not such a wide gap between different editing techniques as first it would appear.

Rearranging time and space

When two shots are cut together the audience attempts to make a connection between them. For example, a man on a station platform boards a train. A wide shot shows a train pulling out of a station. The audience makes the connection that the man is in the train. A cut to a close shot of the seated man follows, and it is assumed that he is travelling on the train. We see a wide shot of a train crossing the Forth Bridge, and the audience assumes that the man is travelling in Scotland. Adding a few more shots would allow a shot of the man leaving the train at his destination with the audience experiencing no violent discontinuity in the depiction of time or space. And yet a journey that may take two hours is collapsed to thirty seconds of screen time, and a variety of shots of trains and a man at different locations have been strung together in a manner that convinces the audience they have followed the same train and man throughout a journey.

Basic editing principles

This way of arranging shots is fundamental to editing. Space and time are rearranged in the most efficient way to present the information that the viewer requires to follow the argument presented. The transition between shots must not violate the audience's sense of continuity between the actions presented. This can be achieved by:

Continuity of action: action is carried over from one shot to another without an apparent break in speed or direction of movement (see figures opposite).

Screen direction: each shot maintains the same direction of movement of the principal subject (see opposite, the cut between two shots of man rising from desk).

Eyeline match: the eyeline of someone looking out of frame should be in the direction the audience believes the subject of the observation is situated. If they look out of frame with their eyeline levelled at their own height, the implication is that they are looking at something at that height.

There is a need to cement the spatial relationship between shots. Eyeline matches are decided by position (see Crossing the line, page 161), and there is very little that can be done at the editing stage to correct shooting mismatches except flipping the frame to reverse the eyeline, which alters the continuity of the symmetry of the face and other left/right continuity elements in the composition such as hair partings etc.

Editing conventions

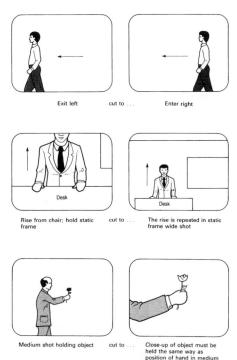

Matching visual design between shots: The cut between two shots can be made invisible if the incoming shot has one or more similar compositional elements as the preceding shot. The relationships between the two shots may relate to similar shape, similar position of dominant subject in the frame, colours, lighting, setting, overall composition, etc. Any similar aspects of visual design that are present in both shots (e.g. matching tone, colour or background) will help smooth the transition from one shot to the next. There is, however, a critical point in matching identical shots to achieve an unobtrusive cut (e.g. cutting together the same size shot of the same individual), where the jump between almost identical shots becomes noticeable. Narrative motivation for changing the shot (e.g. What happens next? What is this person doing? etc.) will also smooth the transition.

Matching temporal relationships between snots: The position of a shot in relation to other shots (preceding or following) will control the viewer's understanding of its time relationship to surrounding shots. Usually a factual event is cut in a linear time line unless indicators are built in to signal flashbacks or very rarely, flash-forwards. The viewer assumes the order of depicted events is linked to the passing of time. The duration of an event can be considerably shortened to a fraction of its actual running time by editing if the viewer's concept of time passing is not violated. The standard formula for compressing space and time is to allow the main subject to leave frame or to provide appropriate cutaways to shorten the actual time taken to complete the activity. While they are out of shot, the viewer will accept that greater distance has been travelled than is realistically possible.

Matching spatial relationships between shots: Editing creates spatial relationships between subjects which need never exist in reality. A common example is a shot of an interviewee responding to an out-of-frame question followed by a cut to the questioner listening and nodding attentively. This response filmed possibly after the interviewee has left the location is recorded for editing purposes in order to shorten an answer or to allow a change of shot size on the guest. The two shots are normally accepted by the viewer as being directly connected in time and the attentive 'nodding' is perceived as a genuine response to what the guest is saying. Cause and effect patterns occur continuously in editing. Any two subjects or events can be linked by a cut if there is an apparent graphic continuity between shots framing them, and if there is an absence of an establishing shot showing their physical relationship.

Non-linear editing

Video and audio can be recorded on a number of mediums: tape, optical, hard disk, or high density memory chips (integrated circuits). Tape has been the preferred method of acquisition because of its of storage capacity and cost.

Cameras recording on tape are recording in a linear manner. When the tape is edited it has to be spooled backwards and forwards to access the required shot. This is time consuming with up to 40% of the editing session spent spooling, jogging and previewing edits. Although modern VTRs have a very quick lock-up, less than a second, allowing relatively short pre-rolls, normally all edits are previewed which involves performing everything except allowing the record machine to be switched to record. The finished edited master has limited flexibility for later readjustment and requires a return to an edit session of the originating tapes if a different order of shots is required.

News acquisition and transmission requires the fastest possible turnaround time that can be achieved and non-linear editing (apart from the initial fast-dub from tape to store) is usually quicker than linear editing. Also it has the great advantage of being able to be recut to fit different news bulletins and updates on the story. Newsrooms are being planned around workstations where journalists can review, edit and voice-over material acquired in the field. Inevitably, post production, transmission and eventually acquisition are moving towards a server or disk-based environment.

Non-linear editing requires the ability to store vast amounts of digital data. With increasing computer power this has become available at a steadily decreasing cost. IBM estimates that the price of computer storage, in terms of price per megabyte, is halving every eighteen months, doubling the storage available for the same cost. Eventually quality digital video storage costs will match existing tape techniques and the transition from analogue tape to the digital disc-based system (or similar) will be complete.

The efficient use of the high cost of video data storage requires some form of compression. Although the cost of data storage decreases each year, it is still not economic to record uncompressed video for any useful length of time. Uncompressed component digital requires 270 MB per second – 486 GB for a half-hour recording. Digital compression can be transparent depending on content and cost but there are limitations. Combining different compressions for shooting, editing and transmission can cause problems. Digitizing the signal and then at each stage in the production/transmission process repeatedly coding and decoding the signal, can have a compound effect on the picture quality that in sum, is considerably worse than the individual compressions initially suggest.

Rearranging time and space

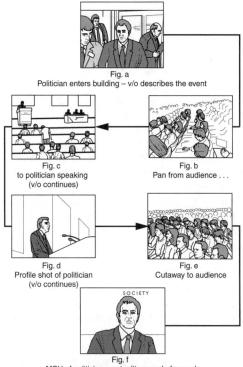

MCU of politician – actuality sound of speech

A politician enters a conference hall and delivers a speech to an audience. This whole event, possibly lasting 30 minutes or more, can be reduced to 15 seconds of screen time by cutting between the appropriate shots. In the first shot (Fig. a), the politician is seen entering the building with a voice-over giving details of the purpose of the visit. A cutaway to an audience shot with a pan to the politician on the platform (Figs c, d) allows all the intervening time to be collapsed without a jump cut, and also allows the voice-over to paraphrase what the politician is saying. A third, closer, profile shot of the politician (Fig. e), followed by a shot of the listening audience (Fig. f), continues with the voice-over paraphrase, ending with a MCU of the politician (Fig. f), with his actuality sound, delivering the key 'sound bite' sentence of his speech. A combination of voice-over and five shots that can be cut together maintaining continuity of time and place allows a 30 minute event to be delivered in 15/20 seconds.

Provided the main subject does not leap in vision from location one immediately to location two, and then to three and four, there will be no jump in continuity between shots. The empty frames and cutaways allow the editing-out of space and time to remain invisible. News editing frequently requires a reduction in screen time of the actual duration of a real event. For example, a 90 minute football match recording will be edited down to 30 seconds to run as a 'highlights' report in a news bulletin. Screen time is seldom made greater than the event time, but there are instances, for example, in reconstructions of a crime in a documentary, where time is expanded by editing. This stylistic mannerism is often accompanied by slow motion sequences.

Editing technology

Video tape editing started with a primitive mechanical cut and join system on 2-inch tape. As tape formats changed more sophisticated electronic methods were devised but the proliferation of recording formats (including the introduction of disc) meant that nearly all formats have their individual designated editing systems or they need to be dubbed to the preferred editing format. In news programmes and in many other types of programming there is also the need to use library material, which may be originated on a superseded and/or obsolete format. The lack of the simple standardization of film (i.e. it is either 35 mm or 16 mm with the complication of changing aspect ratios) has meant that a number of different video editing systems have been devised mostly using the same basic editing methods but taking place in a variety of recording formats. To add to the variety of contemporary formats and the back catalogues of material are the conversion and compression problems posed by the transition from analogue to digital television. An edit suite or field edit system is therefore defined by its analogue or digital format and whether the shot selection is achieved in a linear or non-linear form.

Selective copying

Recorded video material from the camera almost always requires rearrangement and selection before it can be transmitted. Selective copying from this material onto a new recording is the basis of the video editing craft. Selecting the required shots, finding ways to unobtrusively cut them together to make up a coherent, logical, narrative progression takes time. Using a linear editing technique (i.e. tape to tape transfer), and repeatedly re-recording the analogue material exposes the signal to possible distortions and generation losses. Some digital VTR formats very much reduce these distortions. An alternative to this system is to store all the recorded shots on disc or integrated circuits to make up an edit list detailing shot order and source origin (e.g. cassette number, etc.) which can then be used to instruct VTR machines to automatically dub across the required material, or to instruct storage devices to play out shots in the prescribed edit list order.

On tape, an edit is performed by dubbing across the new shot from the originating tape onto the out point of the last shot on the master tape. Simple non-linear disc systems may need to shuffle their recorded data in order to achieve the required frame to frame whereas there is no rerecording required in random access editing, simply an instruction to read frames in a new order from the storage device.

Off-line editing allows editing decisions to be made using low-cost equipment to produce an edit decision list, or a rough cut which can then be conformed or referred to in a high quality on-line suite. A high quality/high cost edit suite is not required for such decision making although, very few off-line edit facilities allow settings for DVEs, colour correctors or keyers. Low cost off-line editing allows a range of story structure and edit alternatives to be tried out before tying up a high-cost on-line edit suite to produce the final master tape.

There are two types of linear editing:

Insert editing records new video and audio over existing recorded material (often black and colour burst) on a 'striped' tape. Striped tape is prepared (often referred to as blacking up a tape) before the editing session by recording a continuous control track and time code along its complete length. This is similar to the need to format a disk before its use in a computer. This prerecording also ensures that the tape tension is reasonably stable across the length of the tape. During the editing session, only new video and audio is inserted onto the striped tape leaving the existing control track and time code already recorded on the tape, undisturbed. This minimizes the chance of any discontinuity in the edited result. It ensures that it is possible to come 'out' of an edit cleanly, and return to the recorded material without any visual disturbance. This is the most common method of video tape editing and is the preferred alternative to assemble editing.

Assemble editing is a method of editing onto blank (unstriped) tape in a linear fashion. The control track, time code, video and audio are all recorded simultaneously and joined to the end of the previously recorded material. This can lead to discontinuities in the recorded time code and especially with the control track if the master tape is recorded on more than one VTR.

Limitation of analogue signal

The analogue signal can suffer degradation during processing through the signal chain, particularly in multi-generation editing where impairment to the signal is cumulative. This loss of quality over succeeding generations places a limit to the amount of process work that can be achieved in analogue linear editing (e.g. multi-pass build-ups of special effects). This limitation can be reduced by coding the video signal into a 4:2:2 digital form (see page 18).

Compression and editing

As we discussed in Motion compensation (page 16), passing on only the difference between one picture and the next means that at any instant in time, an image can only be reconstructed by reference to a previous 'complete' picture. Editing such compressed pictures can only occur on a complete frame.

Provided the digital signal is uncompressed, there is no limit to how many generations of the original are 'rerecorded' as each new digital generation of the original material is a clone rather than a copy. Imperfections introduced in the editing chain are not accentuated except where different compression systems are applied to the signal in its journey from acquisition to the viewer. Nearly all digital signals from the point of acquisition are compressed. Care must be taken when editing compressed video to make certain that the edit point of an incoming shot is a complete frame, and does not rely (during compression decoding), on information from a preceding frame.

Editing requirements (1)

In-camera editing requires each shot to be recorded consecutively. Before recording a new shot, the previous shot must be previewed using the PLAY button on the VTR and when the edit point is decided pressing STOP. After pressing the RET button on the lens the tape will be rewound in approximately 7 seconds. When VTR START is pressed, action must be cued and taken up instantly on the cue. Any retake will require an earlier cut to avoid the cut it replaces with the consequent loss of another few frames of the previous shot (previous recording length must be at least 4 seconds).

This is time consuming because at every stage you have to close your options and make non-reversible decisions. It is inefficient because each shot has to be recorded in sequence and therefore constant camera repositioning means returning to previous set-ups. It is almost impossible to iron out sound jumps and, in total, it is most unlikely to produce an item that will compare with an edit suite compilation that brings the expertise, the post-production technology and the fresh eye to the material of an editor.

News editing requirements

Camera/recorder location work is often connected with news coverage. News by its nature is seldom if ever pre-scripted and therefore material is recorded without a written plan. The editor, sometimes with a journalist, needs to shape and structure the raw material, which will be a sequence of unconnected shots. There are many ways to assist the editor to get the best out of your camerawork. Shooting with editing in mind is essential. A series of disconnected shots have to be meaningfully edited together and this relies on the cameraman thinking and providing edit points. Nothing is more time consuming than the attempt to edit a pile of cassettes of ill-considered footage into some intelligent and intelligible form. To avoid this, the editor requires from the cameraman maximum flexibility with material supplied and the nucleus of a structure.

Brevity and significance

The value of a shot is its relevance to the story in hand. One single 10-second shot may sum up the item but be superfluous in any other context. Check that the vital shots are provided and at the right length before offering visual decoration to the item. Editing for news means reducing to essentials. Make certain that shot length allows for brevity in editing and the relevant cutaways are provided for interviews.

Technical competence

There is very little point in providing a number of shots if they are unusable due to wrong exposure, or if they are out of focus, or the colour temperature is incorrect, or if they are shaky and badly framed, and important action begins before the recording is sufficiently stable to make an edit.

The natural length of a shot

Wide shot of bus is held longer than close shot of damage, but close shots of people talking will sustain interest longer than wide shots of figures talking

Jumping backgrounds

Do not include the same background object in both MCUs

Information

Always mark cassettes with story title (if known), location, reporter, cameraman and any important information that has been gathered at the location and that may assist editing which is not in vision or on the soundtrack. Searching for a wrongly titled cassette can take as much time as shuttling to find the vital cutaway.

Editing requirements (2)

Variety of shot

In order to compress an item to essential information, the editor requires a variety of options. This means a variety of relevant shots in order to restructure a continuous event (e.g. a football match, a conference speech) and to reduce its original time scale to the running order requirement. A continuous 20-minute MCU of a speaker without audience or relevant cutaways will inevitably lead to a jump cut if more than one portion of the speech is required. Take the opportunity during a pause, which may signal a new topic, or on applause, to change the size of shot. Only 'keynote' sentences will be used and a difference in shot size at these points will avoid irrelevant cutaways to shorten the item.

Pans, zooms and tilts can be used in a number of ways if the shot is held for 5 seconds or more before the start and at the end of the camera movement.

Continuity

Be aware of possible continuity mismatch between shots in background as well as foreground information. As well as changes over time (weather, light, face tones) watch for changing background action that will prevent intercutting. Avoid staging interviews against significant movement (e.g. a crowd emptying from an arena or a prominent working crane) as background continuity mismatch may prevent the interview being shortened. If possible, have different parts of the background in the singles and two-shots if there is significant continuity of movement in the background or choose a static, neutral background.

Keep a check of position of coats, hats, cigarettes, attitudes of body and head on singles so that they can be matched in two-shots.

Speed of access

A large portion of an editing session can be taken up simply finding the relevant shot. Shuttling back and forth between different tapes is time consuming and the edit is greatly speeded up if thought is given to the order in which shots are recorded whenever this is possible.

Shot size

Avoid similar size shots whether in framing, scale, horizon line, etc., unless you provide a bridging shot. For example, a medium shot of an interviewee will not cut with a tight over-the-shoulder favouring the interviewee in the same medium size shot. Wide shots of sea and boats need to be intercut with closer shots of boats to avoid the horizon line jumping in frame. Make certain that the all-over geometry of a shot is sufficiently different from a similar sized shot of the same subject (e.g. GVs of landscapes).

In general, television is a close-up medium. Big wide-angle shots do not have the same impact they might have on a larger screen.

Crossing the line

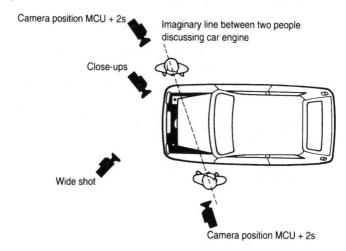

All camera positions must be on this side of the line unless there is a bridging shot to cross the line.

Crossing the line

To intercut between individual shots of two people to create the appearance of a normal conversation between them, three simple rules have to be observed. First, if the interviewee in a single is looking from left to right in the frame then the single of the interviewer must look right to left. Second, the shot size and eyeline should match (i.e. they should individually be looking out of the frame at a point where the viewer anticipates the other speaker is standing). Finally, every shot of a sequence should stay the same side of an imaginary line drawn between the speakers *unless* a cutaway is recorded which allows a reorientation on the opposite side of the old 'line' (e.g. either the speakers regroup or the camera moves on shot).

It is easy to forget eyeline direction when recording questions or 'noddies' after an interview has been recorded, particularly with a three-hander or when equipment is being demonstrated or explained. Make certain that the camera stays on one side only of the imaginary line drawn between the interviewer and interviewee.

Editing requirements (3)

Run-up time

Video material is edited (away from camera) by re-recording shots from the originating tapes into a new sequence onto a transmission tape.

Before each shot is transferred, both VTRs (playback and record) require a pre-roll from the edit point to allow the transport and servos to reach correct speed and stability. It is essential during this pre-roll, that there is at least 6 seconds of stable picture and continuous time code. If there is unrecorded 'shash' or the time code is discontinuous, then the edit may be aborted.

People have differing abilities to estimate time passing. At times, four seconds may seem like eight. Check that your ability to gauge an adequate runup time is accurate.

To avoid 'shash' keep the camera on PREHEAT during a shoot and only record from (CAMERA) ON and (VTR) STBY. Allow at least 6 seconds of recording **before** any action or interview begins.

Check that the BACKSPACE EDIT facility on the camera is working correctly.

Five-second module

News items tend to be constructed on an approximate 5 second module.

An example of a running order of a news story might be:

20 seconds voice-over establishing shots

15 seconds presenter to camera

10 seconds voice-over

45 seconds interview (with cutaways)

10 seconds voice over.

Running time of item: 1 minute 40 seconds. To allow maximum flexibility for the editor, try to shoot in multiples of 5 seconds. Keep zooms and pans short, e.g. 10 seconds hold at start of zoom (or pan); 5–10 seconds zoom (or pan); 5–10 seconds hold at end of movement. This allows the editor a choice of three shots.

Length of pan

Avoid long panning or development shots. Although it may be difficult, depending on the circumstances, try to begin and end camera movement cleanly. It is difficult to cut into a shot that creeps into or out of a movement. Be positive when you change framing. Use a tripod whenever possible as unsteady shots are difficult to cut and a distraction to the viewer.

Leaving frame

Do not always follow the action (especially on 'VIP' items where the temptation is to keep the 'notable' in shot at all times). It can sometimes help in editing if the subject leaves frame (hold the empty frame for a few seconds and on the

new shot hold the empty frame before the subject enters) as it enables the editor to choose between cutting or not on a moving subject.

Time code and editing

Editing requires the required shot to be quickly located on the appropriate tape (linear editing) or by code or description on a disc (non-linear editing). Identification of shots becomes of paramount importance especially in high speed turnaround operations such as news. Many non-news productions use a log (dope sheet), which records details of shots and the start/finish time code. News editing usually has to rely on previewing or pre-selection (if there is time) by a journalist. Video editing can only be achieved with precision if there is a method of uniquely identifying each frame. Usually at the point of origination in the camera (see page 88), a time code number identifying hour, minute, second, and frame is recorded on the tape against every frame of video. This number can be used when the material is edited, or a new series of numbers can be generated and added before editing. A common standard is the SMPTE/EBU, which is an 80-bit code defined to contain sufficient information for most video editing tasks.

There are two types of time code: record run and free run.

Record run

Record run only records a frame identification when the camera is recording. The time code is set to zero at the start of the day's operation, and a continuous record is produced on each tape covering all takes. It is customary practice to record the tape number in place of the hour section on the time code. For example, the first cassette of the day would start 01.00.00.00, and the second cassette would start 02.00.00.00. Record run is the preferred method of recording time code on most productions.

Free run

In free run, the time code is set to the actual time-of-day, and when synchronized, is set to run continuously. Whether the camera is recording or not, the internal clock will continue to operate. When the camera is recording, the actual time-of-day will be recorded on each frame. In free run (time-of-day), a change in shot will produce a gap in time code proportional to the amount of time that elapsed between actual recordings. These missing time code numbers can cause problems with the edit controller when it rolls back from an intended edit point, and is unable to find the time code number it expects there (i.e. the time code of the frame to cut on, minus the pre-roll time).

Location lighting

The most important element in the design of television images is light. Apart from its fundamental role of illuminating the subject, light determines tonal differences, outline, shape, colour, texture and depth. It can create compositional relationships, provide balance, harmony and contrast. It provides mood, atmosphere and visual continuity. Light is the key pictorial force in television production.

One of the simplest definitions of the aim of any TV production was stated succinctly as 'whatever is happening on screen, the viewer wants to see it and usually wants to hear it'. Good television lighting does a great deal more than simply enabling the viewer to see programme content, but usually the first basic technical requirements are to supply sufficient light to enable cameras to be correctly exposed, at the appropriate colour temperature, and to help modify or create a suitable contrast range for the subject in order to meet the requirements of TV broadcasting.

The basic requirement to provide adequate light for a correctly exposed picture with the required depth of field can easily be achieved. Video cameras are sufficiently sensitive to provide an acceptable exposure under almost any found lighting condition. But whereas the television technical requirements of exposure, appropriate colour temperature and contrast range, may be readily satisfied, the resultant image may be a muddle of competing areas of light and shade that do not communicate the intended 'visual message' of the shot. The control of light to guide the audience's attention and to communicate production requirements plays a crucial part in the creation of any film or TV image. In almost every situation, visual communication can be more effective by choosing the camera position or staging participants with reference to available light or if necessary, by adding some form of additional light.

The nature of light

In order to control light it is necessary to understand how light behaves and have some means of measuring its physical characteristics.

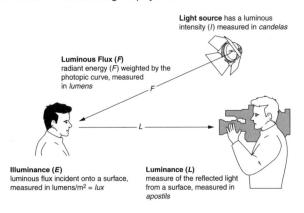

Inverse square law

Luminous flux emitted into the solid cone from a point source of 1 candela = 1 lumen

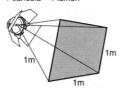

Illumination of shaded surface is $1 \text{ lumen/m}^2 = 1 \text{ lux}$

NB: the diagrams are not to scale and the lamp illustrated is not a point source at the distance indicated.

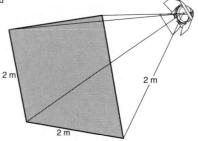

If distance from light source to shaded area is doubled, then the illumination of shaded area will be 1 lumen per 4 sq. metres or 0.25 lumen/m²

Doubling the distance from light to subject quarters the level of illumination (lux) falling on the subject.

Cosine law

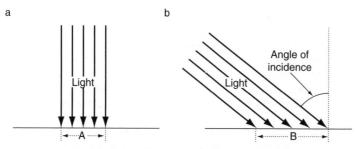

Light perpendicular to a surface (Fig. a) will cover area A. If the angle of a light beam to a surface is less than 90° (Fig. b), the area covered (B) will increase and the illuminance of that surface is reduced by a factor equal to the cosine angle of incidence, e.g. for a 30° angle of incidence, illuminance is reduced to 86% (cosine $30^\circ = 0.86$).

Perception

Using a visual medium is choosing to communicate through pictures and in television, the end result of manipulating lens, camera position and lighting must be images that are compatible with human perception. A basic understanding of how we see the world will help when devising the lighting and composition of a shot. There are significant differences between how the eye responds to a scene and how a camera converts light into an electrical signal. Lighting must take account of these differences and make the appropriate adjustments.

Characteristics of light

The four characteristics of light, quality (hard or soft), direction (frontal, side, back, underlit, top lit, etc.), source (available light, additional lights), and colour, can be manipulated by the lighting cameraman to achieve the precise requirements for a specific shot. The auto features on a camera are often unable to discriminate the priorities of a shot and must be overridden, so likewise, to simply accept the effects of a found lighting situation is to disregard the most powerful part of image making. Available or 'found' light is any combination of sunlight and/or artificial light that illuminates any potential location.

Quality

The quality of light produced by a natural or an artificial light source is often categorized as 'hard' or 'soft'. A 'point' source (i.e. a small area of light at a distance from the subject) produces a single hard-edged shadow. An unobscured sun or moon is a hard light source. Hard lighting reveals shape and texture, and, when produced by a lamp, can be shaped and controlled to fall precisely on the required part of the frame. Shadow areas of an image (the absence of light or very low light levels) often play an essential part in the composition and atmosphere of a shot. Lighter and darker areas within the frame help to create the overall composition of the shot and to guide the attention of the viewer to certain objects and actions. Shadows on a face reveal structure and character.

A soft source of light can be produced by a large area of light (relative to the subject) and can produce many overlapping soft edged shadows and tends to destroy texture. It is not so controllable as hard light but is often used to modify the effect of hard light. For example, by bouncing sunlight off a large area reflector to fill in the shadow created by sunlight falling on the subject.

How much light is used and where it is focused also sets the 'key' of the image. A brightly lit shot with little or no shadow is termed a high key picture and is usually considered cheerful and upbeat. An image with large areas of shadow and very few highlights is termed a low key image and appears sombre, sinister or mysterious.

Direction

The direction from which any part of an image is lit affects the overall composition and atmosphere of a shot (see also Lighting a face, page 170). Frequently when setting lamps for a shot, the position and therefore the direction of illumination is controlled by the perceived 'natural' source of light (e.g. window or table lamp in an interior).

Brightness

One aim of lighting is to create a range of tones either to conform to the contrast ratio of television or to express a production requirement. The relative brightness of a reflective surface is a subjective perceptual construct depending

on the brightness levels of surrounding surfaces. Human perception responds to equal changes in brightness levels in a logarithmic manner and this can be mimicked by changes in grey scale step brightness. As we have discussed in Colour temperature (page 52), the eye continually adapts to changes in colour and has a much wider ability than a video camera to see detail in shadows through to highlights.

How 'bright' one subject appears compared to another and the perceived changes in brightness is a function of perception. In an interior, a face against a window during the day will appear to be dark. With the same illumination on the face against a window at night, the face will appear to be bright. Colours appear to be lighter against a dark background and darker against a light backing.

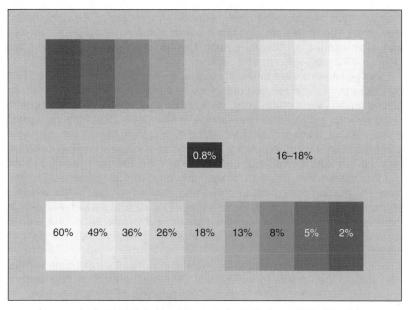

A grey scale chart is designed to mimic perception by having a series of grey tones starting with a peak white reflectance of 60% (UK) and decreasing by $\surd 2$ to produce equal changes in brightness to the eye. This logarithmic progression is similar to the ear's response to equal changes in sound level. Starting at 60% and decreasing by $\surd 2$ produces (in this design of grey scale) 9 wedges with 0.8% black represented by a hole in the chart which is lined with black non-reflective flock paper. The background tone of the chart is often 16–18% reflectance to simulate average scene brightness. As a grey scale chart can be used to check the transfer characteristics of a camera, the chart may indicate the gamma compensated reflectance figure of its design, e.g. gamma = 2.2.

Controlling light

Although daylight is the simplest and most readily available form of exterior lighting it can cause many problems in control, direction and strength. Strong sunlight will cause dark shadows without detail and becomes a particular problem with faces when the sun is overhead. Deep set eyes will be in shadow and unlike a lamp, the sun continually moves during the day causing problems with continuity. The light from the sun is immensely powerful compared to the output of location luminaires employed to mitigate its effects. Daylight is cheap, usually available but difficult to control when it is in the wrong place.

Reflectors and lamps can be used to modify shadows but tungsten lamps require blue filters to correct their colour balance to daylight, which reduces their luminous intensity. There are methods of softening or obscuring strong sunlight by interposing diffusing fabric between subject and sun but the cost and time needed to construct such frameworks virtually eliminates this technique for most video location work.

Location interviews are easier to stage when there is a continuity of lighting conditions such as an overcast day or where there is consistent sunshine. The natural lighting will have to cater for three shots and possibly three camera positions – an MCU of the interviewee, a similar sized shot of the interviewer and some kind of two-shot or 'establishing' shot of them both. If it is decided to shoot the interview in direct sunlight, then the interview needs to be positioned with the sun lighting both 'upstage' faces (i.e. the camera is looking at the shaded side of the face) using a reflector to bounce light into the unlit side of the face. The position of the participants can be 'cheated' for their individual close shots to allow a good position for modelling of the face by the sun. Because of the intensity of sunlight and sometimes because of its inconsistency, it is often preferable to shoot the interview in shade avoiding backgrounds which are in the full brightness of the sun.

The background is often the main decider of position either because of its relevance to the story or for the wish to establish the location. Frequently a position is chosen to avoid a high contrast background (large area of sky in frame) or to avoid wind noise or other background noise.

Neutral density filters

A recurring problem with location interiors is to control and balance the intensity of daylight from windows with the much lower light levels from lamps. Neutral density (ND) filters will reduce the level of daylight without changing its colour temperature. They are made of flexible gelatine or thin acrylic sheets and are available in a range of grades including:

- 0.15 ND 1/2 stop loss
- 0.3 ND 1 stop loss
- 0.6 ND 2 stops loss
- 0.9 ND 3 stops loss
- 1.2 ND 4 stops loss

They can also be combined with colour correction filters (see also page 179).

Battery lamp intensity

Using available top light gives adequate foreground and background exposure but produces ugly nose shadow across mouth and eyes are in deep shadow.

Switching on battery lamp on top of camera provides better face modelling, but increased light on face produces underexposure on background. 'Headlight' effect of brightly lit foreground and dark background.

Diffusing battery lamp with spun and reducing intensity gives better balance between background and foreground.

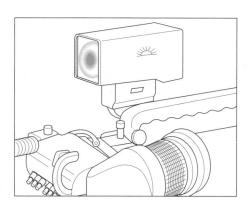

Battery Lamps: Battery lamps have become a standard fixture for news gathering and are indispensable for coping with the unpredictable situation.

They are fixed to the top of the camera and powered from the camcorder battery or, preferably, a separate battery belt. When working in daylight they require a dichroic filter to correct the colour temperature of the lamp to daylight. A dichroic is made of glass and is therefore more fragile than gel filters but their advantage is that they transmit approximately 15% more light than gels.

Battery lamps attached to the top of the camera need careful use if they are not to give a 'startled rabbit in a headlight' look to interviews. If they are used too close to an interior subject the exposure will sit the background down if lit by an existing interior light.

Because the light is full frontal, care must be taken to keep subjects away from walls to avoid background shadows. Use a diffusing filter to avoid blinding the presenter especially at night. On-camera lamps quickly run the battery down if used continually.

Lighting a face

Early film was lit by natural light. Artificial light sources were introduced for greater production flexibility and economic reliability (e.g. to keep filming whatever the weather). A system of lighting faces (often the most common subject in feature films) was devised using three-point lighting (see figure and text opposite).

The quest for a 'natural' look to an image produced a fashion for using large areas of bounced light. Modelling on a face was reduced or eliminated and the overall image produced was softer and less modelled. To heighten realism, and because of the availability of very sensitive cameras, many shots were devised using available light. This is often necessary when shooting documentaries because not only does rigging lights take time and unsettle participants, but being filmed under bright lights is inhibiting and counter-productive to the aim of recording unmediated 'actuality'.

A 'talking head' is probably the most common shot on television. The reflectivity of the human face varies enormously by reason of different skin pigments and make-up. In general, Caucasian face tones will tend to look right when a 'television white' of 60% reflectivity is exposed to give peak white. Average Caucasian skin tones reflect about 36% of the light. As a generalization, face tones are approximately one stop down on peak white. But as well as achieving correct exposure, lighting a face also involves making decisions about how a specific face is to be portrayed. Most professional presenters know their 'good' side and their 'bad' side. This may be to do with blemishes or their nose line but usually it is because faces are often asymmetrical about the centre-line.

The lighting treatment must take into account blemishes ('key' into the blemish), emphasizing or adjusting the overall shape of the face, the shape of the jaw line, the line of the eyes, the line of the mouth, etc. The American cinematographer Gordon Willis used top lighting on Marlon Brando in *The Godfather* to help reduce Brando's jowls but this also had the effect of putting his eyes in shadow and making him more mysterious and threatening. Presenters with deep set eyes can lose contact with their audience unless a way is found to get light on to their eyes. A catch light reflected in the eyes often lifts the personality of the face and allows the viewer 'eye contact' with the most important part of the face.

Location lighting may only have to accommodate one face and one camera position, but the shot may include a natural lighting source such as a window or the direct light from the sun. Ideally, the aim is to light artistes separately to their backgrounds as this enables control of the lighting of both areas to be achieved.

Three point lighting

Key light

A single strong directional light gives the best modelling and structure to a shot. The key light provides the necessary exposure and brings out the three-dimensional aspects of the subject. As we have discussed, when keying faces, the decisions to be made are: where should the nose shadow fall (or should there be a nose shadow?), are deep-set eyes lit, does the angle and position of the key suit the structure of the subjects face, are there reflections in spectacles, and are any facial imperfections exaggerated or concealed? Does it throw unwanted shadows on the background of the shot?

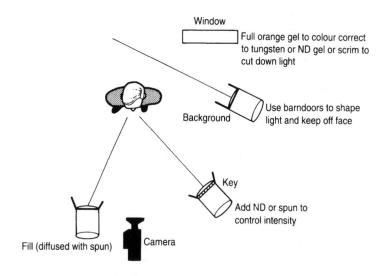

Fill

Wherever the key is placed, the strong shadows it creates need to be modified to reduce the contrast range and normally to lighten the mood of the shot. This is achieved by a fill light usually on the opposite side of the lens to the key, which is a soft source of light produced by a reflector or a diffused flooded lamp or an overcast sky but not direct sunlight. The key-to-fill ratio on the face is the contrast range and can be balanced by using a meter or estimated by eye to match the required mood of the shot. An average is between 2:1 and 3:1.

Backlight

It is usually necessary to find some visual way of separating the subject from its background so that attention can be focused on the subject. Check for suitable unobtrusive background detail when positioning camera and subject and use a hard light source directed from behind the subject to highlight the head. This will give sparkle to the hair and rim light the shoulders. Try to avoid too high an intensity – the backlight should hardly be perceptible.

Background light

To avoid people being shot in limbo, some light needs to be directed to the space behind them. The aim should be to light sufficient background to provide some indication of location whilst avoiding overpowering the foreground. A lit background gives space and mood to the shot but on location, ensure that it conforms to the main source of light.

Lighting levels

How light is shaped, balanced and distributed within a shot plays a vital part in an image but there are a number practical considerations when deciding the overall level of light that is to be used. These include:

- satisfying exposure requirements which depend on camera sensitivity
- · creating an appropriate depth of field
- providing a good environment for artist's performance
- heat generation, ventilation, number of luminaires available, total capacity and cost of the power supply.

Camera sensitivity is usually quoted by camera manufacturers with reference to four interlinking elements - a subject with peak white reflectivity, scene illumination, f-number, and signal-to-noise ratio for a stated signal. It is usually stated as being the resulting f-number when exposed to a peak white subject with 89.9% reflectance lit by 2000 lux and also quoting the signal/noise ratio. For most current cameras this is f8 with some achieving f11 and better. The definition is based on the Japanese standard for peak white reflectivity of 89.9%. The rest of the world mostly use a 60% reflectance peak white based on the need to correctly expose (Caucasian) face tones without overloading (overexposing) on a peak white area. With a 60% reflectance surface, 2000 lux will only allow it to be two thirds exposed therefore the illuminance has to be increased to 3000 lux to transpose the sensitivity rating to 60% peak white operation. The sensitivity of the camera could be increased by simply greater and greater amplification of weak signals but this degrades the picture by adding 'noise' generated by the camera circuits. In many 'actuality' location work (e.g. news gathering, sports coverage, etc.), the gain of the head amplifiers can be increased if insufficient light is available to adequately expose the picture.

Depth of field: Lighting level will determine f-number for correct exposure, which in turn will decide depth of field (see Depth of field, page 42). The range of subjects in focus within the frame will have a significant effect on the visual appearance of the production. The chosen depth of field can therefore be a production design element as well having a crucial impact on the ability to find and hold focus in ad-lib camerawork. Other factors that affect exposure include shutter speed, lens range extenders, zoom ramping, filters, prompt devices and the lighting environment to accommodate performance and mood.

Mood and atmosphere: With highly sensitive cameras, it is possible to achieve correct exposure with very low light levels – levels which may appear to be darker than a brightly lit office corridor. This may be appropriate for some types of location work but it can have a depressing effect on other types of production. A location should be lit at a level that provides a good environment for participants and enhances their presentation. The opposite consideration, of high intensity key lights close to the eyeline, can also inhibit optimum performance and is usually avoided.

Types of location luminaires

Reflector: A reflector board or sheet requires no power and takes up very little space. It is invaluable for fill-in lighting by bouncing light from daylight or lamp into shadow.

Battery lamps: These are fixed to the top of the camera and powered from the camcorder battery or, preferably, a separate battery belt. When working in daylight they require a dichroic filter to correct the colour temperature of the lamp into daylight. A dichroic is made of glass and is therefore more fragile than gel filters, but their advantage is that they transmit approximately 15% more light than gels.

Flight kit (portable lighting kit): This is a two or three lamp kit that derived its name from its compact size, small enough to fit into a metallized container for quick stowage and easy transportation.

Redhead: This is an 800 W lamp drawing 3.3 A, weighing 3 kg including barndoor and safety glass, with an output of approximately 6000 candelas (cd) flooded and 24000 cd spotted when over 4 m.

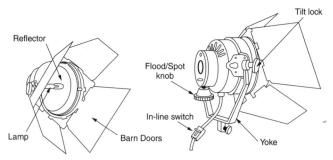

Blonde: This is a 2000 W lamp drawing 8.3 A and weighing 6 kg with barndoor and safety glass. It produces approximately 25,000 cd flooded and 150,000 cd spotted when over 6 m. Because of their weight and flexibility and their low power consumption they can be rigged and derigged quickly and plugged into most domestic power supplies.

Discharge lamps: Discharge light sources such as HMI lamps produce light by ionizing a gas contained in the bulb. They have greater efficiency than tungsten, are lighter and cooler in operation and produce light which approximates to daylight. They require an EHT supply to ionize the gas and a current limiting device. This may be a simple inductive choke or in the form of a flicker free electronic ballast. A 1.2 kW HMI, which is one of the most useful on a small unit with conventional ballast, will draw 12 A when switched on but settle to 6.4 A when warmed up. It can therefore be used on a domestic 13 A ring main circuit providing no other lamps are connected when it is switched on.

Ballast: The use of high-frequency dimmable ballasts operating above 40 kHz provide a flicker free output and allow dimming with a simple 0–10 V control (or $100 \, \mathrm{k}\Omega$ potentiometer) to achieve reduction in lighting levels with little change in colour (unlike dimmed tungsten sources).

Cold light

The use of high-frequency fluorescent lights has become a viable option both in studios and on location. The merits of such lights compared to tungsten are:

- greater efficiency, or more correctly efficacy, producing 3 to 4 times more light than tungsten sources. Tungsten halogen produces 25 lumens/watt, whereas fluorescent lamps, depending on type, can produce up to 100 lumens/watt.
- no radiant heat in the light beam, unlike tungsten sources which radiate typically 55% of lamp power in the beam. This means the artistes are more comfortable under cold light sources.
- fluorescent luminaires usually use several lamps to produce a practical light source, hence they are soft sources, i.e. not point sources. This results in less glare for the artistes, again, adding to their comfort. Control of the light beam shape is either by a fine structured 'egg-crate' or 'honeycomb' fitment.

In recent years the development of improved phosphors has made the fluorescent lamp acceptable for television and film. Phosphors are available to provide tungsten matching and daylight matching colour temperatures. This is a distinct advantage on location; one can simply change the fluorescent tubes to suit the environment.

Ballast

The use of high-frequency dimmable ballasts operating above 40 kHz provides:

- · a flicker free output
- dimming with a simple 0–10 V control (or $100 \, \mathrm{k}\Omega$ potentiometer) to achieve reduction in lighting levels with little change in colour (unlike dimmed tungsten sources).

Luminaires have been developed using:

- (a) 40 W tubular lamps
- (b) 55 W and 33 W biaxial lamps
- (c) 26 W com-quad lamps
- (d) 32 W triple biaxial lamps.
- (b), (c) and (d) are compact fluorescent lamps (CFL).

Most location based luminaires use (a) and (b), enabling a compact structure to be made of large area but small depth. Some luminaires operate with a separate ballast to reduce weight.

Another advantage of cold light sources is the ability to touch and de-rig the luminaires immediately the shoot has finished – very little heat is generated.

Control of light beam spread is by means of a honeycomb type screen over the front of the fixture. The degree of control depends on the depth of the honeycomb or the area of the apertures: typically 90°, 60° or 30°. Alternatives to using control screen are egg-crates, barndoors or flags.

There are two basic types of fluorescent luminaire, one uses the conventional tubular lamps (TL-D), the other uses the compact fluorescent lamps (PL-L and PL-C). Like all discharge lights the fluorescent luminaire includes a current limiting ballast in addition to auxiliary electronics for starting. The ballast also includes the necessary electronics to drive the lamps at high frequency (>40 kHz). The luminaires using the TL-D lamps were designed for use mainly on location. They are made with a separate ballast, usually dimmable, to provide an extremely lightweight and thin softlight, ideal for use in cramped conditions.

Colour rendition index Ra

A method of comparing the colour fidelity and consistency of a light source has been devised using a scale of 0 to 100. The colour rendition index Ra can be used as indication of the suitability for use in television production with an Ra of 70 regarded as the lower limit of acceptability for colour television.

Colour correction

Whether shooting interior or exterior, a fundamental problem with location work is dealing with a mixture of light of different colour temperatures. If the light remains uncorrected, faces and subjects may have colour casts which look unnatural and distracting.

The two most common light sources on location are daylight, which has a range of colour temperatures but averages around 5600K, and tungsten light which is often produced by lamps carried to the location which are approximately 3200K.

Colour correction filters

There are two basic types of correction filter used when attempting to combine mixed lighting of tungsten and daylight:

- an orange filter which converts daylight to tungsten and is most often seen attached to windows for interior shots;
- a blue filter which converts tungsten to daylight and is often used on tungsten lamps.

Any correction filter will reduce the amount of light it transmits and therefore a balance must be struck between colour correction and sufficient light for adequate exposure.

A filter for full colour conversion from daylight to tungsten will have a transmission of only 55%, which means nearly half of the available light is lost.

A filter for full colour correction from tungsten to daylight has an even smaller transmission factor of 34% – it cuts out nearly two thirds of the possible light from a lamp. This is a more serious loss because whereas daylight is usually more than adequate for a reasonable exposure, reducing the light output of a lamp (say a redhead) by blue filtering to match daylight may leave an interior lit by blue filtered lamps short of adequate light.

All light sources at same colour temperature

The choice when shooting in an environment that has a mixture of daylight and tungsten is to decide whether to correct all sources to daylight or all sources to tungsten.

Tungsten: If the choice is tungsten, any window which is in shot or producing light that is reaching the shot requires filtering. It needs a full orange filter squeegeed onto the glass or fastened by double-sided tape onto the frame.

Orange filters can be obtained which have additional light reduction by combining with neutral density filters. This is helpful when attempting to balance out a very bright window with the interior lit by lamps.

Daylight: If the choice is to light by daylight, then all lamps must be blue filtered to correct them to daylight (5600K) and a careful check made on any table

lamps or domestic lighting that may influence the shot. The disadvantage of going daylight is the reduction in light output due to the filters and the increased contrast range between subjects lit by a combination of daylight and tungsten. Neutral density filters without colour correction can be used on windows to reduce the intensity of daylight and to achieve exposure on external detail.

Interview with mixed light

A recurring news and feature item is the location interior interview. It usually requires shots of the interviewee seated in their office or house being questioned by a presenter. There are a number of questions to be answered before deciding camera position and interview position:

- Is there a colour temperature difference and balance between daylight entering from windows and the light provided by added lamps?
- Do windows need to be in shot?
- Does the interview position allow a variety of shot to sustain a long interview if required?
- Can the relationship of people be shown?
- Is the environment of the interviewee important to the interview?
- Does the background to the shot give more information about the topic?
- Is there a comfortable distance between participants to allow them to relate to each other?
- Is there sufficient space in the chosen location and how convenient is it to relight and reposition for reverses?

The first decision to make is whether to go tungsten or daylight. If daylight is consistent and there is no direct sunlight on the proposed interview area, then colour correcting for daylight is the best option, using daylight as the main source.

If sunlight is entering the room and if it is intermittent, then avoid windows in frame and light by tungsten filtering or curtaining out the large changes in brightness from the sun.

Position the camera close to the shoulder of the interviewer with the lens at approximately seated eye-level to get a good eyeline on the interviewee. Light for that position checking for a good fill ratio and if the background is adequately lit. Switch off installed fluorescent lighting if possible and check sound level for background noise. Check exposure, white balance and voice levels and record the interview. Only reframe on interviewee during questions unless a move has been agreed. Keep the camera recording after the interview has ended. Sometimes, a vital comment is made at the end.

After confirming that no more questions are to be asked, reposition the camera for a two-shot checking that there has been no significant change of posture or any other continuity links between single and two-shot. Record the two-shot with the interviewer repeating some of the questions.

Reposition and relight for the interviewer's questions and noddies, staying on the same side of the imaginary line between interviewer and interviewee as the shot of the interviewee.

Mood and atmosphere

Source of light

When adding to existing light, try to make certain that the new illumination and shadows created are consistent and logical with the original light sources that appear in the frame.

A window in an interior shot will be seen by the audience as the main source of light. Additional lighting should be positioned out of frame to reinforce the direction of the perceived main source of light. The keyed side of the face should be on the same side as any lit practical in frame (e.g. table lamp beside the subject).

If there is no apparent source of light within the frame, then lamps can be placed to suit the subject depending on the practicalities of placing the lighting stands and the requirements of the shot.

Think ahead before lighting the first shot to be recorded because lighting continuity in subsequent shots will require the same direction and apparent source of light to be consistent. The questions to ask are: will it be possible to light reverses from the same direction, is there room to place and direct lamps, will that direction be suitable for the subject, and how long will it take to relight?

Mood and programme style

Lighting sets the mood of a shot and therefore consideration should be given to the lighting style and if it matches the aims of the programme.

For example, news coverage is an attempt to report events objectively. Because of expediency, news pictures are often lit by existing light or flooded with a battery lamp to get an exposure. There is neither the time nor the facilities to achieve the style of the controlled portrait lighting that is normal in a studio set.

News pictures achieve a feeling of objectivity because of this apparent lack of careful control – a lack of technique – but this is misleading. News technique is the ability to control and use existing light and deal with a situation at speed, which means implementing a number of lighting short-cuts accumulated from experience.

A documentary style of lighting is close to this technique but there is the time to have a more considered approach when lighting interviews and locations.

Match your lighting style to the content of the programme. Develop speed in lighting by mentally plotting position of camera and lamps wherever you are. Leave obtrusive lighting styles to pop concerts and entertainment shows. Attempt to make your lighting technique invisible and keep it simple.

Basic lighting checklist

- Be consistent with a featured source of light when shots are intercut.
- Avoid over lighting.
- · Avoid shadows on background and flare on camera.
- Use barndoors to control shape of lighting on background.

- · Avoid overfilling and avoid too much backlight.
- Treat glare from shiny surfaces with putty or anti-flare.
- Avoid excessive contrast by adjusting curtains or blinds, restaging or by ND filter.
- Eliminate reflections of lamps in picture glass by angling or tilting the picture.

Filters and diffusers

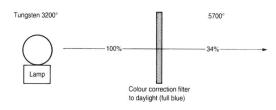

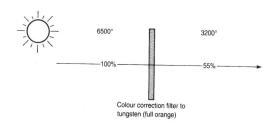

Neutral density filters: A recurring problem with location interiors is to control and balance the intensity of daylight from windows with the much lower light levels from lamps. Neutral density (ND) filters will reduce the level of daylight without changing its colour temperature. They are made of flexible gelatine or thin acrylic sheets and are available in a range of grades. They can also be combined with colour correction filters. The filters are fixed to windows in a method that will avoid being seen on camera. Although ND gel can buckle and produce flares, it is easily transportable in rolls. The acrylic sheet needs to be cut, is difficult to move and is expensive.

Plastic 'scrim' a perforated material silver on one side and black on the other, can also be used on windows (black side in) to act as a neutral density filter (0.6 ND). It is more robust than ND gels and not so prone to flare. Check that its perforated pattern cannot be seen on camera.

Polarizing filters on the camera lens reduce reflections and glare, darken blue skies and increase colour saturation. They are useful in eliminating reflections in glass such as shop windows, cars and when shooting into water. The filter must be rotated until the maximum reduction of unwanted reflection is achieved.

Spun or diffusion, a fibreglass-type material, is used in front of lamps to diffuse or soften the light. It also reduces the lamp intensity. It can be used to cover partially a portion of the lamp's throw to soften edges and to produce a reduction in brightness in part of the shot. It is available in a range of grades and can be doubled up in use to increase diffusion.

Colour filters: Polyester filters have a clear plastic base coated with a coloured pigment. Polycarbonate filters have the base material mixed with the pigment. They are referred to as high temperature (HT) filters and are not affected by heat as much as the polyester filters.

Colour correction filters are used to correct the light sources to a common colour temperature, e.g. tungsten sources to daylight (5500K), daylight to tungsten (3200K) or to correct both sources to an intermediate value.

Barndoors are metal flaps fitted to the front of the lamp lens and can be adjusted in a number of ways to keep light off areas in shot and to shape, soften and produce gradations on surfaces.

Colour and mood

Warming up the picture

Colour temperature correction and white balance are used to accurately reproduce colour. There may be occasions when a slight distortion of colour rendering is required.

One simple technique is to white balance on a card that is not white. Using a card that is slightly blue under the main source of light, the camera is white balanced. The white balance circuit assumes that the card is white and equalizes the output of the red, green and blue channel outputs to produce the correct ratio for white. This means increasing the yellow/orange gain to counteract the bluish tint of the 'white' card. When a normal scene is exposed, the camera will produce straw coloured pictures. Alternatively, if the card used for white balance has a yellowish tint, the balance circuit will produce pictures that are bluer or 'cooler' than normal.

The same result can be achieved by placing a 1/4 CTB filter for 'warmer' pictures and a 1/4 CTO filter for 'cooler' pictures between lens and white card used for white balance. Use the filter only for white balance.

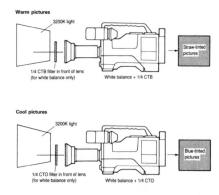

A part of the complete picture (such as a face) can be 'warmed' by selective filtering the lamp illuminating the subject with the appropriate straw-tinted gel. Do not white balance with this lamp (unless you remove the coloured gel), otherwise the camera will correct for the 'warmer' colour and produce a normal colour rendition.

Producing warm interiors and cool exteriors

Colour correction need not go full tungsten or full daylight. A halfway stage using 'half correction' filters can be used. The aim is to partially correct the location lighting and move it a quarter of the way to daylight. Windows are filtered 1/4 colour orange to correct a small way towards tungsten. If the white balance is carried out in a combination of filtered daylight and filtered tungsten the resultant pictures will have very warm tones in the interior and a blue exterior through the windows.

Colour temperature correction of discharge sources

CSI, HMI and CID lamps have different colour temperatures to standard tungsten lamps. They require different filtering when used in mixed light situations (see table below).

Colour temperature and MIRED

A micro reciprocal degree (MIRED) value is based on the reciprocal value of the colour temperature of a light source and allows the relationship between the amount of colour temperature shift and a correction filter to be stated. The MIRED value of a light source = 10^6 /Kelvin value.

A given colour temperature correction filter will produce a constant shift in the MIRED value of a light source.

An example of the formula in action: a lamp with a colour temperature of 3200K needs to be fitted with a colour correction filter to convert its colour temperature to 4000K. What MIRED value of filter is required?

 10^6 divided by 3200K = 312.5

 10^6 divided by 4000K = 250

-62.5 MIRED value filter is required

Colour temperature of discharge sources

CSI	Compact source iodide	4000K
HMI	Mercury medium arc gap iodides	5500K
CID	Compact iodide daylight	5600K
MSR	Medium source rare earth	5600K

Electrical location safety

More haste

Location recording is often a scramble to rig, record, wrap and move on to the next set-up. There is always the urgency to get the job done, but as pressurized as this may be, it is never expedient to cut corners on safety. A couple of minutes saved by not making safe a cable crossing the top of a flight of stairs may result in injury and many hours of lost time. You have a responsibility to ensure that the condition and the method of rigging lamps and cables at a location is safe to yourself and to members of the public.

Periodically check the earthing and safety of your lamps. Make certain the safety glass or wire is fitted and not damaged in any way. Check the condition of cables for frayed or worn insulation and that they are earthed correctly.

HMIs

Discharge light sources such as HMI lamps produce light by ionizing a gas contained in the bulb. Because of a high bulb pressure they are liable to explode and they also produce a harmful level of ultraviolet radiation. Therefore all discharge sources must be fitted with a glass filter as a safety glass. Usually an inter-lock will prevent the supply of EHT if the safety glass is broken or missing.

Check that any HMI you are using has a safety glass fitted.

Location electrical supplies

It is important to check the power supply fuse rating and the condition of the wiring before using a domestic supply. Blown fuses can waste time but burnt out wiring could start a fire. Also check cable runs, especially around doors and tops of stairs. Check where you place lamps. They get hot and so will anything touching them.

Care and consideration

If you need to attach any material to windows, use masking tape or low-tack tape so that you leave the paintwork as you found it. Remember, you may want to return to that location. If you have ever followed a TV crew that caused problems onto a site, you will appreciate that loss of goodwill from the public makes for a very hard day's shoot. People appearing on television for the first time may be nervous or excited. You may be under pressure to get the job done and onto the next set-up. When working with the public, their safety and your safety are equally important.

Accidents and disasters

Police or authorities in control of an accident locale or disaster area may exclude you from the location if you are not wearing a protective (hard) hat and luminous 'vest'. The requirement is in the interests of your safety as well as the interests of other people working on that site.

Check cable runs

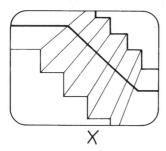

Check capacity of supply

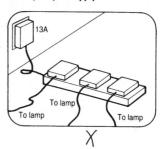

Check position of lamps

Check lamp cables

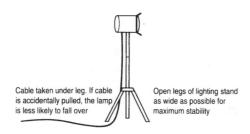

Add weight to the base of the lamp support to prevent it being blown over or accidentally pulled over.

Programme production and audio

Many news and magazine items are shot by a single operator. The cameraman is responsible for pictures, lighting and audio. This section of the manual deals with audio that is recorded in this way although this does not mean the control of audio should be passed over to the ubiquitous auto gain. No cameraman would be happy with a camera that had no viewfinder, simply an auto composition/auto shot selection button. This is the visual equivalent of auto gain – allowing the camera to make all the audio decisions.

Television programme sound can have a significant emotional effect on the audience and yet remain quite unnoticeable. Someone once said that whereas an image is a statement, sound is a suggestion. Sound does not simply complement the image, it can actively shape how we perceive and interpret the image. The production contribution of sound is usually the most unobtrusive and difficult for the audience to evaluate — until it is badly done. Visual awareness appears to take precedence over audible awareness and yet intelligibility, space and atmosphere are often created by sound. The selection and treatment of audio shapes our perception and can be used to focus our attention just as effectively as the selection of images.

Match the sound to the pictures

Matching the sound to the picture is a fairly obvious requirement but whereas image content can be quickly assessed, it often needs a trained ear to identify the complete sound spectrum being recorded. The shot may be someone in medium close-up talking. The sound may include in equal proportion, the person's voice, unseen traffic and a noise from a children's playground. If the cameraman's attention is simply focused on the speaker, the competing background sound is ignored until the cassette gets into post production. Audio post production is a good training ground for location sound. In many ways, recording audio on location is a bigger challenge than the facilities available in a purpose built studio. There are many problems that are created simply by lack of time, equipment limitations and the production convention that sound follows picture. It is rare that good sound conditions are decided on before the selection of the shot and yet sound and image are often of equal importance and need equal attention.

What can be fixed later?

Although remedial work is possible in editing and dubbing, if post production begin their work with good quality audio, sound that matches picture perspective and a range of location sounds (wild tracks to provide flexibility in the edit), they can add to the original tracks rather than be faced with a challenge of salvaging something usable. 'Fix it in editing' is as bad a work convention in audio as it is in video.

Audio manipulation

The selection and treatment of sound in a production shapes the perception of the audience and involves a range of audio techniques. These include: **Adjustment of loudness** in order to emphasize production content; to indicate priority (e.g. dialogue louder than background traffic); to exploit the dynamic range of sound (e.g. quiet contrasted with loud passages in orchestral music).

Pitch is a subjective quality of the frequency of sound vibrations and each frequency band, similar to colour, has associated feelings.

Timbre is the tonal quality of a sound as judged by the ear. It describes the texture or feel of a sound, and can be manufactured for specific production purposes (e.g. the use of distort for a telephone voice).

Reverberation is the reflection from surfaces and can be artificially created by using digital delay to the audio signal to simulate the effect of audio echo to suggest environment. Audio delay is also required when a visual source has been delayed by a frame store or satellite link. The sound is delayed to match the timing of the image.

Fades and mixes mark the transition between sound sources, production sections or complete programmes. The rate at which a sound dies away can be highly evocative.

Sound effects heighten realism, add space and atmosphere, reinforce the action, and can guide the audience to a new situation or scene. Combining sound effects can create an aural impression that is greater than its parts.

Smooth transitions between contrasting images can be created by effects or music.

Anticipation or preparing the audience for change can be achieved by sound leading picture (e.g. the sound of the incoming scene beginning at the end of the outgoing scene).

Sound perspective focuses the attention of the audience on the visual space depicted (e.g. close-up sound for foreground action, distant sound for long shot). Sometimes dialogue clarity is more important than the realism of sound perspective. For example, the sound levels of orchestral instruments in close-up are not normally boosted to match picture content. The overall orchestral balance is an integral part of the performance and therefore takes precedence.

Off-stage sound suggests space and a continuing world beyond the frame of the image. It can also be used to introduce or alert the audience to new events. Sound from an unseen source creates space and mystery.

Narration voice-over acts in a similar way to the thoughts of a reader. Careful balance between voice, effects, and music combine to give a powerful unity and authority to the production.

Music is a sound source that has immense influence on the audience's response. It can create pace, rhythm, emotion, humour or tension, and requires a very subtle balance to weave the music in and out of effects and speech in order to create unity in the final production.

Silence is an attribute of sound that has no visual equivalent. It emphasizes or enhances a production point but only in a sound film can silence be used for dramatic effect.

The nature of sound

What is sound?

When there is a variation of air pressure at frequencies between approximately 16 to 16,000 Hz, the human ear (depending on age and health), can detect sound. The change in air pressure can be caused by a variety of sources such as the human voice, musical instruments, etc. Some of the terms used to describe the characteristics of the sounds are:

Sound waves are produced by increased air pressure and rarefaction along the line of travel.

Frequency of sound is the number of regular excursions made by an air particle in 1 s (see figure below).

Wavelength of a pure tone (i.e. a sine wave is the distance between successive peaks).

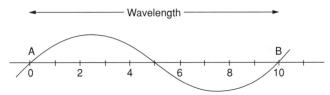

The time taken for a complete cycle of pure tone (A) to begin to repeat itself (B) is the frequency of the signal and is measured in cycles per second (Hz), e.g. $50\,\text{Hz} = 50$ cycles per second. Frequency is inversely proportional to wavelength. For example, a high frequency sound source of 10,000 Hz produces sound with a short wavelength of 3.4 cm. A low frequency sound source of 100 Hz produces sound with a longer wavelength of 3.4 m. Frequency multiplied by wavelength equals the speed of sound (335 m/sec) in cold air. It is faster in warm air.

Harmonics are part of the sound from a musical instrument which are a combination of frequencies that are multiples of the lowest frequency present (the fundamental).

Dynamic range is the range of sound intensities from quietest to loudest occurring from sound sources. This may exceed the dynamic range a recording or transmission system are able to process without distortion.

Decibels: Our ears do not respond to changes in sound intensity in even, linear increments. To hear an equal change in intensity, the sound level must double at each increase rather than changing in equal steps. To match the ear's response to changes in sound intensity, it is convenient to measure the changes in the amplitude of the audio signal by using a logarithmic ratio – decibels (dB). Decibels are a ratio of change and are scaled to imitate the ear's response to changing sound intensity. If a sound intensity doubles in volume then there would be a 3 dB increase in audio level. If it was quadrupled, there would be a 6 dB increase. To hear an equal change in intensity, the sound level must double at each increase rather than changing in equal steps.

Loudness is a subjective effect. An irritating sound may appear to be a great deal louder than a sound we are sympathetic to (e.g. the sound of a neighbour's cat at night compared to our own practice session on a violin!).

Phase of a signal becomes important when signals are combined. Signals in phase reinforce each other. Signals out of phase subtract from or cancel out each other.

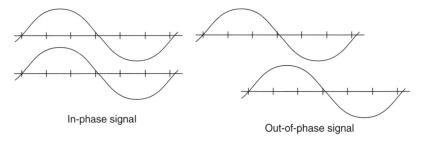

Pitch is the highness or lowness of the frequency of a note.

Acoustics

Reverberation relates to the time delay before sounds reflected from the wall and other surfaces reach the microphone.

Standing waves effect is due to the room having resonances where the parallel walls enhance certain frequencies.

Audio requires processing in order for it to be recorded or transmitted. This may include:

equalization: the process of adjusting the frequency response of the signal usually banded into control of high, medium and low frequencies. Switched filters are used to remove low frequency rumble etc.

limiters: these prevent the signal from exceeding a predetermined level.

compression: the dynamic range of some sound sources (e.g. an orchestral concert) can exceed that which can be transmitted. If manually riding the level is not always feasible, sound compression can be used. The aim is to preserve as much of the original dynamic range by judicious use of 'threshold', the level at which compression starts; 'slope or ratio', which controls the amount of adjustment; and 'attack and release', which determines the speed at which the compression equipment will react to changes.

Audio recording tracks

Analogue camera/recorder audio recording tracks

Many analogue camera/recorders have the facility of recording four audio tracks. Often two of these tracks are recorded on the longitudinal tracks and two tracks are encoded as an audio frequency modulation (AFM) signal and are recorded in the same area of the tape as the video information. These tracks can only be recorded at the same time as the pictures. They are designated as tracks 3 and 4 and are of superior quality to the conventional longitudinal tracks, 1 and 2.

Access to tracks 3 and 4 will depend on the model of the camera in use. The simplest of cameras have only two audio inputs with the signals from track 1 and 2 being automatically routed to tracks 3 and 4 respectively. On more complex cameras, the operator can select either to route the longitudinal (LNG) tracks 1 and 2 to be copied onto the AFM tracks 3 and 4, or to input separate signals to the XLRs 3 and 4 on the rear of the camera. This allows the use of up to four mic inputs, which can be mixed later during the edit or the dub. It is particularly helpful for the recording of stereo effects, where two tracks can be used for the stereo, leaving the other two tracks for the dialogue.

On SP cameras, tracks 1 and 2 can be encoded with Dolby 'C' noise reduction, improving the dynamic range and reducing the recorded noise. Using SP tape forces the camera to encode with Dolby regardless of the position of the selector. It is only with oxide tapes that the user must decide. Care should be taken to write down whether or not Dolby was encoded on these tapes in order to ensure they are correctly decoded. In 'one-man' operation, use channel 1 as there are two gain controls, one of which can be monitored and controlled through the viewfinder.

Audio inputs

Mic (front): When an audio channel is switched to this position, any microphone connected to the front audio input can be selected.

Mic (rear): This position enables the user to plug a microphone into the connector at the rear of the camera. On some camera/recorders, a separate switch can be found under the mic input marked +48 volts (Phantom Power) that supplies power to the microphone if required.

Line: When an audio channel is switched to this position, an external audio mixer can be connected. All microphones to be used are connected and controlled via this mixer and its input sensitivity to the Betacam is 0 dB; this is known as line level. Line input can also be used for a feed from a public address system mixer before amplification.

Position of audio controls (Digital Betacam 700)

- (2) **Audio channel recording level indicator switch:** this switch determines whether the recording level of audio channel is displayed on the viewfinder screen.
- (4) **MIC (microphone) AUDIO LEVEL control:** if the AUDIO IN switches are both set to FRONT, you can adjust the recording level of the microphone. If the AUDIO IND switch is set to ON, you can watch the audio level display in the viewfinder while adjusting the level.
- (5) AUDIO LEVEL CH-1/CH-2 (audio channel 1 and channel 2 recording level) controls: these controls adjust the audio level of channels 1 and 2 when you set the AUDIO SELECT CH-1/CH-2 switches to MAN.
- (6) AUDIO SELECT CH-1/CH-2 (audio channel 1 and channel 2 select) switches: these switches set the audio level adjustment for channels 1 and 2 to MANUAL or AUTO.
- (7) AUDIO IN (audio input) switches: these switches select the audio input signals for audio channels 1 and 2. The input signal source is either: FRONT: the input signal source is the MIC IN connector. REAR: the input source is the AUDIO IN CH-1/CH-2 connectors.
- (8) CUE IN (cue track input) switch: this switch selects the input signals for recording the cue track

CH-1: Channel 1 input signal

MIX: Mixed input signal of channels 1 and 2

CH-2: Channel 2 input signal.

- (9) AUDIO OUT (audio output) connector (XLR type, 3-pin, male): this connector outputs the sound selected by the MONITOR switch.
- (10) AUDIÓ IN CH-1/CH-2 (audio channel 1 and channel 2 input) connectors (XLR type, 3-pin, female) and LINE/MIC/+48 V ON (line input/microphone input/external power supply +48 V on) selectors: these are the audio input connectors for channels 1 and 2, to which you can connect a microphone or other audio sources. The LINE/MIC/+48 V ON selectors select the audio input signal source connected to these connectors, as follows:

LINE: line input audio equipment

MIC: a microphone with internal batteries

+48 V ON: a microphone with an external power supply system.

(11) **DC OUT (DC power output) connector:** this connector supplies power for a portable tuner. Do not connect anything other than a UHF portable tuner to this connector.

Basic audio kit

The directional response of a microphone is an important factor in the choice of microphone on location to avoid or reduce unwanted background sound. As well as quality headsets (single and double-sided), a basic audio kit could include:

- a pair of radio mics;
- a pair of condenser lapel microphones with clips or black gaffer tape for taping in place:
- a dynamic stick microphone reliable and versatile;
- a short condenser rifle microphone which requires a shock mount, a foam wind-shield for interior use, a basket windshield for exteriors and a hairy cover for extreme wind conditions:
- · microphone clamps and stands;
- XLR microphone cables and extensions;
- balance transformer.

For more specialist audio recording (e.g. music), other types of microphone can be hired. Every microphone used on an exterior location will need a purposedesigned wind shield protection plus a clip or stand.

XLR connectors: XLR (eXternal, Live and Return) type connectors are used for all balanced microphone connections and balanced high level signals. The connector has three pins - earth, live and return - and follows the convention that cable connectors with holes are inputs to the mixing/monitoring point. Connectors with pins point in the direction of the signal source.

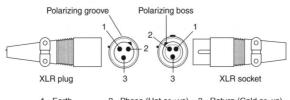

1 - Earth 2 - Phase (Hot or +ve) 3 - Return (Cold or -ve)

Pool feeds: Press conferences, theatre performances, concerts, publicity presentations etc., often provide a PA feed. This may be an unbalanced system and therefore a device called a direct injection (DI) box or balance transformer will be required. These usually have an unbalanced input fed with \(\frac{1}{4} \)-inch jack plugs and a balanced output on an XLR connector that can be plugged into the back of the camera. They may require internal batteries. An assortment of cable connectors and in-line adaptors is often invaluable when faced with a nonstandard set-up. Alternatively, use a PA feed through an unbalanced cable, with appropriate attenuation to connect to the input of a radio transmitter. If there is only a single speaker at a press conference, a radio microphone in close proximity avoids cables trailing to the back of the hall, but pre-check that no other camera crew are using radio microphones on or close to the chosen frequency.

Cables

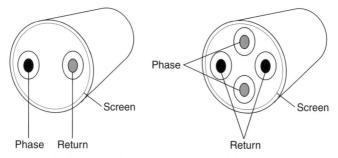

Screened balanced cable designed to reduce unwanted pick-up of interference.

Star-quad cables have two pairs of conductors laid in opposite directions. This configuration produces an antiphase component of the interference as the pairs are connected together at each end of the cable.

Microphone cables should be screen balanced or star-quad design to avoid unwanted pick-up and flexible to avoid cable tangles. It is useful to have a selection of cables in various lengths such as 2, 4 and 6 metres. As well as the potential for pulling you off-shot, if operating hand-held with a connected audio cable, be aware of straining the camera audio input connector if the cable should get snagged.

Windshields

A basket shield used to reduce wind noise.

A long-haired cover (a 'Dougal') for extreme wind conditions.

Choice of microphone

Types of microphone

There are three basic types of microphone: moving coil, ribbon and condenser.

The moving coil or dynamic: The polar diagram of this microphone can be omni-directional or cardioid, i.e. having a dead side to the rear of the microphone. This type of microphone can be used as a reporter's 'hand held' but care must be taken in its handling. They are less sensitive to wind noise than other microphones and are often fitted with wind protection within the body of the unit although they may need extra protection in extreme conditions where foam windshields should be sufficient. Windshields give some protection against rain and provide the microphone with a waterproof cover for short periods.

The ribbon: This microphone's polar response is 'figure of eight' – open front and rear, but closed to the sides. This microphone has been used mainly in radio studios with the interviewer and interviewee sitting across a table facing one another.

The condenser: The condenser microphone achieves the best quality of the three and requires a power supply to make it operate. This can be supplied by an 'in line' battery supply although many condenser microphones can be powered directly from the camera or audio mixer unit, the supply being known as 48 volt phantom power.

There are other forms of condenser microphone power supply known as 12 volt A/B and 'T' Power. Always check that the mic power supply matches the microphone to be used *before* connecting to the camera.

One type of condenser microphone is the short rifle type. This has a markedly good directional characteristic and is seen on booms and fish poles. The manufacturer which produces the MKH 416 short rifle (Sennheiser) assists the user with clear identification of the power source needed by marking the microphone with either:

- (a) MKH 416 P48 (48 volt Phantom Power), or
- (b) MKH 416T (12 volt A/B or 'T' Power)

There is a third option of supplying power using a battery that will be inserted either into the body of the microphone, or in the case of personal mics, in the 'in line connector'.

Choice of microphone

Choosing which microphone to use in a specific production environment will require consideration to be given to some or all of the following factors affecting a microphone's performance:

- nature of the sound source (e.g. speech, pop group drums, bird song etc.);
- matching the technical characteristics of the microphone to the sound source (e.g. frequency response, transient response, ability to handle high/low levels of sound (sensitivity), and directional properties);

- mechanical characteristics such as size, appearance, robust, wind shields, affected by humidity, stability, reliability, etc.;
- compatibility cable plugs, connectors and adaptors, matching electrical impedance, cable run required, interface with other audio equipment;
- powering arrangements (see Condenser microphone opposite);
- programme budget, microphone cost/hire and availability.

Frequency response of a microphone

Microphones convert acoustic energy (sound waves) into electrical power either by exposing one side of a diaphragm (pressure-operated) to air pressure variations or by exposing both sides of the diaphragm (pressure-gradient). Directional response of the microphone will depend upon which method is chosen or a combination of both and the physical design of the microphone. This an important factor in the choice of microphone on location to avoid or reduce unwanted background sound. Response of the microphone is also related to frequency of the audio signal. Directional response can be plotted on a polar diagram that places the microphone in the centre of a circular graph indicating the sensitivity at each angle with respect to the front axis of the microphone.

Microphone sensitivity

The sensitivity or output of a microphone is expressed in units of millivolt/pascal (mV/Pa) but more commonly quoted in comparison to 0 dB line level in decibels (dB). The more negative the dB figure, the less sensitive the microphone. For example, the output of a hand-held moving coil microphone will be in the region of –75 dB and is less sensitive than the output of a short condenser microphone which will be around –55 dB. Usually the camera microphone input sensitivity is around –70 dB, therefore most types of microphone can be used directly into the camera.

Radio microphones

A radio microphone system consists of:

- a microphone which could be any type of microphone but for many television programmes is a personal or lapel microphone;
- a small FM transmitter carried by the programme participant (or it can be built into larger microphones) into which plugs the microphone;
- · a short aerial attached to the transmitter;
- a receiver often mounted on the rear of the camera/recorder, powered by the camera's power supply and designed to receive the same frequency signal as the transmitter;
- an XLR connector cable from the radio receiver to an audio input on the camera usually at mic level (but check – some receiver outputs are at high level).

Personal radio mics have been designed to be small and unobtrusive and their appearance is usually acceptable to be seen in-vision. It is good practice, when using several radio mics, to have the same type and clip for uniformity in vision and for ease of maintenance if spares are required. Although the most common application of a radio mic is as a lapel/personal type microphone, any microphone can be attached to a radio transmitter when it is difficult to lay out cable, for example, at a press conference when shooting from the back of a room. The transmitter's range can be 50 metres or more depending on the site.

Choice of operating frequency

The power of the transmitter and its frequency are controlled by licence and legislation, which varies between different countries. In the UK the maximum power is 10 milliwatts which gives an effective radiated power of 2 milliwatts. This is to ensure that their use does not conflict with other users of radio communications. Location radio mics usually transmit on the VHF (138–250 MHz) band and in the UK, the use of frequencies between 173.8 MHz and 175 MHz does not have to be licensed. Each radio mic transmitter at the same location will need to operate at a different frequency with some separation, (minimum 0.2 MHz), otherwise they will interfere with each other. With the necessary 0.2 MHz channel separation, five common frequencies are 173.8, 174.1, 174.5, 174.8 and 175.0 MHz. An essential design requirement for radio mic transmitters is that they must be crystal controlled to ensure that their transmitting frequency does not drift outside their specified limits.

Design features

Most radio microphone transmitters/receivers are fitted with some or all of the following facilities:

• the ability to send a 1 kHz tone to check continuity of transmission strength and an input gain on the receiver to balance the use of various microphones with a signal strength indicator;

- a transmitted 'low battery' inaudible warning signal;
- a 'compander' to compress the signal before transmission and expand the signal after reception to improve the signal-to-noise ratio and bandwidth. This is switchable at the receiver and transmitter and both must be either on or off:
- to avoid multipath reception (e.g. reflections from metal structures) 'dead spots' when the programme participant is moving, and signal cancellation by the interaction when a number of radio microphones are in operation, diversity systems are fitted. This involves having two receiving aerials and a circuit which switches to the strongest and least distorted signal path.

Lining-up and rigging a radio microphone

- Check the condition of the transmitter battery and fit a good quality alkaline battery.
 Be aware that nickel cadmium rechargeable cells decay below operating voltage with very little notice.
- The microphone needs to be clipped or taped at about 200 mm from the mouth about mid-chest on a lapel, tie or adjacent clothing. Personal microphones are condenser microphones but some are more prone to wind noise or rustling clothes than others. Choose a design that is suitable for location work. Omnidirectional personal microphones can be rigged pointing up or down. If the speaker is liable to look down and talk, breathing across the microphone (e.g. a cooking demonstration), point the capsule down. Use adhesive tape to secure the microphone when hidden under clothing to ensure that it cannot move and rub against the fabric. If they are to be fixed directly to the skin, use non-allergenic plaster or a sterilized strip.
- Obtain a sound level check and adjust the gain on the transmitter using the peak level indicator on the transmitter. An LED is often fitted which flashes to indicate the onset of limiting. Set the gain with normal voice level so that limiting occurs and then reduce the gain so that only unexpected peaks will limit.
- Rig the transmitter in a pouch, belt or pocket of the artiste so that it is visually unobtrusive and away from any metal objects carried by them. The aerial should either hang vertically down or be taped upwards if the participant is sitting.
- The receiving aerial should also be upright and, if available, switch in zero level tone from the transmitter and set receiver level to zero level.
- Adjust the input audio level on the camera to read –20 dB on the digital audio level meter on the display panel.
- If time allows, ask the presenter/participant to talk and walk the anticipated area of movement. Check there is no interference to the signal path from large reflective surfaces. The receiver is fitted with a squelch circuit that mutes the output if there is insufficient signal strength. If this occurs try and identify the source of the problem, try a different frequency or modify the area of movement. It is better to prove the signal path in a rehearsal than discover problems on the recording, or worse, on transmission.
- Problems are often experienced with man-made fabrics causing noise and static. If
 the capsule is rigged below certain types of dense fabric, sound quality and level will
 not be satisfactory. If the rustling of clothing is picked up, a windshield or small cage
 can be fitted to keep the fabric away from the microphone.
- Avoid rigging personal microphones near necklaces or jewellery that could come into contact with the capsule if the artiste moves causing bangs and clicks.
- Check for wind noise and use a windshield if necessary. As the capsule is usually
 quite close to the mouth and shielded by the body, the balance of background effects
 to voice is usually quite good although the balance is constant regardless of shot
 size and desirable sound perspective.

Audio levels

There is a restriction to the range of quiet to loud sounds that can be faithfully reproduced without distortion in any broadcast system. This limited audio dynamic range (similar to the contrast range of brightness variation) can be shifted up or down the spectrum of human hearing to record and transmit the required segment of sound intensities. It is possible to record the sound of a pin dropping or the sound of a passenger jet taking off but not both at the same time. It is necessary, as in exposure, to estimate the production requirements, choose the appropriate range of sounds and set the audio level accordingly. A limited amount of compression of the dynamic range can be achieved without distortion becoming obtrusive but any excessive variation in sound levels requires metering and gain control (see Auto-gain, page 204).

Sound intensity range

The intensity of sound is a function of the pressure variation set up in the atmosphere. Intensity is proportional to pressure squared. A microphone is used to convert sound energy into electrical energy and the voltage produced is proportional to the sound pressure. The range of intensities from quietest to loudest is the dynamic range of that sound situation. For example, the ratio of the loudest sound produced by an orchestra to the quietest sound can be as much as 60–70 db in an orchestral performance. This dynamic range is greater than can be transmitted and therefore sound control and possibly sound compression is required when recording large variations in sound levels. To match the ear's response to changes in sound intensity, it is convenient to measure the changes in the amplitude of the audio signal by using a logarithmic ratio – decibels (dB) (see The nature of sound, page 186).

Zero level voltage

Just as light is converted into a TV signal with a standard peak amplitude of 0.7 V so sound energy when it is converted into electrical energy requires a standard signal, a baseline voltage to which all changes can be referred. This is known as zero level and the standard voltage selected is 0.775 V – the voltage across $600\,\Omega$ (a common input and output impedance of audio equipment) when 1 mW is developed. 1000 Hz is the frequency of the standard zero level signal. Increasing or decreasing sound intensity will alter the level of this voltage.

Appropriate production audio level values involve:

Peak level: the maximum acceptable level that the signal can be allowed to reach when passing through any individual piece of audio equipment in the broadcast chain. Above this level, the signal will be clipped and any increase in sound level will not be transmitted. The audio signal will be distorted.

Dynamic range: the ratio between the softest and the loudest sound.

Perceived loudness: a partly subjective value that often depends on the nature of the sound and its relationship to the listener.

Signal power: a mathematically determined value of the root mean square (RMS) of the signal and related to the way sound levels are heard.

Microphone technique

Recording location audio, particularly in a one-man camera/recorder operating mode, poses many problems. This is a brief introduction to some of the solutions.

Pieces to camera: Probably the first choice for a shot of a presenter talking straight to the lens is to rig a radio personal microphone but a piece-to-camera can also be accomplished using a short rifle microphone protected from wind noise mounted on the camera provided the camera is not panned to or away from the presenter. If the shot is tighter than a medium close-up, a stick microphone can be held by the presenter just out of shot.

Voice-over recordings: If it is necessary to record a voice-over on location try to ensure the audio quality will match any in-vision audio from the same presenter. Avoid interiors such as vehicles perhaps chosen to exclude background noise as often the interior acoustics will colour the voice. Try to eliminate background effects that will be distracting and probably not match the pictures the commentary is laid over. The aim is to record a neutral sound that will supply information without distraction. Lip ribbon microphones have a sports quality convention where they are used to exclude high ambient spectator or event noise. They often sound misplaced in other production situations.

Effects: Recorded effects (often known as a buzz track or atmos) are invaluable in post production to iron out audio mismatches. Audio 'jump cuts' in editing caused by an obtrusive background sound (e.g. running water, machinery, etc.) can be made less obvious and a single 'spot' effect may provide space and location atmosphere to the recorded images.

Help post production by being consistent in level and quality when recording effects and provide as much information on the cassette as possible. When covering an event using a camera-mounted microphone, the sound perspective may not match the picture. An additional effects recording may help to remedy the difference provided it is of sufficient length to cover the cut item. An omnidirectional microphone will provide all-round atmosphere. Avoid distinctive audio that is never seen in shot unless it is provided for atmosphere (e.g. church bells, train noise). It is often impossible to match specific locations with library audio material and a good, long consistent effects track is extremely useful. Avoid auto-gain unless there is no opportunity of achieving a sound level before the event (e.g. a loud explosion). It is impossible to record such highintensity sound level with a presenter's voice. The presenter must stop talking when the anticipated event happens (e.g. stop talking before switching on a food mixer). A moving coil microphone is useful for very loud, transient sounds. A hand clap near the microphone can be used to set gain if auto-gain is not selected

Recording levels

Sound monitoring

Monitoring audio quality is difficult in single person camera/recorder operations. If there is time, a double-sided headset can be used to check quality but more often time is at a premium and single-sided headsets (or none) are used. It is only by listening to the sound that an evaluation can be made. Audio level meters in the viewfinder and on the recorder side panel only assess loudness and do not identify the source of the sound. The least one can achieve with the intelligent use of a meter is to avoid a sound overload pushing the audio into the limiting circuit when its level exceeds the maximum permissible recording level. Beyond this point, the audio will be progressively distorted with no increase in loudness. Listening to the audio establishes production priorities (subject prominence, disturbing background, sound perspective etc.). Metering the audio allows the correct technical requirements to be fulfilled. An audible sound check confirms that audio is being recorded. There is usually provision for a confidence audio check on the camera speaker by switching between the audio tracks or combining (mix). E-E (electronics to electronics) is a facility that allows a check to be made on the signal before it is recorded.

Audio meters

There are two types of mechanical meter used to measure analogue audio levels. A peak programme meter (PPM) measures peaks of sound intensity. A programme volume meter (VU) measures average level of sound and gives a better indication of loudness but at the expense of missing brief high-intensity peaks that could cause distortion. Many digital cameras are fitted with electronic bargraph metering. These may have LED, plasma or liquid crystal displays that appear to be continuous from top to bottom. These are peak response meters but some have the facility to switch their response to VU mode where they will imitate the scale and ballistic response of a VU meter. Be careful when judging the recording level with VU meters as their slow response time may prevent them from showing short duration peaks present in voice recordings (especially female voices). It is good practice to peak 3 to 6 dB below zero VU if limiting of the signal is to be avoided. Cameras used without limiters may produce distortion on these short duration peaks, even when 0 VU is not reached on the meter. This may be seen on the camera as the peak indicator will flash before the meter reaches 0 VU.

Sound monitoring through the viewfinder

If you are using a single microphone, use track one (although check the post-production audio policy of the commissioning agent). Having connected the mic and selected mic position, turn the gain control at the side panel of the camera to maximum. Select the viewfinder for metering of audio. Obtain a sound level and adjust the front gain control on the viewfinder to register normal audio level on the viewfinder audio indicator. Reduce rear audio gain on side panel if

sufficient attenuation cannot be achieved. You now have attenuation and gain should it be required on the front audio control.

Adjusting the audio level through the viewfinder (DVW-700 series)

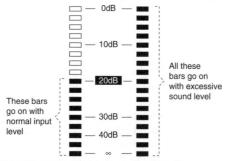

- 1 Set the AUDIO SELECT CH-1/CH-2 switches to MANUAL.
- 2 Set the AUDIO IND switch at the viewfinder to ON.
- 3 The audio level indication of channel 1 will appear in the viewfinder only when the AUDIO IN switch for the channel is set to FRONT.
- 4 Turn the MIC AUDIO LEVEL control on the front of the camera/recorder to adjust the audio level whilst monitoring the level indication in the viewfinder.
- 5 When the incoming audio level is normal, the nine bars from the bottom are on (-20 dB).
- 6 The second bar from the top may turn on occasionally, but do not allow the *top bar* to go on. If it goes on the audio level is too high.

Cue track

As well as the four digital audio tracks the digital format also allows for a longitudinal audio cue track. This can be used for time code or have a guide version of the sync, or feature audio to assist in editing. This track will be easier to listen to when the tape is being played at a non-standard speed whereas digital tracks will be decoded in bursts, omitting material when played faster than standard and repeating material when slower. The cue track can be recorded at any time, either with the picture or inserted separately. The information to be recorded on the cue track is normally set via the set-up menu in the viewfinder or on the camera/recorder output.

Audible sound checks: Sound quality can be checked by headphone or speaker: PB – to monitor the sound, switchable between tracks 1, 2 or MIX. There may be interference of time code or frame buzz and therefore the audio monitoring on PB provides a confidence check (i.e. sound has been recorded – 'an echo') and not a quality check. The switch position E–E (electronics to electronics) can be used to check the amplified audio signal before it is recorded.

Problems: If a microphone is connected to an analogue camera/recorder mic input with the correct power supply, but the level control has to be placed at maximum to obtain the slightest movement of the meter (i.e. indicating low sound level or faulty mic), the end result will be a high level of unwanted noise from both the microphone amplifier along with line buzz transmitted from the viewfinder.

Digital audio

It is important to have a basic understanding of how the audio is converted into digital information so that errors are not made in setting up the equipment. The audio signal is sampled at a constant rate like a series of pulses. For each of these pulses, the level of the sound is checked and this value is given a number. This number is transferred into binary code and this code is recorded as the digital information. The actual recording is therefore a string of codes, each representing the level of the audio at a particular moment in time. In order to achieve a good frequency response, the sampling is carried out at a very high frequency; 48,000 samples per second (48 kHz) is used for most professional systems. The level of the sound to be converted into binary numbers must also have sufficient steps to ensure accuracy, which is called quantizing. With the 16-bit system employed by most camera/recorders, 65,536 finite levels can be represented. Put simply, this means that in order to encode and decode the signals, all the systems must operate at the same sampling rate and the signal level must never exceed the maximum quantization step or no value will be recorded.

Digital audio recording

Video recording resolved the problem of recording a much higher frequency spectrum than analogue audio on tape by means of a rotating record/replay head as well as moving the tape. Digital stereo audio needs to record at 1.4 MHz and the DAT (digital audio tape) system was developed to meet this criteria. For editing purposes, an identical analogue audio track is added (sometimes called cue track) as rocking a slow-moving digital signal past a head produces no sound, unlike an analogue signal. The frequency response and signal-to-noise ratio of digital recorders are superior to analogue machines and repeated copying results in far less degradation. Drop out can be corrected and print through has less significance or is eliminated. Wow and flutter can be corrected by having a memory reservoir system from which data is extracted at a constant rate eliminating any variation in the speed at which it was memorized. In general, when a signal is converted to digital, there is more opportunity to accurately rebuild and rectify any imperfections (see Error correction, opposite), and to allow signal manipulation.

Sampling and the conversion of the amplitude of each sample (quantizing) is carried out at precisely regulated intervals. The precision of these intervals must be faithfully preserved in order to accurately mimic the original analogue signal. The binary data produced by the quantization must be accurately timed. Coding converts the data into a regular pattern of signals that can be recorded with a clock signal. When the signal is replayed, the recorded clock information can be compared with a stable reference clock in the replay equipment to ensure the correct timing of the digital information. The timing and reference information not only ensures an accurate decoding of the signal, but also allows error correction techniques to be applied to the samples.

Simplified audio digital process Sampling

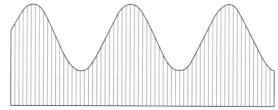

The analogue audio signal is split into samples at a fixed rate of 48,000 samples per second (48 kHz). The height (amplitude) of each sample (each vertical line in the diagram) is then measured in a process known as quantizing. The high number of samples is to ensure that the analogue signal is faithfully mimicked because changes in signal amplitude between samples would be lost and distortion would occur in the digitalizing process. The sampling frequency needs to be at least twice the maximum audio frequency that it is required to reproduce. Filtering the audio signal is required to ensure that no audio exists at more than half the sample frequency.

Typical sampling rates that have been chosen include, for transmission systems such as NICAM 728, the system design uses 32 kHz giving a practical limit to the audio of 15 kHz. For compact disc the rate has been set at 44.1 kHz whilst many broadcasting stations set the rate at 48 kHz.

Quantization

The amplitude of each sample needs to be converted into a binary number. The greater the range of numbers, the more accurately each sample can be measured. To simplify this measurement, each sample is converted into a whole number and the accuracy of this conversion will depend on how many divisions are chosen to make the representation. For example, the height of people could be measured in metres ignoring centimetres. There would be 2 metre high people or 3 metre high people and no heights in between. This would not reflect the variation in people's height. In quantization, if there are a greater number of levels used in the encoding process the decoded signal will be nearer to the original sound.

Error correction

In addition to quantizing errors, other defects can occur in analogue/digital conversions.

Burst error is the loss of a number of consecutive samples when recorded. It is possible to minimize this by arranging the data in a non-sequential order by a controlled code that can be reassembled in its correct temporal order when decoding. This effectively separates the missing data, ensuring that consecutive values are less likely to be lost.

Random error is the loss of single samples due to noise or poor signal quality. Correction systems can either replace the missing sample with a copy of the preceding sample (although this is only useful for a very few consecutive samples), or replace it with an average of the preceding and succeeding data. If the error cannot be resolved the system will mute until sufficient samples are available for the conversion to continue.

Using an audio mixer

The main reasons for using a separate mixer are that more microphones can be used and the operator will have better control of the balanced output between the microphones along with greater control of each microphone.

Audio mixer

Small portable audio mixers usually have the following facilities:

- · powered by internal batteries or external DC supply;
- PPM meters indicating peaks of programme sound;
- multiple microphone inputs (4-6 channels);
- switched power supply (phantom 48 V/off/T) for each microphone input;
- coarse gain control for each channel (usually a switch selecting 0 dB (line),
 -10 dB; -40 dB; -60 dB; -80 dB);
- high-pass filter for each channel consisting of a three-position switch enabling low frequencies to be cut (e.g. 90 Hz, 150 Hz or no filtering). This will help to reduce low-frequency wind noise, low-frequency traffic noise and ventilation rumble;
- master gain controls for two separate outputs or combined in selected proportions;
- headset monitoring of the output mix or tape return (useful to ensure that the correct connection has been made to the camera and that the signal is actually being recorded);
- · possibly a 'pre-listen' facility on any mic.

Line level (zero level)

An audio mixer should have a built-in tone generator, which will produce a 1000 Hz tone when switched on. The level of the tone generator is controlled by the main output gain of the mixer and should be set so that the PPM meter peak is at 4. This level is known as ZERO LEVEL and when connected to the line input, the camera meter should read -4 VU.

Typical mixer sound levels

Using a condenser rifle microphone plugged into channel 1, the power switch positioned to 'phantom', and the coarse gain set to (-60 dB), check for a meter reading between PPM4 and PPM5 with the microphone 1.2 m (4 ft) from the presenter talking at normal speech level. Beware of getting a directional microphone too close to the presenter (minimum approximately 300 mm (1 ft)), as this will affect the frequency response of the mic, causing an increase in bass response; this is known as proximity effect. Channel 1 fader should be at approximately three-quarters of maximum to produce a peak on the meter between PPM 4 and PPM 5. If there is insufficient level, extra gain can be had first from the channel fader and then from the main fader.

Portable audio mixer

Front panel

To avoid the possibility of introducing noise into the mixer chain, ensure that the minimum attenuation is used on the channel input and adjust the working level of the channel fader before any increase of the main gain if channel gain is insufficient.

Hi and Lo outputs

The output of the mixer marked Hi is at line level and should be used wherever possible in order to improve protection from induced unwanted electrical interference causing a reduction in the signal/noise ratio.

The output marked Lo is at microphone level and can be used to feed into equipment (e.g. tape recorder) only provided with mic level inputs.

Location sound

Microphone on camera

There are a number of disadvantages in mounting a microphone on a camera but it is expedient when covering news. Care must be taken not to transfer camera operational noise to the microphone and that when using a very narrow angle, to check that the sound the microphone is picking up matches the picture. High quality mics should be used wherever possible.

Auto-gain

Auto-gain can be considered the equivalent of auto-iris and needs to be used with the same caution. Auto-gain will respond to rapid increases of sound intensity by rapid reduction of recording level. This may often be undesirable.

An example would be while recording 'quiet countryside atmosphere', when someone close to the microphone controlled by auto-gain slams a car door. The result would be a very rapid attenuation of 'quiet countryside atmosphere', followed by an equally quick rise in gain after the car door noise has finished.

Use auto-gain when there is no opportunity of obtaining a sound level before recording (e.g. an explosion; aircraft take-off) or when it is anticipated there will be sudden and large changes in sound level (e.g. a crowd cheering). Decide whether auto-gain will produce more problems than it solves.

Manual control

Manual control allows intelligent decisions to be made about level and will rely on the built-in limiter to take care of the unexpected sound overload. There are three basic requirements in sound control:

- 1 To keep within the dynamic range of the audio recording system.
- 2 To adjust the recorded sound levels to suit the subject (e.g. match the sound perspective to the size of shot).
- 3 To maintain consistent sound level and quality over a number of shots or the result will be difficult to edit.

Wind noise

The major problem for outside location recording is wind noise. Most microphone manufacturers will produce windshields for their products in the shape of foam covers. Lapel or personal mics suffer badly from wind noise and their small windshields provided by the manufacturers are only of limited effect. It is usually possible to rig the mic under the clothing, provided the clothing is made of reasonably open fabric; cotton or wool garments are ideal. Care must be taken to prevent rustle from the fabric rubbing the mic, which can be avoided by taping the mic in place rather than using the clips provided. Listen carefully to ensure that the fabric is not too thick, causing a loss of high frequency and resulting in muffled sound, although in strong winds, a small loss of high frequency is more acceptable than serious wind noise.

Auto gain

With auto gain switched in, the level of foreground speaker's voice will be forced down as auto gain compensates for increasing level of approaching tractor engine.

Background noise

A prominent rhythmic background sound such as a clock may cause problems in editing.

Record a wild track of clock and ensure clock is not heard in cutaway questions.

Alternatively, stop clock (if this is not obvious in shot) and record a wild track to be added in post production.

Background noise

On location there is often the unwanted background noise of traffic, aircraft noise, machinery, etc. Try to back the microphone off from the background noise and use the presenter's body as an acoustic screen. Record a wild track of persistent noise to help in post production. There are difficulties in editing with some types of background noise (i.e. a passing aircraft) and note that directional mics are only directional at high frequencies. Traffic noise on eithe side of the microphone's 'acceptance' angle may still be intrusive.

Be watchful in the vicinity of airfields, military establishments or high powe electronic equipment for radar/radio transmissions that may induce electronic enterference in microphone cables. Always use the high level output portable mixer to improve the ratio of signal level to interference.

Recording an interview

On one microphone

When recording an interview with the presenter holding one hand-held microphone, always listen to establish who has the prominent voice and get the presenter to favour the microphone towards the quieter of the two. The obvious danger arises when the presenter consistently moves the microphone from one person to the other. If he or she is incorrect in favouring the person who is talking, the result will be worse than not moving the microphone at all.

On two microphones

When recording an interview using two personal microphones through an audio mixer:

- 1 Ensure that the microphones are free from catching clothing, brooches, beads, etc. and are firmly clipped on to substantial fabric. If there is heavy breathing noise during normal speech level, invert the microphone and point it to the ground.
- 2 Set the level of each microphone individually to read between PPM 4 and PPM 5, then check (using headphones) to ensure that both voices are at the same listening level by adjusting the two faders. Be careful when one person is quieter than the other, requiring extra gain in one mic. When the louder person is speaking the extra gain on the quiet person must be removed by reducing the fader level, to prevent colouration being recorded (rather like an echo). This is present because the speaker is picked up by both mics.
- 3 If the overall level is above PPM 6, then attempt to adjust channel input attenuation. If this is not possible, adjust channel fader and lastly the main output control if attenuation is still required to produce a meter indication of between PPM 4 and 5.

Two microphones and no mixer

Without a mixer, two microphones can be used if they are routed to separate channels.

- 1 Connect interviewee's microphone to Channel 1 setting level as above.
- 2 Connect interviewer's microphone to Channel 2 setting level to read no more than -2 dB.
- 3 Note: Only Channel 1 (interviewee's microphone) can be monitored in the viewfinder and adjusted from the front audio control. Usually the interviewee is more important and more likely to vary in level.

Identify channel number and voice on the tape cassette.

Interview with hand-held microphone

It is better to hold microphone in a static position favouring the weakest voice than attempting to favour the speaker and positioning it incorrectly.

Personal microphones and jewellery

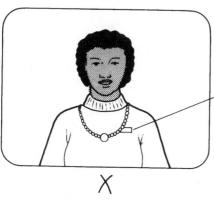

Personal mic positioned close to beads will result in clicks and bangs when speaker moves

Stereo

Normal hearing provides depth and space, perspective and separation, effects and atmosphere by 360° spatial hearing. The ear/brain judges direction of sound by the time difference of sound arriving at the ear. This 'time of arrival' difference is what must be considered when recording and handling stereo audio signals. Television mono sound originates from a single speaker but television stereo sound attempts to provide an approximation of normal sound experience. Ambisonics or surround sound takes the stereo image further and allows signals to appear all around the listener. For television, ambisonics is commonly reproduced using five loudspeakers, one either side of the screen with a third placed under or over the screen and two further speakers placed behind the viewer. The ambisonic signals can be processed to feed a larger number of speakers. Many television sets in use are not equipped with stereo sound and therefore stereo transmissions must be compatible with mono reception.

Locating stereo sound

Effective stereo sound requires the 'on screen' sound to be augmented with 'off screen' sound. Stereo adds to the screen image sound, background sound located left or right of the screen whilst still being compatible with mono listening. If approximately 15° is the central wedge of sound image on screen, everything else that does not have an obvious geographical relationship to the picture is 'elsewhere'. A further complication is the variation in transmitted television formats, which can be 4:3, 14:9 and 16:9. Sound that is 'off-screen' for a 4:3 image may be on-screen for a 16:9 format. Stereo sound is not simply a technological enhancement but should be integral to the programme aims and production style.

Microphone placement

A stereo effect will occur if the time of arrival of an audio signal at a pair of coincident microphones is different and this difference is faithfully reproduced on two loudspeakers. This inter-channel difference can also be artificially replicated from a mono source by the use of a pan-pot, which determines what proportion of the mono signal is directed to each stereo channel. The angle of acceptance of the two microphones, which are usually positioned 90° to each other, will depend on their polar diagrams and their position relative to the sound source. Similar to the angle of view of a lens, the closer the pair of microphones are to the sound source the greater the sound image will fill the region between the monitoring loudspeakers. The sound can originate from a point source such as a voice (excluding reverberations, etc.) or occupy a wide physical area such as a symphony orchestra. As television stereo sound pickup is normally required to match the field of view of the displayed image, the width of the sound image and the polar diagram of the microphones are important. For example, a figure-of-eight ribbon microphone close to a camera will pick up sound in front of as well as behind the camera.

Middle and side

The middle and side (M and S) pair of microphones above consists of a cardioid facing forward, providing the M (middle/main) signal or centre image and a figure-of-eight microphone providing the S (side) signal.

Advantages of the M and S technique in news and documentary production are:

- the proportion of side component can be decided and adjusted away from pressure of location work;
- a good mono signal is available if stereo problems occur in post production;
- the middle forward-facing microphone gives a clear indication of the direction the microphone is facing.

The main disadvantage for location work is that the S microphone (a figure-of-eight response) is prone to wind noise and rumble.

Points to consider when recording stereo sound on location exteriors when there is likely to be less control of placement and choice of microphone are:

- Are the left-right position images correct relative to the picture?
- Are there any time delays between picture and sound?
- Are there any time delays between the left and right legs of a stereo signal producing a hollow sound, lacking clear imagery?
- Do the sounds appear at the correct distance from the camera (perspective)?
- Is the relationship between the primary sound sources and the background effects satisfactory, and is the effect of the acoustic suitable?
- Does the sound match the picture?
- Stereo sports coverage often uses very widely positioned microphones rather than a co-incident pair on spectators to suggest an 'all round' atmosphere.
- Spot effects of on screen images (e.g. a cricketer hitting a ball) can be covered by an 'on-camera' microphone if it is continuously providing close shots of the main action.
- Commentary will be central if the commentator is speaking in-vision or slightly off centre when out of vision.

Road craft

The audio/visual industry has a huge international turnover. For many millions of people, television is the prime means, and often the only choice of entertainment. Such a potentially profitable product requires tight budgetary control and efficient methods of production. Location camerawork is part of this industrial process and requires the standard professional disciplines of reliability, efficiency and consistent product quality. Quality is the result of good technique. Being reliable and efficient is a combination of the personal approach to the job and using and understanding technology. Road craft is preparing and maintaining the essential camera equipment needed for location production.

Start of day check: If you work with the same camera equipment each day and it is stored in a purpose-equipped vehicle, then you should know exactly what you are equipped with, its operational performance and its maintenance condition. In effect you have a set of production tools that are familiar and consistent. Many users of camera/recorders do not have this continuity of equipment experience and may be faced with pool equipment shared by a number of people. The three questions that always need asking at the beginning of the day are: What is the nature of the day's shoot? What equipment is required? What is the condition of the equipment that is being taken to the shoot? There is never a complete answer to the first two questions (until after the event), but it should be possible to establish the condition of the camera and the consumables you are taking into the field.

- Check that every item of equipment you need is there and remember to check over the equipment you bought to a location when you leave the location.
- Check the state of charge of the batteries (see Batteries, page 218).
- Check all mechanical parts for security and stability (e.g. tripod adaptor and the condition of the pan/tilt head).
- Run the camera up and check scene file settings and lens operation.
- Check and clean if needed the rear and front lens elements.
- Check equipment and your own provision for foul weather protection.

Pool equipment: On an unfamiliar camera there are some time-consuming checks that need to be made before location day. These include checking that the auto-iris is functioning correctly (i.e. is the exposure setting accurate?), what signal level is the zebra exposure indicator set at, when were the recording heads last cleaned, and are there any malfunctioning facilities you should know about? Check, if possible, with the immediate previous user.

Sometimes, electronic equipment appears to be as idiosyncratic and as temperamental as some of the people you work with. A thorough knowledge of the technology involved, regular maintenance and equipment care will help to minimize equipment failure. People malfunction is outside the scope of this manual.

Programme requirements

Check that the kit you are taking to the location is adequate to fulfil the programme requirements. Is a replay monitor required? Will there be mains at the location to power it or are batteries required? What about lighting?

Getting answers to production questions *before* the day is better than getting them before you start out and infinitely better than getting a shopping list of requirements when you arrive at the location with the wrong gear.

WHAT'S MISSING? WHAT'S WORKING? WHAT'S NEEDED?

Camera Reflector

Standard lens Spun/ND gel/scrim

Wide-angle lens
Tape cassettes

Batteries

Battery belt

Light meter
White card
Portable player
Playback adaptor

Battery lamp AC/DC colour monitor – with

Battery charger hood/batteries

On camera microphone Charger for monitor batteries

External mics Pistol grip

AC mains adaptor On camera antenna Rain cover Audio mixer

Transit bag
Lens cleaning gear
Matte box/filters

Audio cables
Radio mics and receiver
Alternative camera mounts

Tripod adaptor Wheels

Tripod/spreader Pack-away dollies
Pan and tilt head 5-inch viewfinder

Remote zoom control Remote zoom and focus

Pistol grip controls
Pan bars Gaffer tape

Mobile phone Mains extension sockets
Lighting kit Mains extension cable

Operational checks (1)

This section of the manual is for those people who have little or no experience of camerawork. They usually have a double disability. First they are not proficient with the camera controls and need time to remember what to do and in what order. Second, they are probably operating with a camera that is shared with others.

Battery check: Check the state of charge of the batteries. Find out when they were on charge and in what condition they were before the charge. A battery that has been charged and not used for several days may not remain fully charged. Individual cells discharge at different rates and the battery may have become unequalized. It may not respond to a fast charge before you leave (see Batteries, page 218).

Mechanical checks: Check all mechanical parts for security and stability. A common problem is the interface between tripod adaptor and the pan/tilt head. Check that the tripod adaptor on the pan/tilt head is suitable for the camera and that the locking mechanism will hold the camera secure. Make certain the friction clamps on the legs lock the tripod at any height required.

Lens check: Remove lens (see fig. on page 215) and inspect rear element and filter wheel for finger marks or scratches. Refit lens if clean. Check that auto-iris and auto-zoom are set to AUTO position if you wish to operate in this mode. **How to clean the lens:** A front of lens screw-in filter such as an ultraviolet (UV) is the best protection for the front element of a zoom. The cost of replacement if damaged is insignificant compared to the cost of repairing or replacing zoom

front element.

Lens tissue and breathing on the front of lens filter is the most common and the simplest method of removing rain marks or dust. Dirt and dust can be removed with an air blower or wiped off gently with a lens brush. Never vigorously rub the lens surface or damage to the lens coating may result. To remove oil, fingerprints or water stains, apply a small amount of commercial lens cleaner to a lens tissue and clean in a circular movement from centre to edge of lens.

Moisture: Protect lens from driving rain. Dry off lens casing with a cloth and front element with lens tissue. Place lens in a plastic bag overnight, with a desiccant such as silica gel.

Humidity: Check that the HUMID indicator is off in display window before inserting tape cassette.

Viewfinder: brightness and contrast

The monocular viewfinder is the first and often the only method of checking picture quality for the camcorder cameraman. The small black and white image has to be used to check framing, focusing, exposure, contrast and lighting. It is essential, as the viewfinder is the main guide to what is being recorded, to ensure that it is correctly set up. This means aligning the brightness and contrast of the viewfinder display (see page 60). Neither control directly affects the camera output signal. Indirectly, however, if the brightness control is incorrectly set, manual adjustment of exposure based on the viewfinder picture can lead to under- or over-exposed pictures. The action of the brightness and contrast controls therefore needs to be clearly understood.

- Brightness: This control alters the viewfinder tube bias control and unless it is correctly set up the
 viewfinder image cannot be used to judge exposure. The brightness control must be set so that any
 true black produced by the camera is just not seen in the viewfinder.
 - If, after a lens cap is placed over the lens and the aperture is fully closed, the brightness is turned up, the viewfinder display will appear increasingly grey and then white. This obviously does not represent the black image produced by the camera. If the brightness is now turned down, the image will gradually darken until the line structure of the picture is no longer visible. The correct setting of the brightness control is at the point when the line structure just disappears and there is no visible distinction between the outside edge of the display and the surrounding tube face. If the brightness control is decreased beyond this point, the viewfinder will be unable to display the darker tones just above black and distort the tonal range of the image. There is therefore only one correct setting of the brightness control, which, once set, should not be altered.
- Contrast: The contrast control is in effect a gain control. As the contrast is increased the black level of the display remains unchanged (set by the brightness control) whilst the rest of the tones become brighter. This is where confusion over the function of the two viewfinder controls may arise. Increasing the contrast of the image increases the brightness of the image to a point where the electron beam increases in diameter and the resolution of the display is reduced. Unlike the brightness control, there is no one correct setting for the contrast control other than an 'overcontrasted' image may lack definition and appear subjectively over-exposed. Contrast is therefore adjusted for an optimum displayed image, which will depend on picture content and the amount of ambient light falling on the viewfinder display.
- Peaking: This control adds edge enhancement to the viewfinder picture as an aid in focusing and has no effect on the camera output signal.

Operational checks (2)

Electronic adjustments

Run the camera up and carry out a quick check of all the main controls. Make certain that each switch is set to the mode you wish to operate in.

Menu

Most digital camera functions and parameters such as gain, shutter, viewfinder indicator display, etc. can be programmed from a computer menu displayed in the viewfinder or external monitor. Each set of memorized variables is called a scene file and is stored either on a removable memory card or in a memory system integral to the camera. There are usually four or five different categories of file available.

- 1 A default scene file containing values that have been preset by the manufacturer. This should be selected when using a camera following on from other users. Alternatively there may be a scene file that has been customized by an organization for a group of users such as students. This may have a standard zebra value for example, programmed for consistency in operation by a number of people or maybe a stored automatic adjustment to auto exposure to correct error readings on that specific camera/lens.
- 2 A blank scene file can save any adjustment to the camera variables displayed on the menu. It is advisable to name the file to indicate its application (e.g. J. Smith File or Preset Studio, etc.).
- 3 Adjustment to the programmable camera variables may be spilt into two sections camera operations and engineering. The engineering file may be locked to prevent accidental adjustment to crucial camera settings (e.g. matrix table).
- 4 There is usually a self-diagnostic programme which checks the camera/recorder electronics and reports on the status of each section.

Select user and check the set-up card identification

Check the menu settings and select *default* or *factory setting* if another user of the camera has reprogrammed the set-up card.

Check the settings for the following and refer to the appropriate topic page if you are uncertain what should be selected for the intended shot/lighting conditions:

- shutter (PAL system 1/50th) and gain (0 dB) (page 84)
- skin tone detail and variable detail frequency (pages 79–80)
- gamma and matrix (page 96)
- contrast control and auto-exposure settings (page 70)
- level dependence and crispening setting (page 79)
- aspect ratio mode (if using switchable camera) (page 106)
- viewfinder indicator graticules (e.g. centre screen mark; 4:3 indication, etc.) (page 61).

If in any doubt of what setting should be used, restore the default setting.

Battery check

Battery voltage indication

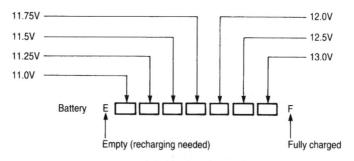

300/400 series battery indicator

Clip on battery and turn the POWER switch to ON. Check the state of charge of the battery indicated in the display window.

How to remove the lens (300/400 series)

Remove lens cable from clamp (4) and unplug lens cable from camera (3). While supporting lens, press up lens fixing lever (2) and remove lens.

Camera mounts

Because lightweight cameras were the first generation of video cameras that could be operated from the shoulder, they were, and still are, frequently referred to as hand-held cameras. Although shoulder operation is suitable for fast breaking news stories or where the camera needs to be frequently repositioned at speed, the great majority of lightweight camerawork benefits from the camera being mounted on a pan/tilt head and tripod. Shaky and unsteady pictures are difficult to edit into standard 'invisible technique' productions, but they have become a feature in those programmes where an unsteady frame is equated with 'realism' and 'naturalism'. The 'camera surprised by events' has become a popular camerawork style where the camera nervously on the move, with unsteady framing, has sought to replicate unrehearsed news coverage.

Pan and tilt heads

A good pan and tilt head will have adjustment for the centre of gravity (C of G) of the combination of camera/recorder, lens and viewfinder in use. If the C of G is not adjusted then the camera will either be difficult to move from the horizontal or it will fall forwards or backwards. When adding a 5-inch viewfinder on top of the camera, the C of G will need adjusting.

Adjustment of C of G balance should not be confused with mid-point balance, which involves positioning the camera and lens to find the point of balance on the head. If any additional accessories are added to the camera or lens (e.g. a pan bar with servo zoom control), then the balance needs to be readjusted.

The friction or drag control of the head depends on the shot and personal preference. Using a very narrow lens for an extreme close shot (e.g. a bird nesting) may require much more friction than that needed to pan the camera smoothly when following rapid impromptu movement (e.g. skating). Some cameramen prefer a heavy drag or 'feel' on the head so that there is weight to push against, whereas others remove all friction and the head can be panned at the slightest touch.

The head should have provision for locking the camera in the pan and tilt mode when not in use, plus a fail-safe system for locking the mounting plate attached to the base of the camera.

Tripods

If a tripod is to be of any value it must be quick to set up, rigid, with no tendency either for the legs to twist or flex. These essential design features need to be achieved with the lightest possible construction. It must have a good range of easily adjustable heights with an infallible locking clamp on each leg section. The feet of the tripod can be spikes that also fit into a spreader – a device to prevent the tripod legs from spreading out. The head-to-tripod connection can be a bowl fitting (100 mm or 150 mm), allowing the camera to be levelled using the built-in level bubble in the head, or a flat plate fixing which requires levelling to be carried out by adjusting one or more legs. A set of wheels can be exchanged for the spreader if the camera has flat level ground to reposition on.

The tripod adaptor plate

Use two screws to attach adaptor plate to tripod (if possible) to prevent plate swivelling.

Slide camera into wedge until a click is heard. Check that camera is locked by attempting to slide camera back on plate.

Steadicam

Steadicam EFP is composed of a harness worn around the torso supporting the camera and detached view-finder monitor. When the operator walks, the device eliminates roll or shake in the picture.

Safety note: Obtain qualified instruction before using Steadicam to avoid injury.

Other camera mounts

There are a number of foldaway light portable dollies, which can be packed and transported in a car. They consist of track and a wheeled base on which a tripod can be securely mounted. They require a tracker and sufficient time to level the track before shooting.

Clamps, gimbals and helicopter mounts provide stability when the camera is required to be mounted in moving vehicles, etc.

There is also provision to remote control pan and tilt, zoom and focus when the camera is mounted on a hothead (a servo-controlled pan/tilt head) at the end of a crane or when the camera needs to be placed in an inaccessible location without an operator.

There is a large range of dollies, arms and cranes that can be hired suitable for any size location or camera development shot.

Batteries

For many years nickel cadmium (Ni-Cad) batteries have been the standard power for portable video cameras. With the growth of portable computers and mobile phones, new battery technologies using nickel metal hydride (NiMH) and rechargeable lithium (Li-lon or Li) have been developed but at present Ni-Cad batteries form the main proportion of professional video batteries in use. The camera/recorder is normally powered by a 13.2 V or 14.4 V nickel-cadmium rechargeable battery clipped to the back of the recorder. There is a range of different capacity batteries available to give extended running times, or several batteries can be grouped together and worn on a belt. In general, digital recording requires more power than analogue recording.

Camera/recorder priorities: Without power there can be no recording and battery life and reliability is an ever-present factor in a cameraman's working day. The basic criteria in assessing a battery for location camera/recorder work are:

- What is the preferred and minimum acceptable run time?
- What is the maximum power drain of the equipment?
- How fast, how reliable and how safely can the battery be recharged?
- What is the optimum size and weight to balance the camera?
- Is there an accurate method of indicating battery power time remaining?
- How much routine battery maintenance and service will be required?
- What is the cost/estimated life of the battery system?

Camcorder power consumption: Most camera/recorder units draw between 15 and 45 watts and are usually powered by a 4 amp-hour battery which will on average provide 1–2 hours of continuous use depending on camera power consumption and the use of an on-camera light. As well as the chemistry of the battery design, the method of charging, discharging and temperature crucially affect the performance and life of the battery.

Battery voltage range: Another crucial camera specification is the operating voltage range. Most cameras will specify a minimum voltage below which the camera will not operate and an upper voltage beyond which operating the equipment will cause damage or trigger the power breaker. The value of this power figure is stated, for example, as 12 V (-1 +5) which means that the camera will function over the voltage supply range of 11 V through to 17 V. Many battery manufactures provide a viewfinder indication of time remaining with the battery in use.

Fast charge/quick charge: With aging, individual cells in the battery charge and discharge at different rates. With a fast charge, the charger needs to assess when any cell has reached full charge and then drop the charging rate to the slow charge rate to prevent venting and overheating.

Shelf life: A battery that has been charged and not used for a few days may not remain fully charged.

Safety hazards when charging a battery

Temperature: The Ni-Cad battery is affected by temperature. Temperatures below freezing (0°C) will not damage the cell but during discharge will seriously reduce the available capacity.

Cold temperature charging: The fast charging of a cold battery is one of the most dangerous hazards associated with Ni-Cad batteries and can result in a violent explosion. When a Ni-Cad is fast charged at temperatures below +5°C (+41°F), the internal charging reaction cannot proceed normally and a significant portion of the charge current can be diverted into producing highly explosive hydrogen gas. A spark can ignite this gas causing an explosion that can turn the battery into a grenade. Cold batteries must be allowed to reach room temperature before being placed on a charger.

Fire hazards: Ni-Cad batteries and chargers have been identified as the source of several fires and toxic smoke incidents over the years. One major TV network instructed their cameramen that batteries must not be charged in their hotel bedrooms. Most of these incidents are connected to fast chargers that failed to recognize when a battery reached full charge. The continuing current produces heat and eventually smoke or fire. This can be avoided by the use of a thermal fuse in the power circuit which will disconnect the battery from the charger if dangerous temperatures are detected.

A similar fire hazard can also occur if there is a mismatch between the charger and battery on a slow charge. Always provide for air circulation around batteries and do not charge batteries in a bag or flight case.

Physical shock: If a battery is internally damaged by physical impact or being accidentally dropped, internal wires can be short circuited and become red hot elements, causing the battery to burst into flames. Take every precaution to avoid subjecting batteries to violent physical impact.

Interactive battery charger

Most of the above hazards can be avoided or eliminated by using an interactive charger that continuously interrogates the battery while charging.

Pre-recording checklist

Get into the habit of carrying out a routine check before each recording. All of the following checks may not be necessary on each shot and you may prefer to carry out your review in a different order.

- 1 If the camera is mounted on a tripod, check the camera pan/tilt head is level and the required friction adjusted. Check the condition of the front element of the lens.
- 2 Switch power on and check state of battery charge and humidity warning indicator.
- 3 Check if there is a tape cassette loaded and if the tape is unused, record 30 seconds of bars.
- 4 Select colour correction filter according to colour temperature of light source.
- 5 Check and set the time code to the editing mode required.
- 6 Frame and focus the shot required and check exposure and lighting.
- 7 Check white balance.
- 8 Select and plug-up required mic and obtain a test sound level and adjust recording level.
- 9 Switch camera to stand-by, i.e. tape laced and ready to instantly record.
- 10 Press RECORD button and wait at least 5 seconds before starting shot.

General operational notes

- Avoid recording from any 'power save' mode, which usually means that the
 tape is not laced up and in contact with the head drum to conserve power. If
 the record button is pressed in this 'save' mode, there will be a small delay
 while the tape is laced and the recording achieves stability. This may result in
 a second or more of unusable picture. Always allow some run-up time before
 significant action to make certain that a stable edit can be achieved. Some
 formats require at least 5 seconds.
- Tape over any controls that are likely to be accidentally switched during operation (e.g. viewfinder brightness/contrast controls on viewfinder if they are likely to be knocked during lens operation).
- On some formats, camera power must be on to load or eject tape.
- A portion of the last shot can be previewed by using the RET button. The VTR will park after review awaiting next recording.
- Analogue Beta recorders require an adaptor to playback via a monitor.
- The BREAKER BUTTON is designed to 'trip' out on a voltage overload to protect the camera. This seldom occurs and if it needs resetting more than once for no obvious reason, have the camera serviced.
- Cue lights on the front and back of the camera (which can be switched OFF)
 will light or blink while recording and will also light in sync with display panel
 warning lamps.
- The ALARM CONTROL can be adjusted for minimum audible warning.

Warnings and indications on the display panel

- RF: lights if the recording heads are clogged.
- SERVO: lights if servo mechanism has failed or not locked to the reference signal.
- HUMID: lights if there is condensation on the head drum. Tape may stick to head.
- SLACK: lights if the tape is not winding properly. Eject cassette. Tighten or replace.
- Battery status: BATT flashes when battery nearly dead. Usually 'BATT' and 'E' flash when battery must be changed.
- Tape status indicator: Close to end of tape 'TAPE' flashes. End of tape when 'TAPE and 'E' flash.
- Audio channel 1 level meter: see Recording levels, page 198.
- Audio channel 2 level meter: see Recording levels, page 198.
- RB: lights during replay.
- VITC: lights when VITC is selected for the time code (see Time code, page 91 for time code adjustment).
- EXTLK: lights when the camera is synchronized with an external time code.
- HOLD: lights when the time code is on hold.

Manually unloading a cassette (700 series)

The cassette can be removed manually if the battery voltage drops below 9 V.

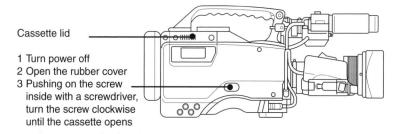

There is no need to return the screw to its original position after taking out the cassette. The cassette lid will operate normally when the camera is next switched on with a charged battery.

Safety

Individual responsibility

Health and safety legislation obliges you to take reasonable care of your own health and safety and that of others who may be affected by what you do or fail to do. You also have a responsibility to co-operate, as necessary, to ensure satisfactory safety standards. If you comply with the requirements for safety and something goes wrong, then your employer will be held to account. If you fail to comply, you may lose any claim for compensation for injury and could even be prosecuted as an individual. What you must do is:

- follow the safety requirements and any instructions you are given, especially in relation to emergencies (e.g. know the location of fire exits)
- ask for further information if you need it and report accidents (or a near miss!), and any dangerous situations or defects in safety arrangements
- do not interfere with or misuse safety systems or equipment, or engage in horseplay that could be dangerous
- work within the limits of your competence, which means a knowledge of best practice and an awareness of the limitations of one's own experience and knowledge.

Assessing risk

The key to good, safe working practices is to assess any significant risk and to take action to eliminate or minimize such risks. The procedure is:

- identify precisely what is required in the production
- identify any potential hazards in that activity
- identify the means by which those risks can be controlled.

The key terms in risk assessment are:

- Hazard the inherent ability to cause harm.
- Risk the likelihood that harm will occur in particular circumstances.
- Reasonably practicable the potential improvement in safety is balanced
 against the cost and inconvenience of the measures that would be required.
 If the costs and inconvenience do not heavily outweigh the benefits, then the
 thing is reasonably practicable and should be done.
- Residual risk the risk remaining after precautions have been taken.

An example: It is proposed to shoot from a camera hoist near overhead power lines. The power lines are a hazard. Touching them could result in death. What is the likelihood (risk) that harm will occur in particular circumstances? There may be the risk of a high wind blowing the hoist onto the power lines. Is the weather changeable? Could a high wind arise? What is reasonable and practical to improve safety? The obvious action is to reposition the hoist to provide a usable shot but eliminate all risk of it touching the power lines. As weather is often unpredictable, the hoist should be repositioned as the costs and inconvenience do not heavily outweigh the benefits. There remains the

residual risk of operating a camera on a hoist which can only be partially reduced by wearing a safety harness.

A checklist of potential location safety hazards

- Boats: It is essential to wear life lines and life-jacket when operating on a boat or near water such as on a harbour wall.
- Confined spaces: Check the quality of air and ventilation when working in confined spaces such as trench, pipes, sewer, ducts, mines, caves, etc.
- Children are a hazard to themselves. When working in schools or on a children's programme, check that someone is available and responsible to prevent them touching or tripping over cables, floor lamps, camera mountings etc.
- Explosive effects and fire effects must be regulated by a properly trained effects operator and especial care should be taken with those effects that cannot be rehearsed.
- Excessive fatigue is a safety problem when operating equipment that could cause damage to yourself or others and when driving a vehicle on a long journey home after a production has finished.
- Fork lift trucks must have a properly constructed cage if they are to carry a cameraman and camera.
- Lamps: All lamps should have a safety glass/safety mesh as protection against
 exploding bulbs. Compact source discharge lamps must always be used with a UV
 radiation protective lens. Lamps rigged overhead must be fitted with a safety bond.
 Check that lamp stands are secured and cabled to avoid being tripped over and that
 they are securely weighted at the base to prevent them being blown over.
- Location safety: In old buildings, check for weak floors, unsafe overhead windows, derelict water systems and that the electrical supply is suitable for the use it is put to. Check the means of escape in case of fire and the local methods of dealing with a fire. Check for the impact of adverse weather and in remote locations, the time and access to emergency services.
- Noise: High levels of location noise (machinery, etc.), effects (gunshots, explosions)
 as well as close working to foldback speakers can damage hearing. Stress will be
 experienced attempting to listen to talkback with a very high ambient noise. Wear
 noise-cancelling headsets. If wearing single sided cans, use an ear plug in the
 unprotected ear.
- Stunt vehicles: Motor vehicles travelling at speed involved in a stunt are likely to go
 out of control. Leave the camera locked-off on the shot and stand well away from the
 action area in a safe position agreed with the stunt-coordinator.
- Filming from a moving vehicle: The camera must be either securely mounted or independently secured on safety lanyards. Operators should be fitted with seat belts or safety harnesses attached to safety lines securely anchored.
- Roadside working: Wear high visibility gear and get the police to direct traffic if required. Police may give permission for a member of the crew to direct traffic but motorists are not obliged to obey such instructions.
- Adverse weather: A cameraman setting out for the day needs to equip himself with a choice of clothing to match any changing weather conditions. Those who work regularly out of doors must make themselves aware of the risks involved and how to protect themselves against sunburn, skin cancer, heat stress and heat stroke, hypothermia, white finger and frostbite. A check on the effects of any extreme weather forecast must be assessed each day on exposed camera positions. Individual safety requires a personal assessment and only the individual on a scaffold tower or hoist can judge when it is time to call it a day and retreat from the threat of lightning.

Glossary of production terms

Actuality event: Any event that is not specifically staged for television that exists in its own time

Ad-lib shooting: Impromptu and unrehearsed camera coverage.

Camera left: Left of frame as opposed to the artiste's left when facing camera.

Camera right: Right of frame as opposed to the artiste's right when facing camera.

Canting the camera: Angling the camera so that the horizon is not parallel to the bottom of the

Caption generator: Electronic equipment that allows text to be created and manipulated on screen

via a keyboard.

Crossing the line: Moving the camera to the opposite side of an imaginary line drawn between two or more subjects after recording a shot of one of the subjects. This results in intercut faces looking out of the same side of frame and the impression that they are not in conversation with each other.

Cue: A signal for action to start, i.e. actor to start performing.

Cutaway: Cutting away from the main subject or master shot to a related shot.

Down stage: Moving towards the camera or audience.

Dry: Describes the inability of a performer either to remember or to continue with their presentation.

Establishing shot: The master shot which gives the maximum information about the subject.

Eveline: The direction the subject is looking in the frame.

Grip: Supporting equipment for lighting or camera equipment. Also the name of the technicians responsible for handling grip equipment, e.g. camera trucks and dollies.

GV: General view; this is a long shot of the subject. **High angle:** Any lens height above eye height.

High key: Picture with predominance of light tones and thin shadows.

Locked-off: Applying the locks on a pan and tilt head to ensure that the camera setting remains in a preselected position. Can also be applied to an unmanned camera.

Long lens: A lens with a large focal length or using a zoom at or near its narrowest angle of view.

Low angle: A lens height below eye height.

Low key: Picture with a predominance of dark tones and strong shadows.

Piece to camera: Presenter/reporter speaking straight to the camera lens.

Planning meetings: A meeting of some members of the production staff held for the exchange of information and planning decisions concerning a future programme.

Point-of-view shot: A shot from a lens position that seeks to duplicate the viewpoint of a subject depicted on screen.

Post production: Editing and other work carried on pre-recorded material.

Prompters: A coated piece of glass positioned in front of the lens to reflect text displayed on a TV monitor below the lens.

Recces: The inspection of a location by production staff to assess the practicalities involved in its use as a setting for a programme or programme insert.

Reverse angle: When applied to a standard two-person interview, a camera repositioned 180° to the immediate shot being recorded to provide a complementary shot of the opposite subject.

Shooting off: Including in the shot more than the planned setting or scenery.

The narrow end of the lens: The longest focal length of the zoom that can be selected.

Tight lens: A long focal length primary lens or zoom lens setting. Upstage: Moving further away from the camera or audience.

Virtual reality: System of chroma key where the background is computer generated.

Voice over: A commentary mixed with effects or music as part of a sound track.

Vox pops (vox populi): The voice of the people, usually consist of a series of impromptu interviews recorded in the street with members of the public.

Wrap: Completion of a shoot.